FIELDS OF VIEW

Rossellini Journey to Italy

FIELDS OF VIEW

Film, Art and Spectatorship

A. L. Rees
Edited by Simon Payne

THE BRITISH FILM INSTITUTE
Bloomsbury Publishing Plc
50 Bedford Square, London, WC1B 3DP, UK
1385 Broadway, New York, NY 10018, USA

BLOOMSBURY is a trademark of Bloomsbury Publishing Plc

First published in Great Britain 2020 by Bloomsbury on behalf of the British Film Institute
21 Stephen Street, London W1T 1LN
www.bfi.org.uk

The BFI is the lead organisation for film in the UK and the distributor of Lottery funds
for film. Our mission is to ensure that film is central to our cultural life, in particular by
supporting and nurturing the next generation of filmmakers and audiences.
We serve a public role which covers the cultural, creative and economic
aspects of film in the UK.

A catalogue record for this book is available from the British Library.

A catalog record for this book is available from the Library of Congress.

ISBN: HB: 978-1-8387-1994-4
PB: 978-1-8387-1992-0
epub: 978-1-8387-1995-1
ePDF: 978-1-8387-1993-7

Typeset by Deanta Global Publishing Services, Chennai, India
Printed and bound in India

To find out more about our authors and books visit www.bloomsbury.com and
sign up for our newsletters.

CONTENTS

FOREWORD
HARVESTING FIELDS

ields of View: Film, Art and Spectatorship was originally commissioned
for the British Film Institute by the editor of A. L. Rees's highly regarded
A History of Experimental Film and Video, which was first published in
1999. Rees put *Fields of View* to one side in around 2007 though, and it was left
unfinished. This was partly because his trusted editor at the BFI had moved on, but
also because he became ill and decided to prioritize other projects that he could
more easily complete. This foreword explains some of the editorial decisions in
making the book ready for publication and offers some thoughts on what Rees was
aiming to achieve with the project. In the first instance it might be useful to situate
Fields of View with respect to other projects that he undertook between 2007 and
2014, when he died.

Perhaps the most significant project was the new edition of *A History of
Experimental Film and Video*, which came out in 2011 with a new introduction
and conclusion. Other writing included several essays on specific filmmakers that
were central to the short-lived magazine *Sequence*, published by no.w.here, a film-
lab and screening space run by Brad Butler, James Holcombe and Karen (now
Noor Afshan) Mirza, and a key point of contact for artists in or visiting London.
Rees's contributions to that magazine and his general enthusiasm and support
for no.w.here, in its heyday, were testaments to his being directly engaged with
contemporary artists whose work he appreciated. In this period, Rees also wrote
provocative essays for a wide variety of magazines and journals, as well as key
contextual pieces in a range of survey publications and catalogues such as the Tate
publications *Film and Video Art* and *Expanded Cinema* (2008 and 2011). Another
project, which I was brought in to help finish, was a co-edited book on Kurt Kren's
'structural films' with Nicky Hamlyn, published in 2016.

All of Rees's writing principally looks to connect up and represent experimental
film and video in relation to the wider culture and a lineage, but the connections
that he draws out point in myriad ways. In *A History of Experimental Film and*

Video the links are to other avant-gardes, from Cubism onwards, in a nuanced chronology that carries over into extensive endnotes. In *Fields of View* the network of connections is more instinctive and selective, taking in art-house cinema, minimalism, classical film theory, Soviet montage and suggestive key terms that span a range of disciplines. The links go back and forth more freely and are not necessarily chronological. Another common feature of Rees's writing is his attention to detail when writing about artists' works, which makes for direct and illuminating accounts. Notable examples in this book are the sections on the filmmakers Lis Rhodes and Marilyn Bailey (née Halford), whom he had not written about extensively before.

Another project that Rees was committed to, right until the end of his life, was teaching. Rees's enthusiasm for teaching was part and parcel of his promoting the appreciation of experimental film and video, and it is key to the attitude and perspective that underlies the book at hand. One of the arenas in which he most obviously shone as a teacher was that of the screenings that he regularly programmed and compered at the Royal College of Art, between 1996 and 2014, where he was a research tutor in Visual Communication. The form of these and other screenings at galleries, cinemas and arts centres around the country dates back to the 1970s, when he would show films in the back room of a pub to an art club in Luton on the first Sunday of every month. At the RCA, an evening of films spanning avant-garde classics and contemporary experimental films, alongside the odd music video and clips from Hollywood movies, or other narrative films, would be interspersed with deft observations about seemingly simple (though often overlooked) formal devices as well as more buried references and allusions. Rees's audience included colleagues, visiting artists, long-haul PhD students, MA students and friends, but his observations were always pitched as if he was talking to individuals that were new to the field. Even if some of the films that Rees was screening were very familiar, his skill was such that one inevitably came away seeing them in a new light.

Aside from these lecture-screenings, Rees was also always keen on working closely with students. I first met him at the Kent Institute of Art and Design, in Maidstone, where he was in charge of Time-Based Media, an influential course that was one of the first to coin the title. I caught up with him again as a PhD student at the RCA in 2001. Tutorials there could easily spill over into lunch and one would always come away with a long list of references to follow up, plus a stack of VHS tapes on loan from his library. On his part, Rees was never more excited than when hearing about projects in the pipeline that were going to involve young artists showing, discussing and making the kind of film and video work that he saw made for a tradition. The history of that tradition was confirmed when one read *A History of Experimental Film and Video*, which remains a key text internationally. Earlier significant books and essays include *The New Art History* (edited with Frances Borzello, 1986), the foreword to the English translation of

Hans Richter's *The Struggle for the Film* (also 1986) and several essays (spanning his career) on individual film and videomakers including Nick Collins, Peter Gidal, Nicky Hamlyn, Michael Snow, Jayne Parker, Stephen Partridge, Stefan and Franciszka Themerson and Chris Welsby.

For every historical account of a field there are umpteen critics who will announce its bias in terms of the author's particular perspective, forgetting that without that perspective there is nothing to say, or at least nothing very challenging or authoritative. With respect to his own history of experimental film and video, Rees answered the charge in advance, with the indefinite article – the 'a' – in his title. One of the questions that Rees often asked of other academics, writers and critics was 'What's their position?' Another was 'Who have they discovered?' Both questions pointed to his role as an engaged advocate rather than an impartial observer.

The starting point for Rees was his wholehearted identification with the notion of the 'avant-garde', his sense of which comes through in his quotation of Clement Greenberg's assertion that 'you don't define it, you recognise it as a historical phenomenon'. He wrote historical and critical accounts of artists' films and video from that position and judiciously dealt with trends and movements that were anathema to the work he most valued, recognizing that in the end only time would tell whether certain works deserved sustained attention.

In the second edition of *A History of Experimental Film and Video*, the new introductions and conclusions both declare a partisan and polemical position. One of the charges that he makes concerns the prevalence of 'post-millennial Cultural Studies' in art colleges and universities, which he saw as incapable of dealing with avant-garde cinema, given the focus on popular culture and its reception as overriding determinants. Another charge is to do with the rise of gallery-oriented film and video works and 'screen-based art' since the 1990s, which he suggests might comprise a wholly different phenomenon to experimental cinema. The fact that artists have regularly adopted film and video might not prove anything but a superficial connection.

Aspects of that critical position carry over to this book and there are passages in *Fields of View* where Rees pins his criticism on lists of artists. Such lists could be expanded or updated potentially, but they are a form of shorthand essentially and less important than the critique that is extrapolated, which is to do with artists that entertain a mode of production, or a model of spectatorship, without questioning attendant meanings and associations. In one passage of his notes the chief criticism he announces is to do with the acceptance of the 'reality effect' that tends to come as 'ready-laden' and 'ready-made' in the images that artists often source or emulate. In that vein he makes a distinction between the 'public artist' – the artist seeking to engage with current affairs, politics and the media landscape – and 'purist filmmakers in the co-op and avant-garde circuits'. Not all of the work he championed is 'purist' by any means: David Hall's television 'interruptions' are

central to the canon for example, and his lifelong friendship with the 'unofficial war artist' Peter Kennard was important to his take on political art. At the same time, he looked to highlight the culture of experimental film and video that has often been anathema to the gallery world in its reflection of public mores and debates.

Several artists whom Rees discusses, including Anthony McCall, Morgan Fisher, John Smith and Lis Rhodes, have been brought into the fold of the international art circuit, but it has largely been a game of catch-up for galleries. Few of the younger artists that Rees has written about, or programmed in screenings, have exhibited their work in gallery shows. Nor have they made their work by way of 'development' initiatives and professionalized funding streams for artists' cinema. Typically, films and videos by makers such as Neil Henderson, Yvonne Maxwell, Jennifer Nightingale, Gareth Polmeer and Samantha Rebello and me have been more readily seen in *ad hoc* artist-run screenings, festivals and sympathetic cinematheques. Many of the filmmakers discussed in this book might be well known to readers, but Rees also gives a significant amount of attention to works that won't necessarily be familiar, including the remarkably concentrated films and videos of the English artist and graphic designer Toby Cornish (now based in Berlin) and sue k. (an Australian artist who was a regular visitor to London) and the group of artists know in the early 2000s as the 'Austrian Abstracts'.

Angela Allen has been central to seeing *Fields of View* published. She regularly asked her husband about the book, and his standard reply, with a gesture towards a filing cabinet in his study, was: 'It's all there.' That material included a 250-page manuscript with chapter headings, different versions of the first quarter of that document and several versions of many of the subsequent sections. Some of the prose was fully worked up and material for one or two chapters has appeared in different guises elsewhere. In other sections arguments come to the fore in the form of literature reviews. Some of the literature he covers, such as Lev Manovich's *The Language of New Media* and Vlada Petrić's *Constructivism in Film*, will be well known to film and media scholars, and in so far as 'new media' are concerned there are more recent books that Rees might have gone on to tackle, but there are clearly ideas in a range of 'key texts' that needled him, and he dealt with them by collating quotes and commenting on the issues as he saw them. By comparison, various other essays that Rees discusses are quite obscure, and it is valuable to have them brought to light.

Some sections of the book are based on wonderfully intuitive associations. These associations might have been worked up further if there had been an editor on board at the right time. As it stands the reader is given generous insight into Rees's method of making links and developing an argument. At the same time, the project had its own rationale from the beginning, which easily allows for the extensive montage of associations that he was trying to accommodate. Rees refers to Humphrey Jennings's *Pandæmonium* and Walter Benjamin's *Arcades Project* in

more than one section of the book; both are models of imaginatively combined quotations and citations. Like these exemplars, the associations between ideas in *Fields of View* aren't necessarily contained, but they give rise to meaningful connections between cinema and diverse fields that span architectural studies, perceptual psychology, perspectival imaging and different instances of poetic imagination.

[handwritten: literary montage methods]

Besides referring to the literary montage methods deployed by Jennings and Benjamin, Rees also works through Eisenstein's different formulations of montage in various sections of the book. In highlighting Eisenstein's wide-ranging exploration of cinematic aesthetics, which took in art history, music and literature, Rees reflects his own interests. But it is the contradictory impulses in Eisenstein's writing – including the issu[...]
that Rees was most keen [...]
backdrop of the times.

Fields of View also takes [...]
goes back to Vertov and wi [...]
the presiding value of the 'i [...]
language by way of a focus [...]
reductive ontology: the 'in [...]
(depending on the transl[...]
such. In some ways one m [...]
but in charting contested [...]
between Vertov and Eiser [...]
expand its legacy. The int [...]
of the geometry explored [...]
considered the interval a v [...]
The account of cinema [...]
film and video technolog[...]

[handwritten: digital era of moving image]

[handwritten: image (photo, graphic & text) & sound are encoded as data]

[handwritten: CINEMA AS GROUNDED IN FILM & VIDEO TECHNOLOGY]

the ways in which one might think about the technological aspects of the medium are never absolutely determined. In the chapter entitled 'Frames', for example, Rees shows that no two filmmakers understand or make use of the film frame in the same way. There are also passages in the book that show how different forms of 'frame-based thinking' have carried over from film to digital video, where the frame is configured quite differently: as a time-base, rather than a physical unit. In this regard, his choice to look at film and video in terms of 'fields' is particularly interesting. On the one hand, the 'overlapping set of fields' that Rees plots reflects the notion that cinema is a 'mixed' medium, drawing on the aesthetics of other art forms and disciplines, especially in the digital era where image (whether photographic, graphic or text) and sound are encoded as data. On the other hand, the invocation of 'fields' involves a slightly anachronistic reference to the way that video technology produces an image. With analogue video and early digital formats, the image was produced by the horizontal scan of two interlaced fields

[handwritten: FRAMES ↓ from film (physical) to digital (time based unit)]

[handwritten: cinema grounded in film & video technology]

(as a means of 'compression' that reduced the required bandwidth of the signal) but the vast majority of video formats now involve 'progressive scanning' so that the image is produced in one pass of the screen. Fields are no longer a ready component of the video signal, but as a distancing device the term might allow us to think differently about the medium.

In one version of the manuscript the words 'field' and 'fields' were often underlined, perhaps marking points that Rees was going to return to. For the sake of consistency, the book has lost that signposting, but the term is regularly flagged in discussions throughout the book, whether in accounts of the discrete visual fields associated with graphic arts, photography, abstract paintings and minimalist art; the 'magnetic fields' described by George Kubler; the 'field theory' of gestalt psychology or the 'field theory' in physics that the filmmaker Werner Nekes refers to. The book also hones in on images of fields (and their surrounding fences) in several films.

One reference to fields that I have recently come across, which Rees must have seen because he had certainly read the book, is from Frederic Schwartz's *Blind Spots*. An epigraph to one of the chapters is from Goethe, and reads: '*My legacy, how grand, broad and wide! / Time is my property, my field is Time.*' According to Schwartz, time for Goethe 'was a field, one to be surveyed, one to be worked with care so that it would yield a good harvest in the present and be a proper legacy for future generations'.[1] In this context Schwartz characterizes Goethe's sense of time as 'classical', given his assumption that it could be made to 'stand still for long enough to work the ground with care and caution'. Time as a field is a pertinent image with regards film and video, and the classicism of Goethe's metaphor chimes with *Fields of View*. Rees was drawn to references that might increasingly be considered 'classical': Michael Fried's distinction between 'theatricality' and 'absorption' in modern art; Richard Wollheim's account of the surface of paintings with regards 'seeing-as' and 'seeing-in'; the chapters on 'classic film theory' where he discusses Arnheim, Bazin, Panofsky and Lukács; and indeed the passage on Goethe's discussion of the Laocoön, by way of Philippe-Alain Michaud and Peter Wollen. (In each instance it is immediately obvious that there is more to be mined from ideas than one might have imagined.) With respect to Goethe's harvesting of fields, Rees's approach in writing about experimental film and video was also very much aimed at leaving a legacy for future generations. We hope that *Fields of View*, though unfinished, will provide a valuable resource for its readers.

In editing the manuscript for this book I have tried to keep in as much of the material that could be contained. I have occasionally rephrased and clarified some sentences and short sections in the writing, and elaborated on a point or observation where the prose was in an abbreviated form. These instances sometimes involved checking different drafts of the chapters and sometimes going back to the books and essays that are cited to make sure of the arguments that Rees was engaging with.

The first chapter to *Fields of View* is a neat introduction to the project that Rees was undertaking, but the book ends without a conclusion, and hence this foreword perhaps has a dual role. Readers could also go back to the second edition of *A History of Experimental Film and Video* for a conventional conclusion, which in fact post-dates the writing in this book. Besides describing and delimiting the field of experimental film and video, which was clearly one aim of the history book, Rees's intention was to map historical connections for those looking forwards. The fields he plots in this book also correspond with that ambition. The insightful and suggestive associations he makes are inexhaustible, a happy thing for those who knew Al Rees as well as those who will be new to reading him.

Simon Payne

horizontal scan
≠
progressive scan

ACKNOWLEDGEMENTS

This book would not have come into being without Angela Allen having passed on the manuscript to several people for their comments about what to do with it. She had discussed various options with Al about how best to finish the book, but it was not a task that he was up to at the time without the right help. Nicky Hamlyn and David Curtis, both early readers of the manuscript that Al left behind, were enthusiastic supporters and offered immediate encouragement to publish the book as well as thoughtful comments and reflections. Rob White, who originally commissioned *Fields of View* for the BFI, also instantly saw the potential for an edited version of the manuscript, which he had first read in 2007. A group of enthusiastic friends including Maria Anastassiou, Brad Butler, Amy Dickson, James Holcombe, Jamie Jenkinson, Deniz Johns, Noor Afshan Mirza, Rachel Moore, William Raban, Karolina Raczynski, Cathy Rogers, Begonia Tamarit and Andrew Vallance met at no.w.here in 2016 and were among the first to be excited by a new book by Al Rees. Friends who have latterly offered advice and commented include Peter Gidal, Neil Henderson, Elizabeth Hobbs, Victoria Hobbs and Peter Kennard. Several authors and artists whom Rees covers have helpfully responded to specific requests. Institutional support was lent to the project by Rob Winter and Heather Stewart at the BFI as well as Nigel Ward, Head of the Cambridge School of Creative Industries, ARU. The publisher and editorial team at Bloomsbury have provided invaluable guidance and direction in the process of completing the book. LUX were very helpful in granting access to film prints to make stills. Neil Parkinson provided useful access to the RCA Special Collections Library at one point and had a fond remembrance of the 'mighty Al Rees', a sentiment echoed by many others who have been prompted to think of him. Lastly, enormous thanks are due to the numerous artists, filmmakers and galleries who have generously provided stills for the book, which are absolutely invaluable in providing a picture of experimental cinema.

FIELDS

x alliance between cinema & art gallery
art cinema in the gallery 1990s
x montage + post production + location

This book is mainly about the artists' or experimental tradition in film, video and digital media, but it diverts into wider questions about cinema for a number of reasons. The most immediate of these is a relatively new alliance between cinema and the art gallery, which has overturned the previous and often troubled relations between them. After a long period in which cinema was cited or alluded to by modern painters from Edward Hopper and Walter Sickert to the Pop movement and beyond, and a shorter period in which artists made experimental films as a sub-genre of other art activities, the 1990s saw a new phenomenon: the placement of cinema in the gallery. This was in fact heralded by now-forgotten attempts to bring film into art galleries in the 1960s and 1970s, which had only limited success. The technical difficulties were great, the work itself often demanding and unsaleable. But thirty years later, large-scale digital-video projections in the gallery echo cinema's big-screen format. The narrative or drama film is no longer confined to its former role as a mere source for art in other media, but is directly appropriated in whole or part for continuous loop installation, or re-enacted and re-edited in films made by artists for the gallery wall or viewing booth.

The rise of gallery video is in this respect distinct from the aspiration of artists to direct films for the cinema as such. Painters like Julian Schnabel and photographers like Cindy Sherman are among those gallery artists who have directed feature movies, with mixed results, and many others – including Francis Bacon – had long dreamt of doing so. The wider and generalized notion that the gallery artist is a kind of film director – even when they do not actually make films – has been buttressed by the importing of critical concepts, like 'montage', 'post-production' and 'location' from cinema into art discourse, to describe the posture, stance and practice of the most recent kinds of postmodern art. These terms seek to sever the contemporary artist from traditional claims to achieve creative uniqueness and value, and instead imply a more collectivized – or corporate – mentality. The film industry is in this sense a model.

While films made by artists in the 1970s were mainly outside the commercial cinema and in opposition to it, today's gallery artists are more relaxed, if not

wholly uncritical, about the globalized revival of the feature film since its near-demise over thirty years ago. Cinematic style, iconology and history now form part of the visual and sonic field of contemporary art. One result of this has been to obscure the more experimental and iconoclastic kinds of film and video that emerged from the late 1960s, at a time when the commercial cinema was thought by many to be at the end of its history, soon to be wholly overtaken by television and more modern kinds of entertainment. As it did so, this seemed to open space for a more radical kind of independent film to emerge, both for experimental artists who sought to expand the medium and its scope, and for new kinds of political documentary that challenged existing content, norms and styles.

The structural film era throughout the 1970s also developed a critique of media art that is now perhaps even more pertinent to the advanced stage of the spectacle than it was at the time. Besides involving a substantial body of theory, it explored another kind of filmmaking outside narrative fiction, one more akin to the other studio disciplines – painting, printmaking, photography – from which experimental film emerged. Its watchword was 'participation' – work that the viewer completes by working through the film – but rarely 'immersion', a current goal of media art that aims to wholly ~~absorb~~ ... and engagement. Immersion ... in which the film viewer is ... the typical drama-conter ... fragmentary than in the ...

These relations betwee ... sites of change and innov... was expressed by the arcl... new pattern is a field – n... different each time that it c... theory. In the first instanc... locked in, via the Latin te... recently, we see a social tw... field' suggested by Martin J... Benjamin.[2] In film, Jean-M... involves an architect who p... in terms of a 'field of fire'. ...

fascist version of a timeless way of building, which took Albert Speer's frightening path rather than Alexander's pacific vision. In this broad sense, the military field evokes the power that the early city state exerted over the surrounding estates which fed and clothed it.

These images are all evoked in Eisenstein's *October* (1928) and play a part in his acknowledged Oedipal conflict with his father, a leading architect of Riga in the greater Russian Empire. Another connection here is the meeting between Eisenstein and Kurt Lewin, the founder of 'field theory' in gestalt psychology. The

[handwritten margin notes: "FILM outside narrative fiction ≠ STORY"; "compare & contrast FILMMAKING with painting printmaking photography"; "towards participation ≠ today's 'immersion' (the film viewer is incorporated into the narrative on the screen)"]

two met in 1929 when Lewin sought Eisenstein's advice on filming human motion
and gesture. Other contemporaries of Eisenstein evoke related fields.

Editing the notes made by Humphrey Jennings for his book *Pandæmonium* – a
collection of extracts from various literary sources, comparable with the uncompleted
Arcades Project of Walter Benjamin – Charles Madge associated the collated 'images'
with a 'gestalt', in their fusion and combination of affects.[3] Where popular Elizabethan
cosmology inspired the style of thought in Jennings, he saw its elemental conflicts
always in connection with agriculture. His 'images' of industrial history were
similarly fusions of conflictual and 'illuminatory' vision, caught by 'the flash time of
the photographer or the lightning'. That flash caught various figures and movements,
such as Sherlock Holmes, Paul Valéry and Impressionism, in the same frame or field.
'History does not consist of isolated events and occurrences', wrote Jennings, but each
has 'a particular place in an unrolling film'.[4] Perhaps because the field – as in 'the
field of vision' – implies this sense of motion, or process, it evokes displacement or
continual change when applied to the 'unrolling film' as it is viewed. Compare this
with André Bazin, who wrote: 'The meaning is not in the image, it is in the shadow
of the image projected by montage onto the field of consciousness of the spectator.'[5]

These diverse and interlinked fields, from nature to culture, lie deep in Western
history. But a technical sense draws the 'field' close to a more recent term, the
'matrix'. The fields and frames that make up the video image, or pixel-space on a
screen, are based on an underlying matrix, just as the three-colour mix in early
Technicolor was created from a matrix of three separate monochrome filmstrips.
While older video cameras record a 'mosaic' of the primary colours on a single
chip, contemporary cameras have a beam-splitter behind the lens that divides up
the light rays into the three colour paths of red, green and blue, to record them
on separate chips, a system analogous to the original Technicolor process that
involved three rolls of film in the camera.

In current writing about art, the metaphor of the field is now so common as to
be unremarkable. It has become its principle of underlying order. Writing about
minimalist art, for example, James Meyer suggests that 'we come closer to the
truth in viewing minimalism not as a movement with a coherent platform, but as
a field of contiguity and conflict, of proximity and difference'.[6] He continues the
metaphor by seeing minimalism as 'a dynamic field of specific practices' in which
one artist responds to challenges from another: Donald Judd's claim that his art
is 'in-between' painting and sculpture elicits Robert Morris's assertions about the
qualities of sculpture over mere 'objecthood', and so on.

When describing Carl Andre's varied use of text, space, architecture, landscape
and even furniture as 'sculpture of an expanded field', Meyer is citing an essay
title of 1979 by Rosalind Krauss, which features the 'Kleinian Square', a fourfold
mirroring structure that contains its own opposites, adapted from Lacanian
theory.[7] The same figure persists in psychoanalytical accounts of art and of
cinema, as in Slavoj Zizek's *The Parallax View* where it illustrates the principle

of incommensurateness or contradiction.[8] Krauss herself, over the next twenty years, abandoned such graphic and grid-like figures in favour of a new notion: the 'anti-form' of the matrix.[9] The passage from the grid to the matrix is in part the shift from the modern to the postmodern eras, for which minimalism is a kind of cusp or disputed territory. Clearly, both the subject of minimalist art and its theorization (if they are distinguishable) are also overlapping fields.

This brief and compressed review of fields in cinema, technology and minimal art suggests that what fields have in common is less their content than their context. The field is the locus of boundaries, the frame which demarcates its territory. It is the edge that counts in defining the field, not its internal space, which is variable. And so this leads to a further sense of fields in [...] ally in painting, where it e[...] ur-field painting through to [...] n contradictory impulses w[...] nherently added to the cine[...] is reduced to its chief supp[...] common with the blank [...] filmstrip or its counterpar[...]

The key [...] ld is something that is seen, [...] view. Especially in the aren[a...] of the ways in which the c[...] object. The film image, and [...] istant to being fixed; its nat[...] te reasons. The (1) various part[...] is a seemingly stable imag[e...] notion (in the passage of a[...] pulses (in the scanlines of a video signal). The second element is another movement-system, (2) but one that takes place inside the film as it were, in the passage from shot to shot, which is usually rendered 'invisible' through seamless continuity editing. Differences from shot to shot, and the notional construction of sequences, might be marked, but they are not made visible as such. Thirdly, there is the division of (3) fields and frames themselves, which corresponds with light having been broken up into tones to be registered in film grain or scanned electronically.

The concept of film as field involves crossing borders, so that film as cinema is also film as related to science, technology and art. The perceptual field in question is specific – *film as film* even – which now also includes the adjacent and overlapping fields of video and digital media. At the same time, film and its adjuncts are media, not just technologies, with specific conditions in which they are produced and shown. The conditions which made an art-form specific, and which guaranteed the integrity of painting as distinct from sculpture, for example, had been the crucial and controversial issue in the writing of Clement Greenberg

[Handwritten annotations overlaid on the page:]

The film & digital image is never FIXED ~ it is naturally moving

(1) intermittent motion through the projector / traces of light-impulses in the scanlines of video signal — VIEWING

(2) passage from shot to shot, rendered invisible through continuity editing — MAKING / SHOOTING

(3) field & frames → light is broken up & registered in film grain / electronic scanning — MAKING THE PHYSICAL OBJECT

during the 1960s and those influenced by him. Th[...]Rosalind
Krauss and Micha[...][re]duction
of art to the mate[...]flatness'
of painting.[10] Krau[...]nd have
described at lengtl[...]m each
other. Where Kraus[...]/ way of
Georges Bataille an[...]ainting,
to focus on and reve[...]

Fried's model pro[...]ised on
the rise of 'tableau'[...]timacy,
exemplified by Cha[...]en the
viewer and the paint[...]appear
unaware of a specta[...]mplify
'absorption'. In the 'tl[...]lay, as
on a stage, and their l[...]rer. By
grounding this distin[...]st era,
Fried set his earlier o[...]essed

[Handwritten annotations: "ABSORPTION — subjects are unaware of spectator ≠ THEATRICALITY — acknowledge the viewer" and vertically "film is media not just technology"]

in the essay 'Art and C[...] of 1967) in a longer tradition of spectatorship.[12]

Many writers on film, including Ben Brewster, Lea Jacobs and Thomas Elsaesser, allude to Fried as a potential source for thinking about cinema, taking the two central and contrasting terms of Fried's book (*Absorption and Theatricality: Painting and Beholder in the Age of Diderot*) as suggestive.[13] Though Fried took his bearings from Diderot, the argument was inflected by a decade of his writing about contemporary New York painting, especially Frank Stella and Morris Louis. He had effectively ended his first career as an art critic in the late 1960s by attacking the new 'minimalist' artists – Donald Judd, Robert Morris and Carl Andre – whom he sought to distinguish from his favoured 'post-painterly abstractionists'. His central criticism was that the minimalist adventure turned art into objects, confused the distinctiveness of media, appealed illegitimately to the spectator's 'completion' of the art work – or worse, the 'art event' – and inevitably led to 'theatre', cast here in opposition to an art of self-contained immediacy. Crucially, the opposition is a time-based one.

Although Michael Snow's film *Wavelength* (1967) was shot while Fried's attack on minimalism was being written, it is one of a number of works that implicitly seeks to respond to his critique (see Colour Plate 1). It offers up film as a fully modernist medium, accounting for its own illusionism by strategies of self-reference, mockery and the exposure of its own devices. *Wavelength* is firmly located in an artist's studio loft and could be described as 'a record of its own making'. The film's viewer is hardly passive, given that Snow has invented many ways to jolt them from the usual comatose habit of watching a film. *Wavelength* was all about seeing and sound in the abstract sense, but a turn to language and drama, the very stuff of theatre, was signalled in a 1972 interview with English filmmaker

John Du Cane, in which Snow discusses repetition and predictable structures.[14] At this point Snow compared his current concerns with Rameau and eighteenth-century classical space. This coincided with Fried's turn from contemporary art criticism to art history and his early influential lectures on absorption and theatricality with Diderot's writings at their core. In the subsequent book, Fried distinguishes paintings that are directed outwards to the viewer, as if the action were on a stage, from those in which the activity is self-enclosed or contemplative and inner-directed. These and other modes of seeing and being were the subject of Snow's epic length film of 1974, tellingly entitled *Rameau's Nephew (By Diderot)*.

Meanwhile, Fried was moving deeper into post-classical art, especially to Manet, who arguably inaugurates the earliest modernism in painting. Manet's friendship with Baudelaire, his iconoclasm, overt painterliness and intertextual allusiveness, all qualify him for the role. In the book *Manet's Modernism* (1996), Fried also discusses a number of etchings by Whistler published in 1871 as *A Series of Sixteen Etchings of Scenes on the Thames and Other Subjects (The Thames Set)* (Figures 1 and 2). Examining two prints from the series in particular, *Eagle Wharf* and *Black Lion Wharf*, seemingly unprepossessing subjects, Fried uncovers hidden layers of meaning that disclose the scenes as a field of vision.[15] First, and unlike the Impressionists, Whistler takes a 'long-shot' into the far distance. Everything in the etching is equally open to view, and all is in sharp focus, from nearby into the far distance (as in the earliest films). The artist does not determine a single viewpoint, but instead the eye of the viewer scans or roves the picture plane. This represents

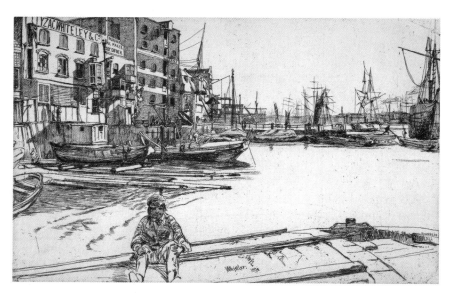

FIGURE 1 *Eagle Wharf* (1859) James McNeill Whistler. Etching, 14 × 21.6 cm. Courtesy of the Metropolitan Museum of Art, New York.

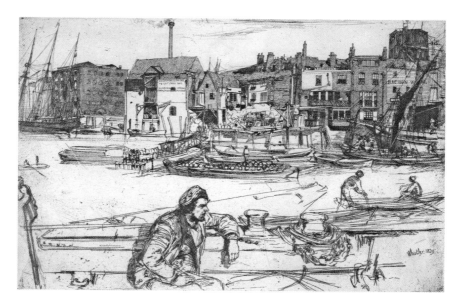

FIGURE 2 *Black Lion Wharf* (1859) James McNeill Whistler. Etching, 15 × 22.1 cm. Courtesy of the Metropolitan Museum of Art, New York.

one pole of vision, the objective open-to-scrutiny status of the optical image. At the same time, in support of the viewers' scanning of the image, the figures of the boatmen and shore workers in all of the etchings that make up the set are remarkably 'absorbed' – their inwardness contrasting the open planes of vision in which they are set.

A contrasting image (not used by Fried) is a later work: a photograph of a Hansom cab seen from the back as it trundles down Portland Place in the fog (Figure 3). Made in 1906 by the 24-year-old American photographer, Alvin Langdon Coburn, it was commissioned for the collected New York edition of the novels and stories of Henry James. He suggested to Coburn a number of locales in London, New York, Paris and Venice for the frontispieces of the twenty-four-volume collection, making up a series of photographs as a counterpart to the serial collection of the novels. For the photograph *Portland Place*, which accompanied the second part of *The Golden Bowl*, James proposed 'an inquiry into the street-scenery of London; a field yielding a ripe treasure of harvest' and he instructed Coburn to allow 'the scene' to present or to 'generalise' itself.[16]

The novel opens with a near stream of consciousness as Mr Verver's future son-in-law, the Italian Prince Amerigo, wanders in the centre of London's citadel on a hot August afternoon. The Prince is from Rome, whose '*imperium*', and equivalence to London as the core of Empire, is invoked on the first page. The associations and images are also optical in a near-cinematic sense, evoking cinematic framings, including close-ups and point-of-view shots as well as intermittent motion. The

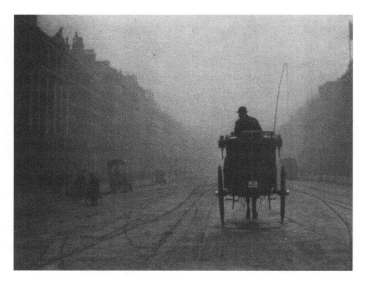

FIGURE 3 *Portland Place* (1906) Alvin Langdon Coburn. Photogravure, 8.5 × 10.9 cm. Frontispiece to *The Novels and Tales of Henry James XXIV: The Golden Bowl II* (1922). Photograph © 2020 Museum of Fine Arts, Boston.

Prince's 'imagination, working at comparatively short-range' makes him 'now and then stop before a window'. Here, in Bond Street, are the fruits of world trade and empire. Glass, metal and leather 'objects massive and lumpish' are 'tumbled together as if, in the insolence of Empire, they had been the loot of far-off victories'. After this invocation of power and the citadel, the Prince 'in one of his arrests' sees, but does not pursue, the 'possibilities in faces shaded, as they passed him on the pavement, by huge beribboned hats, or more delicately tinted still under the tense silk of parasols held at perverse angles in waiting victorias'. It is August, when 'the flush of the streets' had 'begun to fade'.

The images of close viewing, pausing, fading, screening and sunlight suggest by association the cinematic image, especially the early street 'vues' in which the passing scene 'presents itself'. This, as James had declared, was his intention for Coburn's photographs, although many of these are 'pictorialist' or soft-edged in the Impressionist manner, rather than strictly focused like Whistler's Thames etchings or the films of early cinema. The wider connections are also suggestive: etchings and photographs in sequence; etchings, books and photographs as variations of 'gravure'; two or three generations of Americans, of contrasting ages and in overlapping milieux in the artistic and literary life of London at the emblematic turn of the century. The same key major cities of Europe – Venice, Paris, London – recur in Whistler's images and James's novels. Also among the cinematic overtones, but ahead of them by a few years, is a different aspect of Coburn's art that was revealed in the time-lapse multiple exposures of his 'Vortograph' portraits, famously of

Ezra Pound. But in *Portland Place*, the main thing was the absorptive quality of the photograph, including the huddled coachman (face invisible) and the barely distinguishable figures scattered across the scene. The cab not only is literally enclosed but is also disappearing away from us, into an indeterminate distance wholly in shadow and mist. In contrast to Whistler's etching, where everything is in focus and revealed to the mobile eye, Coburn's 'atmospheric' photograph is self-enclosed and essentially flat, looking ahead to modernist painting and to the conjuring away of the vanishing point.

- everything is in sharp focus from nearby to far distance — as in the earliest films
- no single viewpoint determined by the artist — the viewer scans/ roves the picture plane
- subjects are absorbed in themselves → Whistler paintings FOCUSED
 Coburn ≠ photographs
- pictorialist & soft edged
- disappearing away from us
- self enclosed & flat image → the vanishing point

FILM MACHINE

In his study 'Kafka in America: Notes on a Travelling Narrative', Mark Anderson sees not only 'a cinematic apprehension of reality' in the fragmentary, framed and dissolving images of Franz Kafka's mythic but also documentary images of New York, derived in part from reading journalistic accounts of the city. According to Anderson, Kafka (who had not seen New York) depicts it in a series of disjointed optical impressions that are 'cinematographic in the sense of a tension between vivid, framed images and their self-cancelling movement', autonomous and indifferent to the spectator, and as disembodied as 'a ribbon of celluloid images passing before the eye of the projector'.[1] Kafka himself preferred a proto-Bazinian metaphor, pertaining to the stability of the unrolling panorama, which his diaries record as offering 'the eye all the repose of reality', in contrast to the cinema that 'communicates the restlessness of its motion to the things pictured in it'.[2] Anderson refers to similar qualities in Edgar Allan Poe's short story 'Man of the Crowd', forty years before cinema was invented. Eisenstein similarly mined Dickens for examples of pre-cinematic imaging and montage.[3] Cinema itself, however, also asserts its own self-figuration. In a view that Malin Wahlberg, in her article 'Wonders of Cinematic Abstraction', attributes to Walter Benjamin, 'the mimetic impulse of filmic representation thus gives way to "a new tactility", that is, the desire to reproduce movement is conflated with the desire to document the cinematic movement itself'.[4]

Mimetic vision is both literalized and made a metaphor in cinema with the familiar 'mirror shots', common to both mainstream and art film, to figure the theme of split identity. One example – in this case extending to the title of the film and much of its content – is Jean Epstein's *La Glace à Trois Faces* (The Mirror Has Three Faces, 1927). The idea that the theme of a film, which in this case is about duplicity, can be 'reflected' in the iconic image of a mirror may also be extended to sound and image montage. In a wider context it is related to Mark Anderson's comparison between traditional novels that depict and define protagonists in relation to 'property' and hence stability, and modernist 'travelling narratives' that

replace this structure of location with fluidity, randomness and destabilization. 'Perhaps the most radical use of travelling narratives has been made by filmmakers such as Jean-Luc Godard, Werner Herzog and Wim Wenders, whose films repeatedly thematize mechanized forms of travel as a self-reflexive gesture towards the moving, unstable nature of cinematic representation. … Subject, camera, and projected image are all implicated in the traffic of travelling images.'[5]

In Wim Wenders's *Kings of the Road* (1976) a lorry driver (Rüdiger Vogler) carrying projectors to rural cinemas picks up a crashed driver (Hanns Zischler). The crucial but random traffic accident depicts a key feature of Anderson's category of the 'travelling narrative', which is here framed and made literal by Wenders's 'road movie'. In one sequence of the film, the passenger (Zischler) walks out onto the very edge of a steel platform overlooking a field and then leaves a note for the driver on the windscreen of the truck, arranging to be picked up later in the day. He then walks to the nearest bus stop, passing through a flock of sheep. Meanwhile, Vogler appears, reads the note and drives off. The whole sequence is accompanied by a seemingly casual, slowish country-style guitar soundtrack.

Closer analysis reveals that the music is not only loosely attached to the image. In fact, it is rigidly cued: every cut is made to the beat of the music and a change in key or rhythm signals a change of shot. Sound effects are treated in the same way. From the slam of the truck door to the bleating of the sheep, the timing of the sound effects is metrical. The effect of the whole, however, is so 'laid-back' that this tight structure of synchronous sound is hidden when viewing the film. The film is shot in an apparently 'open' style and the music seems only an 'accompaniment'. There is, however, a technological artifice of 'seamless' editing that lies beneath the flow of events and the evocation of dailiness.

This isn't the only sense in which the sequence draws attention (at least in retrospect) to its filmic construction. Each shot is full of visual surrogates for the filmstrip and the frame by which the image is conveyed. Tellingly, the episode opens with the passenger inspecting the racks of projectors in the back of the truck. When he opens the door, he constructs a kind of primal cinema in the body of the truck as it floods with light. The stacked projectors similarly refer directly to the film medium that carries the images we are seeing. The long arm of the conveyer belt – the platform for the passenger's walk – is sectioned in the regular patterns of a strip of film divided into frames (Figure 4). The chugging sound of the motor that powers the conveyer is similarly a metaphor for the noise of the projector, also usually hidden from the spectator by the soundproofing of the projection room. Likewise, both the regular sound of the truck engine and, just possibly, the rhythmic sound of the guitar music evoke the rhythm of the film machine. Visually, the enclosed truck and its windowed cabin are also stand-ins for the film apparatus and indeed for cinema as a whole (a closed space with frontal seats and a light source at one end). Finally, as one man falls asleep (the passenger settling down to sleep in the back of the lorry) another

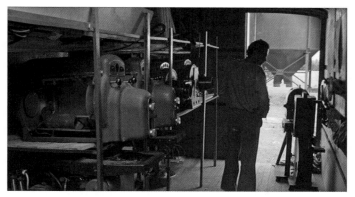

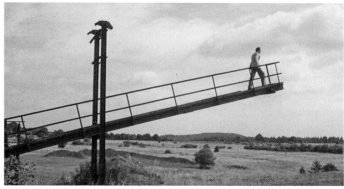

FIGURE 4 *Kings of the Road* (1976) Wim Wenders.

(the driver) wakes up and drives away. These are unmistakable surrogates for the willed fantasy state when watching films in the dark. A verbal echo of this idea occurs in the film itself. One of the men wakes from sleep and says he has been dreaming of pop songs. 'Yes', the other replies, 'the Americans have even invaded our dreams'. (An idea that chimes with the guitar track that flows over the shots in the sequence analysed previously.)

Obviously, not every instance of a sectioned shape, machine or a repetitive sound (or anything else that is a potential sign of cinema and its frames) is a filmic signifier as such. It depends on the context. Here, and in all the similar examples that one might quote, it only becomes a cinematic signifier (signifying cinema) because the film unites form and theme. The truck is after all carrying cinema equipment, and the film reflects on and debates the decline of film as an art form in post-war (and pre-unification) Germany. At certain moments, usually signalled by some emphasis on technology, the film as a machine seems to rise to the surface of visibility. The film puts itself on show, in this case through oblique montage in the form of rhythmic cutting and studied contrasts of angles and sequencing.

Such episodes often appear at a moment of crisis or a breakdown of communication, although in *Kings of the Road* this takes an unusually benign form. More visceral is a scene in *On the Waterfront* (1954) directed by Elia Kazan, a film which presages the isolated anguished hero of the underground genre. A crucial confrontation occurs in front of a fence (a metaphor for film frames) against a background of an industrial plant (cinema) and the regular beat of heavy machinery (projector motor). A priest persuades Marlon Brando's character to confess his part in her brother's murder to his girlfriend (Eva Marie Saint). His confession and her horrified reaction are shown in abrupt montage, concentrating on the faces of the two protagonists, with his words and her cries drowned by the noise of the machines behind them. The film becomes more and more filmic and correspondingly the heightened montage is doubled by the analogical elements of sound and framing – including the image of the fence and the machine noise – which duplicate the filming of the event (Figure 5).

In *The Battle of the River Plate* (1956) by Powell and Pressburger, the shots are all frontal or lateral when depicting the interiors of ships at sea. Much of the action takes place in cabins and closed spaces that hold British sailors captured by a German warship. When the scene changes to the city of Montevideo (a name that evokes vision: *video* means 'I see') the film is rounded out to include shot/reverse-shots and point-of-view shots. In this change of scene, the tightly closed

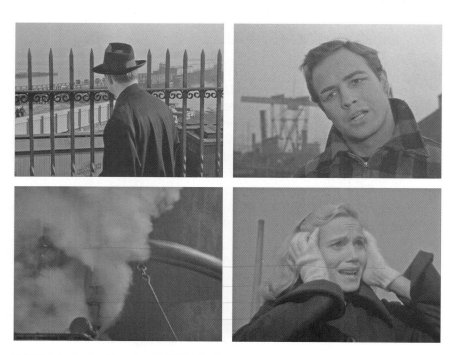

FIGURE 5 *On the Waterfront* (1954) Elia Kazan.

'Euclidean' geometry that shows the prisoners in a staged space literally unfolds into multiple perspectives of the 'lived' non-geometrical space of the South American city whose colour and vigour show a world that seems barely aware of wars and battles.

Besides the contrast of dramatic-geographic space, *The Battle of the River Plate* also has allusions to other kinds of imaging (Figure 6). The flatness of the scenes in which English prisoners debate their fate in the hold alludes to a quasi-Elizabethan

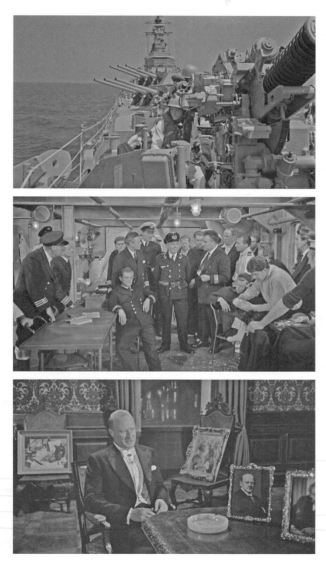

FIGURE 6 *The Battle of the River Plate* (1956) Michael Powell and Emeric Pressburger.

theatrical space while the frontal sea-shots imply the flat space of painting (signalled or literalized by the conspicuously Cubist and Impressionist paintings in the president's office). The scenography here is a metaphor for the events that it depicts, but the final scenes of warfare in the harbour are more literal evocations of the film experience (and the theme of conflict). The guns of the battleships stand in for projectors, and the fire of the guns emulates the intermittent light of the filmstrip that beams the very image of destruction it embodies. The burning destroyer at the end is seen through the frames of a window and watched by people with binoculars and telescopes. All of these are references to cinema, and especially to Eisenstein's *Battleship Potemkin* (1925), the alternating montage of which is employed directly in the narrative form.

In Carl Dreyer's *Vampyr* (1932), the evil doctor is trapped in a silo and killed by tonnes of grain falling down the funnel until he is covered by the immense weight and clouds of dust. This scene is accompanied by the rhythmic beating of the silo's engine. Here the analogies are as direct as in Kazan's movie. The downward pouring of the grain represents the movement of the film through the projector. The wheat grain is analogous to film grain, and by the end of the sequence the two are indistinguishable as the image becomes wholly abstract: the film is reduced to its primary surface qualities (Figure 7). This was differently literalized in 1923 by Man Ray's *Return to Reason*, in which film grain is doubled by the appearance of salt and pepper grains laid on the film itself and 'photogrammed' by exposure to light to, as it were, resemble its own appearance. The dust in the *Vampyr* sequence also echoes the visible smoke and dust caught in the beam of the projector when the film was shown in cinemas of the period. Finally, as in Kazan, the beat of the silo motor is analogical – especially in its relentlessness – to the projector sound. The doctor who claws at the grain that covers him also evokes the claw of the projector, which in turn creates the illusion of the downward force that is killing him. Here the form of the film is exactly mapped to its content, by strict patterns of resemblance. The scene is recapitulated in Peter Weir's *Witness* (1985), where a crooked cop has a similar fate. As the title of the film indicates, it is narrated almost wholly in terms of point-of-view shots; visuality is absolutely central to its themes of crime, observation and enigma.

The point about the silo in *Vampyr* could also be made by looking at Dreyer's last silent film, *The Passion of Joan of Arc* (1928) an ancestor of Kazan's use of extreme close-up in the confession sequence of *On the Waterfront*, but here dispersed across the entire body of the film. When Joan of Arc is 'shown the instruments' of the inquisition, the rotating torture drum – studded with nails, moving faster and faster in montage – is clearly a signifier of the medium that produces this image (Figure 8). The rotating wheels are those of the projector; the nails are the claws. The body of the protagonist is threatened with tearing, as is the film itself if it slips out of alignment. The sequence was modelled on *Battleship Potemkin*, which Dreyer had recently seen. In this regard, like

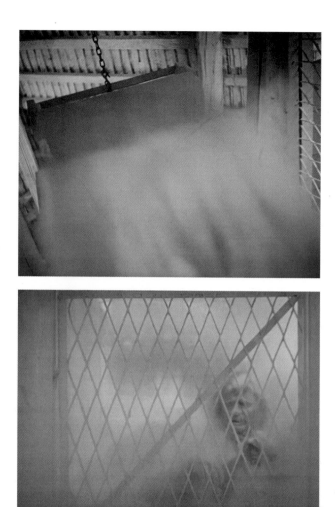

FIGURE 7 *Vampyr* (1932) Carl Theodor Dreyer.

The Battle of the River Plate, the sequence also references film in terms of its (contemporary) history. Besides the allusion to the film projector, the hand-cranked instrument of torture is also a direct allusion to the act of shooting a silent movie, which didn't require a consistent camera speed. The relationship is an inverse one, however, since rapid hand-cranking when filming produces the effect of slow motion in projection, whereas the faster the torturer cranks, the faster the motion of the machine itself and correspondingly the more blurred the image on screen becomes. Joan's eyes 'blur' before she faints as if the torturer is cranking the projector itself.

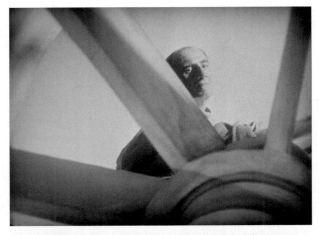

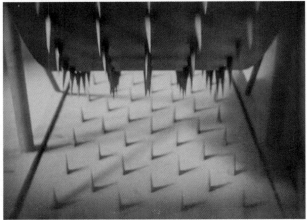

FIGURE 8 *The Passion of Joan of Arc* (1928) Carl Theodor Dreyer.

A few years before *The Passion of Joan of Arc*, French independent filmmakers including Germaine Dulac, Henri Chomette and Eugène Deslaw were making 'machine-eye' films inspired by Fernand Léger's *Ballet mécanique* (1924). In a famous sequence of this film, a laundry-woman ascends a steep flight of steps only – like the Greek fable of Sisyphus – to be sent repeatedly back to the base of the stairs (Figure 9). Each time she gets to the top, and therefore closer to us, since this too is a frontal shot in flattened perspective which emphasizes the steepness of the steps she climbs, she grins and waves. To contemporary eyes she seems to give a 'thumbs-up' sign, but whether or not she does (the montage renders her gesture ambiguous) she clearly registers her triumphant ascent.

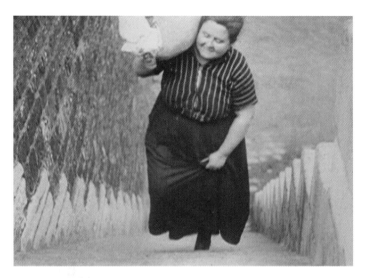

FIGURE 9 *Ballet mécanique* (1924) Fernand Léger.

A proletarianized variant of a 'figure descending a staircase' – the film contains shots that were made by, or for, Marcel Duchamp's collaborator Man Ray – and emphasizing the act of montage simultaneously with the presentation of repetition, this sequence contains the same kind of analogical graphing as the films of Wenders, Kazan and Dreyer previously discussed. The stairs analogize the filmstrip divided into frames, so deployed as to create the flicker effect of motion repeated in the montage structure itself. The repetition plays on the double edge of difference within and between the frames that 'hold' the image, by posing the question of whether we see the same shot many times or similar shots screened in succession. That is to say, it literalizes the sameness and difference of shots within a twenty-four (or eighteen) frame sequence on the filmstrip, which yields the illusion of movement. The frontality and shallow depth of the image in the frame is itself a reference to the screen on which the film is projected. The laundry-woman, as she moves from step to step, is also a figure of the hidden claw guiding the film through the gate, her progression matching the progression (and regression) of the image, and thus interlocking two accounts of time and motion: that of the rotating film shutter and the claw engaging with the filmstrip. These 'figures of motion' (to use Len Lye's term) are directly imaged in the film and its title: a mechanical ballet.

Other films of the period are equally interesting but less ambitious and more simply shaped. Chomette, Dulac and Deslaw were drawn to more natural images than Léger, especially to those which contained their own (rather than imposed) movement: flickering leaves, light on water, shadows of people and objects. These are not in themselves cinematic, although they are kinetic. They can be directly observed in nature without the intervention of the camera. In contrast, Léger's

washerwoman, or his split frame and kaleidoscopic imaging, cannot. The latter are the products of cinema, or more specifically the moving-image camera.

Nonetheless, there is one class of objects in motion which is directly linked to the cinema apparatus: the category of machines. Deslaw's *Dance of Machines* (1928) is a good example. Its starting point seems to be Léger's pulsing machines in some sequences of *Ballet mécanique*, but here expanded to the length of the whole film (at seven minutes, just under half of the length of Léger's original). The film has a wider optic scope than Léger's. Where Léger closes in on his machines, rendering them in isolation from their function and raising them to the status of ideas rather than tools, Deslaw sets each machine in a wider frame. It is possible to guess their functions, and they are often seen in their locations: streets, factories, stations and so on. But it is not their identity as machines that is key, but their function as analogues of film production; not what they make, but how they make the film in which they appear. Since most of them use rotary arms and cyclic motion, the machines in the film directly evoke the film machine that encodes their image. In particular, the rotating machine wheels echo the same gesture performed by the cameraman cranking the handle of the machine which films them.

Their cyclic repetition similarly invokes the procession of the filmstrip passing through the gate. At the same time, Deslaw – unlike Léger – does not explore the montage aspect of film. The engineer or *monteur* is here subsumed by the regular and slow-paced sequence of one machine after another (the successive nature of which does invoke montage, but rather weakly) and by depicting the machine as a product of the same engineering process that invented the film apparatus. The film does however contain many instances of blurred motion, a coded depiction that might well signal a crisis of vision in the context of cinema.

Montage itself is a way of introducing crisis into vision, and it was in this context, as a series of shocks or attractions (repulsions and attractions, perhaps) that Eisenstein developed his early thinking on editing. Léger's passages of rapid cutting are near-contemporary with Eisenstein's *Strike* and *Battleship Potemkin*. In their sequences of rapid cutting, *Battleship Potemkin* and *Ballet mécanique* are more conceptual than emotive, in that they articulate ideas within a frame of reference. (When combined with their soundtracks – neither was often played with their soundtrack at the time – both films take on more emotive aspects.) Correspondingly, Léger's film looks ahead to the 'intellectual montage' that Eisenstein theorized and turned his attention to with *October*. By contrast, Deslaw's editing is modelled after another of Eisenstein's categories, 'metrical montage', by which he meant shots that are of equal length placed together in a sequence. To this extent, Deslaw is objective in a different way. *Dance of Machines* is more oriented towards documentary in its approach; it is more spatial and less signalled as a point of view.

None of these films made between 1924 and 1928 is psychological in the usual sense. They do not embody the spectator in an identified consciousness,

within narration, but rather address the eye directly as an optic and self-observing process. In this, they evoke the central precepts of modernism, especially the acknowledgement of flatness and the passage of time as central facts of cinema.

Léger's film is an extreme example of a film that lacks closure. There are probably over a dozen different versions of the film, with three or four in regular circulation, with significant differences between them. The soundtrack accompaniment by George Antheil was rarely, if ever, played with the film at the time, and has only recently been added to DVDs of *Ballet mécanique* or played live with an orchestra. Léger himself showed a silent version to students and visitors in the late 1940s, remembered Eduardo Paolozzi, who saw it that way himself.

This tale says something about the more radical side of modernism, all the more impressive because Léger himself was in many ways a traditionalist: an easel and mural painter, a public sculptor and classic printmaker. He was also a Communist and a social artist. In *Ballet mécanique* he had made a canonical film of the avant-garde, and was able to do so because he was a painter primarily, adapting the advances of post-Cubist art to what was then a relatively new medium. The variant editions of his film are an accidental metaphor for the lack of fixity, the literal 'mobility' of *Ballet mécanique*. In his own account of the film, Léger states that he showed a loop of the 'stairs' sequence to his worker-neighbours, and repeated it in the film just beyond the point at which it became annoying to these first viewers. This aggravation of the compulsion to repeat, and its rejection of completed pleasure, is a constitutive aspect of the avant-garde cinema.

editing & montage
x rapid cutting
x metrical montage
x intellectual montage

FILM AS OPTIC AND IDEA

Ballet mécanique is an explicitly self-referential film, in which the model Kiki's eyes open and close like a slow shutter, prisms break up light and the image, and the filmmakers themselves are glimpsed in a reflective bowl as they crank the camera (Figure 10). These allusions are all iconic images, and they therefore differ from the fragmentation of time that is coded in the abrupt montage of the film. In both cases, however, there is a form of shattering that undermines the flow and sequence of moving images. Pictorial icons in the classic narrative cinema also often refer to acts of looking and reflection. Mirror images in film noir, for example, often serve to split or multiply the reflected figure. Primarily, such images have a narrative function – depicting ambiguity or fissure or literally 'duplicity' – but they often act as a submerged reference to the film itself. The image in the mirror is an analogue of the image on the screen.

Images of static photographs, or freeze-frames and shots of the eye are similarly self-referential. In the opening of Godard's *Vivre sa Vie* (1962), the close-up shots of Nana (played by Anna Karina, Godard's wife at the time) is a substitute for the spectator looking at the screen. Her direct outward glances are a complicit acknowledgement of the viewer, and a mirroring of the viewer's gaze. Her indirect glances to the side analogize the denial that one is watching a film in the very act of seeing it (Figure 11). Because these shots implicate viewing and the presence of the spectator, rather than assert the brute presence of the film machine, they are both like and unlike the submerged cinema signalled by images that invoke sequential frames and mechanical repetition in the films discussed earlier. All of these examples are iconic, but in C. S. Peirce's subdivision of icons into two categories one set would correspond to 'pictures' while the images involving frames and sectioned shapes or repetitions would be closer to 'diagrams', which effectively chart or assert the presence of the film. They map the territory of the film field and are literal indexes of the presence of the film, functioning as a kind of performance of the frames and spaces that they substitute.

[handwritten margin note: looking directly out to the viewer]

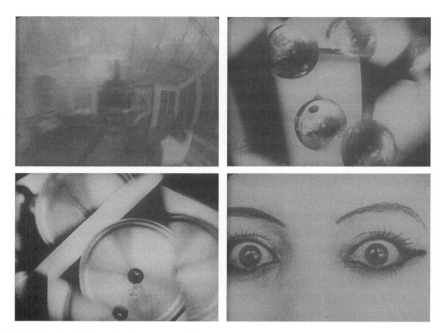

FIGURE 10 *Ballet mécanique* (1924) Fernand Léger.

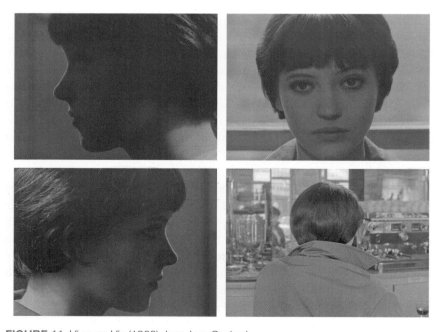

FIGURE 11 *Vivre sa Vie* (1962) Jean-Luc Godard.

At the intersection of the optical and the mechanical systems that underlie the cinema, a special category is made up of shots and sequences that are about the act of looking. Here, an optic structure conveys the plot and content, regardless of genre and style. Examples can be taken from films as diverse as *Chinatown* (Roman Polanski, 1974), *Pi* (Darren Arononfsky, 1998), *Donnie Brasco* (Mike Newell, 1997) and *Peeping Tom* (Michael Powell, 1960). Two brief cases from the films of Hitchcock include a man in *Champagne* (1928) seeing through a glass as he drinks and another figure similarly downing a doped glass of milk in *Spellbound* (1945) (Figure 12). Charles Barr, who has discussed the first example, notes the masculinist 'voyeuristic detachment' of the scene 'in which we are at some level (like the film-maker) implicated, since we too are viewing the world ... through an optical apparatus'.[1]

There is another sense in which the optic and the material aspects of self-reference, suggesting theatrical self-presentation, can also be seen as a case of cinema's interiority, or absorption. In such cases the act of thinking is embodied or incorporated into the film itself, and articulated in the act of viewing, not just shown as a psychologically motivated action performed by a character in the plot, as in the furrowed brow and narrowed eyes. These narrativized gestures are part of the film's story, but they can be compared to non-narrative films, including the following examples, in which the act of thinking is marked in the editing or duration of the film.

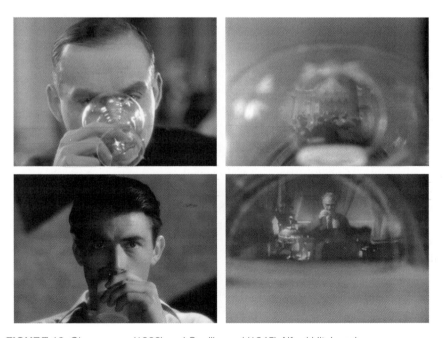

FIGURE 12 *Champagne* (1928) and *Spellbound* (1945) Alfred Hitchcock.

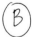

(A) Bruce Baillie, a US West Coast filmmaker, made *All My Life* in 1966. The title comes from the film's accompanying song, sung by Ella Fitzgerald. The film is a single continuous shot in which the camera pans a fence and a series of blooming rosebushes (see Colour Plate 2). It ends by tilting up to the sky, which is bisected by two telephone wires. As the camera moves up, these lines appear to draw the sky down like a blue curtain, in a literal act of closure. The film lasts nearly three minutes: the length of a roll of 16 mm film at 24 fps and the duration of the 78 rpm record that comprises the soundtrack.

3 mms = a roll of 16mm film @ 24 fps

haikulike film poem

P. Adams Sitney has explored the social history inscribed in the voice of the black singer through to the subjective and personal elements in this haiku-like film poem.[2] Faced with the film alone, the burden of thinking rests with the spectator, since there is no other channel through which the film operates. But everything is apparently open to the eye: the broken fence, the great clusters of roses, the diagonal lines above and the massed bushes below. The natural icons of the shot – the scrubgrass, flowers and sky – also elicit the colours of the stock on which the film was shot: yellow, magenta and cyan. The continual reframing that results from the panning shot also implies a process of opening and revealing. At the same time, the film is paradoxical because it yields a line of surprises as the world outside the frame (to the left) is drawn into vision and then disappears again (to the right). What is the shape of the fence? Probably a trapezoid. Another paradox of the film is that a circle (the pan of the camera) and a line (the fence) seem to run together.

The fence is decayed, but hardly anything behind it can be seen. It forms the horizon of vision for the spectator. Above and beyond it we see only the sky which blankets the top half of the screen until it is 'pulled down' to become the whole screen. The last section of diagonal telephone wire, when it is at the base of the screen in the lower right-hand corner, only disappears with the last note of the song and deliberately so, to underline the synchronicity between the eye and the ear. Similarly, the continuous pan contains hidden and paired contrasts: open and closed, surface and depth, revealed and hidden, inner and outer, seen and heard, upper and lower.

While these contrasts are part of the visual language of the film, and can be literally read off from its surface, they also entail a series of metaphors: absent and present, near and far, growth and decay, physicality and immanence. These yield the emotive content of the film, which Sitney uniquely interprets as a lament of lost love and failure. This reading is emphasized by the song, which comes from a recording made in 1936, thus encoding the past and its historical moment: 'All my life, I've been waiting for you.'

(B) *All My Life* can be compared to a film of similar length, *A Study in Choreography for Camera* (1945) by Maya Deren. Made with the dancer Talley Beatty, this film also entails a connection to black American history. Deren and Beatty had met through her earlier contacts with the afro-Caribbean dance and modernist troupe led by Katherine Dunham. Deren had toured with the company as a 'white scout'

in the segregationist South, checking out the hotels on behalf of the dancers and musicians.

In *A Study in Choreography for Camera*, the dancer is first seen among trees. The camera circles round him, and the visible edits bring him nearer. As he slides his back down a tree trunk and raises his leg, an even more emphatic cut brings him into the room (in fact, Deren's New York apartment). Here he dances in front of two emblematic objects – a window and a mirror – as a second strong cut takes him into the long gallery of a museum. Shot in close-up he dances and spins his head in front of a many-headed Hindu sculpture. Then he leaps up and, over seven distinct shots, performs a giant leap that finally brings him back to the natural scene of the forest with which the film began, though now the sea also appears in the background (Figure 13).

In one sense, the film enacts a semi-historical sequence. The dancer, found in *poetic* nature and almost indistinguishable from the trees, leaps into domestic space, *transfor-* then public space and finally – transformed by montage in the great leap – returns *mation* to nature again. Like other Romantic transformations this poetic transumption takes place by the sea. (Deren, a literary major at college, wrote her thesis on Yeats and symbolism.) But while at first the dancer is in nature, at the end he is separate from it, confronting it: a journey through space from absorption to a gesture of posed theatricality. The choreography for camera is a triangulation of dancer, screen space and montage.

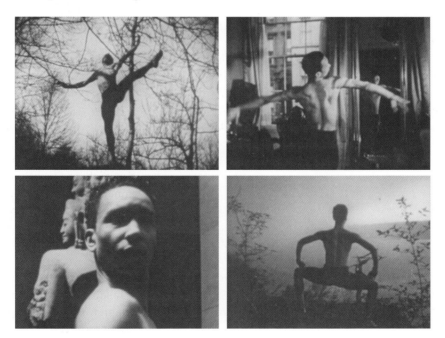

FIGURE 13 *A Study in Choreography for Camera* (1945) Maya Deren.

Packed between its iconic and historic moments is a further layer of meaning, divisible into two parts. The first links the art of movement and dance to the other arts: to paintings on the wall in the apartment (plus the window and mirror) and then the sculpture and architecture in the museum. The second explores the distinctive art of camera vision, through 'marked' or 'stressed' moments such as visible splicing (in the shots of the dancer against trees), jump cuts (literally so in the dancer's final leap through a series of shots) and camera speed (altered in shooting the dancer's head in close-up against the multi-headed Hindu sculpture). Recalling Dziga Vertov's theory of the camera-eye, the dancer spins impossibly fast by virtue of the camera's shooting speed. Another impossible movement is the beginning of the leap at the end of the film. Beatty was shot jumping down, rather than up, but with the camera inverted so that in projection the movement is reversed.

Deren's vision is steeped in Eisenstein's filmmaking even more than Vertov's. *Choreography* can be compared to a brief section in *Battleship Potemkin* where time and vision are similarly manipulated and acknowledged. In a key scene of the film the sailors, who are hungry and getting rebellious, are incensed by the rotten maggoty meat that they are served. A young sailor is washing dishes, and pauses to look at the Tsarist emblem on one of the plates and read the biblical inscription: 'Give us this day our daily bread' (Figure 14). The typography of the intertitle in English-language facsimile echoes the print style of the Russian Futurists. The

FIGURE 14 *Battleship Potemkin* (1925) Sergei Eisenstein.

sailor frowns, in a conventional sign of thought, and silently moves his lips (the sound being completed or 'filled in' by the spectators). He shows the plate to his two companions, in a highly condensed Hegelian-Marxist moment that links the triad with the birth of an idea and comradeship, fraternity in action. This action leaps from perception and reflection, from what the individual sees to what the group affirms. In Sartrean terms, the serial group of informed sailors is transformed into a fused group of activists. Over four brief and stressed edits, which are as visible as cuts in the films of Léger and Deren, the sailor energetically smashes the plate.

To interpret this sequence, the meaning of which is more direct than any in Baillie and Deren, the spectator enacts the same process of thought and development as the sailors themselves. Like them, we read, think and – in the fusion of montage – join them. (The slogan of the last part of the film, which is called 'meeting the squadron' uses this very phrase.) Eisenstein himself was amazed to hear a bourgeois Berlin audience in 1927 cheer his revolutionary film, no doubt further impelled by the musical score composed by Edmund Meisel for this occasion. Montage and close-ups stress the cinematic signifiers while the Futurist text and biblical phrase assert the act of reading over viewing. The words interrupt the film even as they advance the plot.

Reading in film is slower than seeing, with each viewer led by their own reading speed rather than to the looser time frame of the visual image. The structural avant-garde in the United States during the 1970s, including the filmmakers George Landow, Michael Snow and Hollis Frampton, turned to text and language in order to escape lyric expressionism. Eisenstein anticipates them, to turn viewing (or percept) into reading (or concept). Avant-garde typography underlines this cognitive shift. Finally, Eisenstein marks out the montage sequence as itself a figure of transformation (rather than mere change). It was this aspect of montage that Deren and her successors took up in the post-war avant-garde.

From this example of high modernist intensity, where ideas reach out into film form and written (implicitly spoken) language in *Battleship Potemkin*, we turn to *The Birds* (1963), which famously has no musical soundtrack. The sound is either speech or ambient sound, or (mainly electronic) bird noise. In a key sequence, visual thinking dominates: no words are spoken. Tippi Hedren enters the schoolroom where the children are chanting a round song made up of repetitious nonsense words. The song quietly persists on the soundtrack throughout the next five minutes. The teacher signals to Hedren to wait outside. She returns to the schoolyard, and is shown in a mid-shot, smoking a cigarette.

The smoking of the cigarette gives a real-time flavour to the next remarkable moments in which the birds mass behind her (Figure 15). The camera moves closer to her face in shots that alternate with images of the birds, which she cannot see. Amazingly, she never looks into the camera. To do so would, arguably, be to signify diegetic space in crisis. Even so, her eyes flicker past the camera, which

[handwritten margin note: reading in film is slower than seeing]

[handwritten margin note: The Birds → no music, only sound track!]

would have been very close to her. When she finally stands up and turns around, the birds are thickly clustered on the children's climbing frame. The shock is that there are vastly more of them than even we viewers have been led to expect; her total surprise is mirrored by a tricked audience which is also seeing more than it has been prepared to discover.

Here, Hitchcock links and then decouples the unification of knowing and thinking. We think we see more than the fictional character, making us superior to her, but we are not shown as much as there is to see. The revelation stops us feeling smug towards her and allies us with her panic. Thinking here is literally a kind of fiction and what we know is both true and false. The character herself, with whom we were led to identify, is of no help to us in understanding the extent of the scene of the massing birds. The lack of knowledge that Hedren performs is a diversion from the hidden field of vision behind her back (an invocation of the screen) and similarly the field of vision behind us (where the projector would be). Although the camera comes closer to Hedren's face, her expression is indecipherable or indifferent. We can impute no definite thoughts to her at all, just as we cannot induce the number of birds from those we can count. She is looking beyond us, into a space we cannot see for it is implicitly behind our backs,

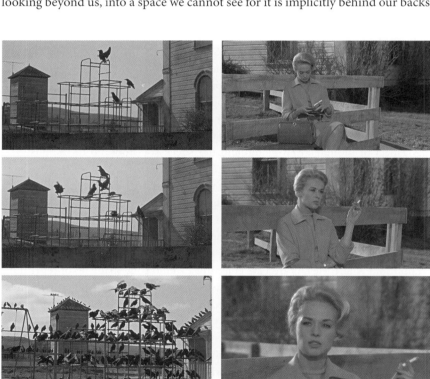

FIGURE 15 *The Birds* (1963) Alfred Hitchcock.

a viewpoint we are denied since there is no reverse-shot; hence the teasing play with the fourth look, the forbidden direct stare into the camera. This inscription of the negative – Hedren's *not* looking at the camera, *not* conveying emotion through facial expression – is important in constructing this affect.

Alain Robbe-Grillet, in an Arena/BBC documentary about Michelangelo Antonioni (*Dear Antonioni …*, directed by Gianni Massironi, 1997), explains the difference between Antonioni and Hitchcock as a question of cinematic signs and meanings. He observes that the 'reverse-field shot' is the basis of film narrative. Hitchcock almost always uses reverse-field; Antonioni only rarely. The result is that Antonioni's films have an open structure – a character looks, but we do not see what he or she sees – while Hitchcock's films are relatively closed or bound. But that's not all. In Hitchcock, where vision is highly mediated and controlled, the mystery is always solved. In Antonioni, where everything seems open to the spectator's eye, the mystery – or the refusal to explain and resolve a situation – is deepened. For Robbe-Grillet, this refusal of closure, and ultimately perhaps of narrative itself, is the key to modernism. Interestingly, the sequence from *The Birds* discussed previously is like Antonioni in its treatment of Hedren (we do not see what she looks at) but purely Hitchcockian in its manipulation of audience reaction (when the massed birds are revealed). The film is also like Antonioni more generally in its preference for broad vistas and for an unusually ambiguous ending, in which the dishevelled and catatonic protagonists drive off to an unknown future.

It is no surprise to find the central figures of cinema at work in the crucial episode of *The Birds*. The regular beat of the projector is picked up by the motor of the car that Hedren drives to the school, and then by the rhythmic repetition of the round song. The frames and bars on which the birds perch are figures for the frames of the filmstrip. Likewise, the seemingly continuous smoking of the cigarette and massing of the birds, which are both intermittent events that take place across several alternating shots, are a further cinematic figure for frame-by-frame motion and the illusion of movement.

central figures of cinema in THE BIRDS

Where does the viewer's part in the field of interpretation lie? The artists' films discussed here eschew narrative, and have no voice-over, dialogue or character identification. But they make statements; they incarnate the thought process (through the spectator). And they do so at a high level, hence the poetry or idealism that haunts the materialist handling of their medium, from Baillie's sensitive use of film stock to Deren's physical approach to cutting which evokes Eisenstein's montage. The thought processes involved in these films cannot be wholly reduced to acts of pure consciousness, because each insists that a percept must pass through a medium. The model of consciousness has nonetheless been remarkably productive and influential. It underlies P. Adams Sitney's analysis of *All My Life* for example, and is signalled in the title of his most well-known book, *Visionary Film*, where vision is seen as the triumph of mind.[3] In a parallel field,

FILMS make statements & don't have to be narrative

all of the major critics and artist-critics of the minimalist movement (including Annette Michelson, Rosalind Krauss, Michael Fried, Donald Judd and Robert Morris) referred to Merleau-Ponty and phenomenology, even while arguing with each other.[4] The same stream of thought must have underpinned Susan Sontag's efforts 'against interpretation', a slogan which sums up the phenomenological reduction, the ability to attend without judgement to the direct perception.[5] The tendency here invokes Husserl's major injunction – 'to the things themselves!'[6] – if only because what was at issue was the status of the thing as a work of art – its 'objecthood', as Fried famously put it.

suspend judgement;
attend to direct perception

EXPANDING CINEMA

In three of the major periods of radical film in the last century (and into this) artists' avant-gardes have mingled with the impulse for radical documentary. In the 1920s and 1930s, artists like Man Ray and Fernand Léger documented street and daily *a* life within Surrealist and Cubist contexts of film language. Walter Ruttmann, Hans Richter and Alberto Cavalcanti shifted from experimental to documentary cinema. *b* By the end of the period, under intense political pressure, the documentary was dominant. Thirty years later, in the underground cinema of the 1960s, the 'new *c* documentary' and cinema-verité were rightly seen alongside the poetic and lyric cinema heralded by Maya Deren, pioneered by Marie Menken and pursued by Stan Brakhage. The films of Ken Jacobs, Hollis Frampton, Michael Snow, Joyce Wieland and Ernie Gehr maintain the documentary impulse, transforming it even as they shot their films in the streets and public places of New York's Lower East Side, Montreal and Berlin.

Like the New York Film Co-op that inspired it, the London Film-Makers' Co-operative (LFMC, founded in 1966) also had a distinctly social aspiration, built on self-help socialism and anti-Vietnam War sentiment. Unlike its predecessor, a distinctive feature of the LFMC was the provision of filmmaking facilities for processing, printing and editing. Associated films tended to eschew directly documentary content, or – where it was used, as in Malcolm Le Grice's *Castle 1* (1966) – subjected it to intensive meltdown. One of the 'Castles' in this film is the British politician Barbara Castle, seen in documentary footage addressing a conference. The melange of industrial and crisis footage which makes up the film is punctuated and flattened by a flashing light bulb in front of the screen, as well as subjected to metric and anti-narrative montage editing. Like the astonishing *Threshold* (1972), this is one of Le Grice's few but significant works in which an overtly political context is cited and undermined, in this case by the flash of light (echoing the projector bulb, but as a different mode of 'illumination') to sabotage the image and reveal its artifice. The film asserts documentary as a kind of performance, and the task of the artist as undermining the authority of the iconic

attitude. Unlike recent gallery installation, however, it does so by insisting on a performance of its own, so that the critique is offered as an act that the viewer must perform rather than as a subjective attitude for the viewer to experience.

Threshold adopts a different tactic, but one which is also performative. The work is ideally shown in its original three-projector version. The initial imaging is highly abstract with colour patterns emerging from the edges and corners of the screen (painting was the art form from which Le Grice emerged). After a time, the film adds two further elements. One is a circular target-like shape, which appears to form an ellipse in the shallow screen space it inhabits. The second, and the most memorable image, is a few seconds long only, but subjected to repetition and ultimate auto-destruction. This is a scene at a European border, in which a few police or customs officers (clearly armed) turn again and again to a small sentry hut (see Colour Plate 3).

While repetition eventually reveals the context of this key image, conveying the broad kind of anti-authoritarian social meaning, which artists to the present day have tried to uphold, it does not resolve the mystery of the soundtrack, a looped speech fragment which remains incomprehensible, if rhythmic, to the end. At the same time, the three projectors are moved over and across each other, creating vibrant new colour mixtures of projected light, as well as creating a new space in which the customs men continue to move and overlap as if in a dance (or trance). Power is not just revealed, it is transcended, within the context of a fully independent artwork, which still retains the political punch of its subject matter. This is backed up by the source of the target image, made by Le Grice on one of the few computers that could create such optical effects, at that time owned by the Ministry of Defence. In creating an abstract work of art on a military computer, Le Grice was making another kind of intervention, in this case along the lines of transforming 'swords into ploughshares'.

Others who notably exploited the techniques of expanded cinema included Gill Eatherley and William Raban, who were originally students of Le Grice at St. Martins and involved in the 'Filmaktion' group that he formed. In a class of his own, although an occasional collaborator with Raban, was Chris Welsby. Le Grice himself continued to explore multi-screen projection, but in ways which paradoxically brought it closer to narrative form, which he overtly adopted in the late 1970s. At the same time, he maintained an 'art' ethos in explicit allusions to classic painting in works such as *After Manet* (1975). Eatherley and Raban, in contrast, invented overtly aesthetic multi-screen works that continued to investigate the character of abstract shape and space, which *Threshold* also exemplifies in its more painterly moments.

In *Diagonal* (1973), Raban also shifts projectors while the three films are running. In this case, they are on three rising levels, creating a staggered screen space in which abstract patterns eventually merge and dissolve. A latter day 'diagonal symphony', it exemplifies a kind of expanded field of painting but wholly

in film terms. Eatherley, like Le Grice, overtly cites the militaristic image in *Sicherheit* (Safety, 1973) a combination of slides and film in which a bomb in a test tunnel, precariously wobbling on its pivot, is alternately seen as static (in the still photographs taken from slides) and dangerously mobile (in the movie footage). In *Hand Grenade* (1971) her aims are more purely to do with movement and light (see Colour Plate 4). Three loosely synchronized images run side by side, with a raucous soundtrack by the German 'krautrock' band NEU!. The dancing highly coloured images on the three screens were made by tracing flashlight beams over domestic objects like chairs and tables in a darkened room – a kind of drawing with light earlier explored by Man Ray and, most lyrically, by Marie Menken. Direct animation in an expanded frame, this joyful film is also revelatory with respect to the process by which it was made. (The same is true, though more cognitively, in Raban's films of this period.)

Le Grice has continued to work with multi-screen projection, but in significantly new directions. In the hour-long film *After Manet* (to give it its full title, *After Manet, After Giorgione – Le Déjeuner sur L'herbe or Fête Champêtre*) the projectors make up a square on the screen, with two above and two below each other (Figure 16). If the projectors are not synchronized (and very few were at this period) they slip out of phase with each other and the work becomes something of a chance-based operation. The film is partly a record of a performance, documenting a lunch on the grass (after Manet's famous painting of 1867, and the Giogione/Titian painting

FIGURE 16 *After Manet* (1975) Malcolm Le Grice.

before that) involving four participants: Le Grice, Eatherley, Raban and Annabel Nicolson. The time frame is inherently 'structural', determined by the progress of the meal and the action of the picnickers filming each other on the grass. The four rigidly projected frames are in contrast to the looseness of the fluent, handheld camerawork that makes up most of the content. Like many films of the period, the piece exhausts itself when its terms have been completed and, as it were, fulfilled.

Very distinct directions were emerging at this point among the filmmakers in question. They were still complementary however, even when their methods and aims were opposed. Eatherley maintained a painter's point of view: flat, frontal, seemingly casual and always representational, holding on to the visible object even at its most abstract. Raban went further into optical space that was clearly derived from a painterly practice, but infused with an understanding of motion and transition that painting can evoke but rarely incarnate (as a static art). *Diagonal* is one among many early works which successfully bridge the narrow but deep chasm between painting and cinema, by finding filmic equivalents for abstract imaging and by using the projector as an active constituent in making the work.

Chris Welsby was linked to the Filmaktion group by affinity and personal friendship. Although he worked with Raban on a major landscape film, *River Yar* (1972), Welsby followed an independent path. Ultimately, he has produced a major body of work in the genre of expanded cinema, and more than most he crossed the fields of painting, photography and film (later adding video) in a new fusion. In a sense, he inaugurated current installation art – through the expanded space of multi-screen gallery projection – while diverging radically from some of its more recent traits and tendencies. Initially a student of painting at Chelsea School of Art, Welsby was encouraged to make films by Anne Rees-Mogg, and introduced to the Film Co-op. He then went to the Slade, and later taught at both colleges. In the mid-1970s he took up his main, indeed only, subject matter: landscape. He has continued to practice in this genre for over thirty years, now resident in Canada.

In his first landscape films, made in this broad context of Systems and conceptual art, Welsby allowed the camera to see for itself rather than have it act as a substitute for the human eye. In *Seven Days* (1974), made in the Welsh mountains, the camera is fixed to an equatorial mount, a scientific tripod which tracks the rotation of the earth, keeping the sun centre-screen, so that alternating images of sky and earth are energized by its circular motion (Figure 17). In the films *Windvane* (1972) and *Anemometer* (1974) the camera's rotational movement is wind-powered, while in *Estuary* (1980) the images are determined by the motion of a boat and by sampling exposures from dawn to dusk over three weeks. As with Systems painting, the films were structured in advance. He chose a place, such as a busy pathway in *Park Film* (1972) or a beach as in *Fforest Bay* (1973) and exposed a fixed number of frames over a day or longer from dawn to dusk. The taste for flat, frontal and undemonstrative images reveal painterly and other art sources that were in the air. Robert Morris's 'Notes on Sculpture', for example, praised the Number and

FIGURE 17 *Seven Days* (1974) Chris Welsby.

Alphabet paintings of Jasper Johns for using logical systems to produce a picture by working through the chosen numerals or letters.[1] Commenting on these same works, James Meyer suggests that the overlaid systematic signs 'seemed almost to make themselves'.[2] The same could be said of Welsby's procedural films.

Chris Welsby shared the fine art ethos of the LFMC more than most, but unusually for a Co-op filmmaker, he did not manipulate or even edit the print. Editing, in his view, smacked of the film industry. Decisions about light, shape and structure were made while exposing the film. The print is a direct copy from the original camera negative. Video, which Welsby came to later, was to be even simpler: there is no original. Only the two-minute overlaid print of *Colour Separation* (1975) comes close to the handmade look of a Co-op film, but it is primarily a revelation of film's colour process.

Similarly, his 'expanded' films on two, three or six screens approach the scale of cinema but are set firmly in the gallery rather than the film theatre. In *Shore Line II* (1979) short repeated loops of the seashore are simultaneously seen across six screens (Figure 18). But the illusion of Cinemascope is quickly checked by the sequence of shots, by the projectors having been placed on their sides in vertical format and by the loops hanging visibly from the ceiling. The single-screen film *Estuary* can also be seen as a gallery piece, given that it has been exhibited in the same space as panel displays of satellite photos, frame enlargements, aerial shots,

FIGURE 18 *Shore Line II* (1979) Chris Welsby.

weather maps, notebooks and topographic charts, so that the spectator pieces the work together in relation to a wider context.

Welsby moves even further from conventional screen space in a variety of works in which the viewer looks down onto films shown on the floor. These ideas first appeared in the l980s (when Welsby was teaching filmmaking at the Slade and drawing at the Central School of Art and Design) as a more troubled response to contemporary landscape imaging. The impact of Chernobyl and other disasters lay hidden in the clouds. *Sky Light* (1986) was a multi-screen installation of a stormy sky, in which fragmented flash frames break up the flow of images in a metaphor of vision as violent interruption. In *Sea Pictures* (1992), Welsby's only montage video to date and his most emblematic, a child builds a sandcastle while fragmented urban images and TV footage act as images of alienation. Also made after he moved to Canada in 1989, *Drift* (1994) is a distillation of his ideas even as it clears the ground for new ones. Filmed in near-darkness, ghost-like boats move slowly across a bare harbour. Thirty years ago, when Welsby made his first projections for large spaces, film and art rarely met in the gallery. Now it is common and installation art is a distinct practice, but whereas mainstream video-culture reflects surveillance and domination, Welsby's video installations involve contemplation, with the camera capturing changes in time and tide.

Younger artists such as Tacita Dean have echoed Welsby's concerns for landscape, light and documentation (as in her film of the 1999 eclipse, *Banewl*), but in an overtly romantic style. More distant still are the 'great machines' of Jeff Wall or Bill Viola, which emphasize video and photography as colour spectacle. Welsby prefers viewers' associations to grow out of the work rather than to be imposed by the maker. In this respect his work joins a wider tradition of modernist landscape, exemplified by St. Ives painters such as Peter Lanyon who saw space from a new angle and gave it an image.

A different and much looser painterliness is seen in the brief and elusive films of Marilyn Bailey (née Halford). Her extensive filmmaking career in the 1970s was closely linked to William Raban, with whom she finally collaborated on a feature-length 'new narrative' film, *Black and Silver* (1981), in which she also

dances. Although she has largely withdrawn her earlier films, they continue to get occasional screenings. Two in particular are evocative of the era in which they were made, while retaining their engagingly casual humour and insight. In *Footsteps* (1974), Halford is filmed by William Raban in the well-known children's game of Grandmother's Footsteps (Figure 19). The aim is for the cameraman to approach Halford, and then freeze when she stops and turns. This game is repeated in positive and negative, and there is some play with continuous and repeated time, but the basic structure is the act of advancing and stopping, emulating the process of making a film. The delight of the game overcomes any hint of stalking and threat: this is play without fear, while the alternating, roughly printed monochrome stock points to the conditions in which the film was made.

The same casual but determined air permeates *Ten Green Bottles* (1975), which is based on another childhood game. Halford chants the verses of the song, and 'each green bottle' duly tumbles from the mantelpiece (in close-up). However, the fall is less than 'accidental'. Most of the bottles are vigorously nudged, out of shot, to help them on their way. Apart from the sheer intuitive delight of this very short film, it provides a little metaphor of film drama. In fiction films there is always off-screen space, beyond the camera's reach, in which cinematic miracles are made to occur. (A classic case is that of movie technicians holding the horse and helping the rider 'leap' into the saddle, which the audience never see.) Here, Halford goes as far as she can in both including that space and – ironized by the song – avowing its absence. This is a painter's film: the bottle, in static form, was often the first thing a young art student was asked to tackle, and a key motif in Western art. Transparent and reflective bottles, reduced by the rough colour and printing of the

FIGURE 19 *Footsteps* (1974) Marilyn Bailey (née Halford). Courtesy of LUX.

film, evoke visual values and distantly recall the glass of the lens which is recording the image. It is this powerful but lightly carried object lesson that underlies the wit and clarity of this song-like film poem, just as it delicately invokes the domestic space of young artists at the time when it was made. This perhaps also explains its evergreen quality and its freshness in very different times.

If Halford exemplifies an almost Mekas-like aspiration to a 'cinema of mistakes' (in the creative sense), Lis Rhodes invokes a contrasting approach. Halford's innocent use of children's play and song is seemingly far from Rhodes's purist and hard-line approach to form. Nonetheless, there are links below the surface, if only because they were both making films in the period of early contemporary feminism. Up to the 1960s, women filmmakers such as Maya Deren, Marie Menken, Chick Strand and Storm de Hirsch, were exceptions in an avant-garde and underground cinema that was largely male. The growth of film in the English art schools helped to create a new balance, since these colleges had equal numbers of men and women students even before the reforms of the 1960s and early 1970s. Jenny Okun, Gill Eatherley, Annabel Nicolson, Sally Potter, Marilyn Halford, Anne Rees-Mogg and Lis Rhodes were among early exponents of the new film, often in its most radical and expanded aspects. By the mid-to-late 1970s they were joined by women filmmakers and activists in the related sociopolitical groups formed at the Four Corners Workshop in East London, notably Jane Clarke, Anthea Kennedy, Jo Davis and Mary-Pat Leece.

This was to become Rhodes's milieu some time later, but her first and some of her strongest work was made in the context of the formal abstract film. While a student at North East London Polytechnic (NELP; now the University of East London) she collaborated with artists including Guy Sherwin and Ian Kerr. With staff honed by the student uprisings at Hornsey and other art schools in the late 1960s, NELP's film department actually emerged from the radical fringe of graphic design. In its main period, under the umbrella of Fine Art, it was headed by a structural stalwart and inspiring teacher, David Parsons. Here Rhodes began the process-based direct abstract work on the filmstrip that inaugurated the first stage of her career.

Originally a painter, like most members of the LFMC, Rhodes found yet another way to exploit the graphic qualities of the filmstrip, using direct methods of printing. The distant origins of the approach are found in one of the earliest works of the film avant-garde, Man Ray's *Return to Reason* (1923). This astonishingly prescient work, only three minutes long, is packed full of ideas which it took the rest of the century and many filmmakers to fully exploit. It still invigorates digital cinema, by its play of illusion, Dadaism and visual effect. Man Ray treated the filmstrip as a surface on which he placed objects (tacks and nails, for example), briefly exposed them to light, and then printed their images as direct traces or photograms. He scattered salt and pepper on the film to imitate grain, and even included a brief glimpse of scribbled instructions to the lab: 'print five times'. At the

same time, in Germany, abstract filmmakers such as Hans Richter and especially Walter Ruttmann were developing a complex 'form-language' of alternating and overlapping black-and-white shapes, notably classic modernist squares and rectangles (although with other touches derived from Dada and expressionism).

In effect, Rhodes took over the abstract aspiration towards direct process filmmaking, pioneered in the 1920s, and expanded them massively into new dimensions of colour and sound. In other respects, her earlier work participates in the context of English Op-art, led by another influential woman artist, Bridget Riley. The Slade School, with which Rhodes has been long associated, was for many years a centre for abstract painting and new fusions between art and technology. But far from pursuing abstract film into the realms of high tech and the digital future, Rhodes drew it back into the artisanal and handmade ethos of the LFMC approach to film material.

new dimensions of colour & sound

→ elements of film-making

Her earliest experiments focused on transferring print and type to the 16 mm filmstrip, but her first major achievement was the four-minute *Dresden Dynamo* (1972) which has been seen by some as violent work, perhaps related to the bombing of Dresden in the Second World War. In fact, it was named after the city's famous football team, perhaps to suggest the overtones of play and action that the film invokes. It was made with 'letratone', visual shapes and icons on transfer sheets, employed by graphic designers and architects at the time. These were printed directly on the filmstrip, forming different sequences, which in projection give the effect of rotation, linear patterning and other complex shapes. The film is in rich colour, mostly combinations of red and blue, sometimes saturating the screen and at other times in dense patterns of dots and squares (see Colour Plate 5).

USING LETRATONE

These patterns also produce the film's sound, an effect similarly created in the act of printing. The technique is to print the letratone shapes into the sound-striped area of the film, the thin band which holds the soundtrack and which lies on the other side of the sprocket-holes bordering the visual frames. When printed and played back on a projector, the shapes are turned into sound impulses so that we hear the noise made by the shapes themselves. A line crossing into the soundtrack area generates a click, while dots produce a cluster of notes or a continuous tone, with the pitch depending on the spacing of the marks. To create this effect in synchronization with the picture, the soundtrack is adjusted in printing, since the sound in film is picked up some twenty-six frames ahead of its corresponding visual image. From these elements, Rhodes created a lyric visual poem that literally sings its shapes, at times exploding the screen into rhythm and counterpoints, in which dots and lines cross and dance.

THE SOUNDTRACK

sound is faster than its corresponding image by 26 frames

Direct optical sound was probably first explored by another of the German abstract filmmakers, Oskar Fischinger, in 1931–4. His 'demonstration' piece on this theme is both witty and forward-looking. He even made use of his name, since his signature which is written as the symbol 'φ', the Greek letter 'phi' often translated as 'f', signifies a sound and indeed a musical note like other letters of the

alphabet used in the musical scale. The context of Fischinger's *Ornamental Sound Film* includes the experimentalist and modernist ethos of the Weimar era, which also housed Schoenberg, the Bauhaus and other Constructivist art. Fischinger's investigations also led into potentially electronic or similar directions, from the music of Edgar Varèse to the post-war expansion of 'musique concrète'. Rhodes, however, seemed more attracted to the direct inscription of image as sound, rather than the potential for remixing, which electronic media suggest.

Rhodes was one of several LFMC filmmakers – notably including Steve Farrer, another graduate of NELP – who used printing processes to rework images and produce new rhythmic combinations. NELP was famous for exploring direct printing, and had a basic if idiosyncratic ex-army processor and printer. The pickled and erratic prints turned out on this machine became a hallmark, its vices turned into creative virtues as filmmaking approached the craft of printmaking. Rhodes and Farrer, however, were at this stage strict precisionists, for whom clarity of surface and texture were primary goals.

In 1975, Rhodes issued a major two-screen work, with the emblematic title *Light Music*, which expanded the ideas and techniques of the much shorter *Dresden Dynamo*, though in black and white. It was followed by another 'live-action' work, made with Ian Kerr, called *BWLHAICTKE* (1976) – the alternating letters of 'black' and 'white'. For this piece, the two filmmakers sat at tables across which two filmstrips passed, one clear and one black. The film was distressed by being trailed across the floor of the ICA gallery, making the clear film dark and vice versa. As such the 'images' were the result of procedures carried out while the film was in motion through the projector.

This aleatoric process, unpredictable and shaped in time, differed from the graphic play of *Light Music*, with its highly constructed form. As with *Dresden Dynamo*, the patterns in *Light Music* are carried into the soundtrack to make their own (synchronized) abstract music. Pictorially, the screen is filled with lines, bars and alternating light and dark flashes, all in complex sequences. These were not made by printing onto the filmstrip, but were shot on a camera through a series of grids or matrixes, a form of drawing with indirect light. The film can be shown on two screens side by side, so that intricate and overlapping relations build up between and across them, the two soundtracks mingling and contrasting in a barrage of structural film-noise. Alternatively, the films can be projected on two opposite sides of the gallery space, so that the viewer looks from one to the other: a dispersion of the fixed gaze which is latent in most multi-screen work of the period, but here decisively removed from frontal positioning and conventional spectatorship (Figure 20). The film therefore contains two key options for spectatorship at the limits of cinema (when adjacent) and beyond them (when on opposite walls).

In 1978, Rhodes made *Light Reading*, a canonical and key film that has had a long-lasting impact and would alone secure her place in the leading ranks of the film avant-garde (Figure 21). During the late 1970s, she took an explicitly

FIGURE 20 *Light Music* (1975) Lis Rhodes.

FIGURE 21 *Light Reading* (1978) Lis Rhodes.

feminist position, partly by exploring new collaborations and crucially, in this film, by including her own spoken text and voice. The year 1979 proved to be a watershed year for the British experimental film movement. The *Film as Film* exhibition at London's Hayward Gallery was devoted to the formal avant-garde, celebrated in a series of installations, projections, diagrams, slides, charts and framestills, accompanied by a huge survey of screenings. At the same time, it sealed the movement historically. It quickly became clear that new and contradictory directions for artists' film were evolving, chiefly in the rise of a new underground championed by Derek Jarman, but with the nascent pop-video – often modelled on avant-garde tropes or conventions – waiting to be born.

At this time, the feminist critique of the perceived male and authoritarian aspects of the formal-structural avant-garde was in full voice. As a selector for *Film as Film*, Rhodes and her colleagues finally withdrew from the exhibition when they were unable to show work by women in an independent context. Their protest joined that of Peter Gidal, who had much earlier walked out on political grounds. The statement by the women filmmakers has since been reprinted many times. But they continued, fortunately, to participate in the related 'Film London' film festival, where Rhodes's own film was premiered. A dense and highly compacted work, *Light Reading* requires repeated screenings. For the next few years it indeed gained wide circulation, together with new films by more explicitly sociopolitical women filmmakers, and with such 'lost' filmmakers as Alice Guy and Germaine Dulac (recovered especially by Felicity Sparrow, then a leading activist and distributor of films by women).

A number of women filmmakers jettisoned their avant-garde roots in this period, or abjured their earlier formalism. Sally Potter, who was on her way to directing art-house films, is the best known. Rhodes did not, and her work retains its structural edge and investigative eye. At the same time, she took up a more personal and ideological posture. *Light Reading* holds these in tight links and at high pressure. It opens with several moments of black screen, with a voice-over text written and read by the filmmaker. Its style is fast, punning and multi-layered in the manner of Gertrude Stein. The nearest equivalents are the roller-coaster Joycean reworking of Balzac's *Unknown Masterpiece* in the soundtrack of Sidney Peterson's film *Mr Frenhofer and the Minotaur* (1949) or perhaps John Maybury's drawling stream of consciousness, druggy voice-over in his early film *Time Code* from 1983 (also made at NELP). But unlike either of these, Rhodes's words are clear and lucid, using these very qualities to undermine their rational sense and replace them with poetic allusion.

After this dense, opaque but luminous opening, which expresses the search for meaning, in a kind of artistic *agon*, the film is silent for almost fifteen minutes. In the cluster of shots and images that follow, a number of distinctive features appear and are subjected to repetition and montage. Two emblematic photographs are successively seen in whole or part, then cut up as if with scissors, or vibrantly reframed with the staggered zoom of a rostrum camera. Again and again we plunge into the photograph of a bloodstained bed (a famous French police-file image) or are cast across the surface of an enigmatic spectacled male figure. Other core images include streaming letter-forms in positive and negative, printed directly on the film surface; animated 'cut-up' scenes of rulers, scalpels and paper; and brief glimpses of the filmmaker's face half-caught in a pocket-mirror reflection. There are no 'purely' abstract sections, as in the earlier films, but it is as if abstraction has entered the frame and pulse of every scene. Like the text which opens the film, objects and images on the verge of readability form internal

strands of connection: measuring, cutting, breaking, looking and – in the streams of overlapped letters – even suggestions of weeping and falling.

The voice returns over the last five minutes of images, which slow down, become more assertive of their identity as a film and affirm the process by which they were made. The voice too takes on this function: it gives instructions, as if to the lab, while frame numbers and lists punctuate the image, an expansion of Man Ray's hand-scrawled injunction to 'print 5 times' in *Return to Reason*. In effect, Rhodes expands some implications of Man Ray's dada logic: sense is dematerialized, scrutinized, broken down (an attack on 'male' logic), only for a new sense to emerge in a kind of rebirth. But even though this is seemingly an assertion of a new female power ('she reads, she re-reads ...'), it is more than a claim to ego and selfhood. The film ends at the edge of freedom; it claims no more. This is supported, in the latter part of the voice-over, by a ghostly second-person presence: 'She said I should wake her in an hour and a half if it had stopped raining. It's still raining. Shall I wake her, or shall I let her sleep?' Whatever complex meanings this repeated, evocative choral phrase may have, it also alludes to the process of watching a film in a trance or dream state. If the filmmaker must read and re-read, the spectator must also wake up; a new cinema demands both. If *Light Reading* has been much seen but rarely discussed this may be because of its inbuilt resistance to language itself – the film is a form of linguistic *détournement* – but it is also because of its sheer depth of interlaced ideas and evocations.

ROOM FILMS

In one sense, *Light Reading* represents the culmination of a particular direction of the UK avant-garde through the 1970s, in direct reference to and use of domestic space in several 'room films'. In part, this trend reflects a deep vein in English culture, including its Bloomsbury streak in which, as with the cineaste Virginia Woolf, the interior of room space reflects the subjectivity of the character, with language flowing from inside to outside and back again. In the English contemporary novel, as elsewhere, this is still a powerful strand.

In film, which can objectify space with the camera, the position is rather different. The room is an effect not of the subject speaking but of the camera seeing. This objective element, which itself can be challenged in the process of making the film, means that the viewer stands beyond the frame and is not in some way 'cut' into it. At the same time, the camera intervenes with the range of its mechanical and optical devices. The 16 mm Bolex film camera is not exactly a domestic object, but essentially it can be handheld, equipped with different lenses, hand-cranked, the film rewound and re-exposed and its speeds altered even in the act of shooting. Developed for fast documentary fieldwork, in the hands of American artists of the 1960s, it sped the way to cinema-verité as well as to the personal lyric film. But in LFMC circles (and after) it took on a rather different function that was more conceptual and less romantic. For some, it was even political. It could be operated by a single person (and usually was) and was completely portable. In this way, it promoted the LFMC project to create a wholly self-sufficient material production base for the making of experimental films.

Nonetheless, the idea of room space as an adequate subject for film art, and thus a field of vision, was largely inspired by Stan Brakhage. Long before the openly autobiographical films, which preoccupied him in the late 1970s into the 1980s, Brakhage had defended 'the home movie'. The widely seen *Window Water Baby Moving* (1959) records in graphic detail the birth of his and Jane Brakhage's first child, which took place at home. In his 8 mm films – free but highly edited lyric poems – and in such luminous 'family and nature' 16 mm films as the

Weir-Falcon Trilogy (1970), Brakhage captures many scenes of evocative private spaces, concentrating however on their surfaces and on the fluidity of light.

Perhaps the duller and slower surface light of London (as opposed to California, Colorado or even New York!) led away from this trend, at least in its direct sense. Instead, the UK room film took on a more formal and investigative stance. Curiously, at this distance in time, they have also become documentaries of a certain milieu of young artists living in London (mostly) during the 1970s; and in this, they have that peculiar and moving quality that runs through many depictions of the 'artist's studio' – or living room – when treated informally (as in the paintings of Gwen John and the English school of moderns). Yet this was probably the last thing on their minds when the films were made. At that time, they simply used the most available spaces to hand, with a variety of shapes, frames, angles, doors and windows, plus some objects of little significance at the time (typically chairs, record players, clothes, trinkets) which were included in the frame. With the passage of time, these lesser items have become more indicative, but – given the art school ethos and training of most LFMC filmmakers – their presence in the film would have been a chosen one, and probably less accidental than the fragments of a crowded family home more casually encountered by Brakhage's freely roving camera. But even a bit of accident can enliven an otherwise cool work, as the painter Piet Mondrian knew.

Most of these room films were process-based, following a more or less predetermined shape. John Du Cane's *Zoom Lapse* (1975) – which depicts the filmmaker's room, in this case when he was living in Hamburg – is shot from an interior space through windows that face onto a large warehouse (Figure 22). The film is repeatedly wound back and re-exposed, so that the staggering zoom shot, from near space to distant view, is overlaid again and again until it whites-out (almost). A whole system of apertures and rectangular fields are exposed, from table to wall and window and then back, the action of lens and camera analogous to the relationship between the window-glass and exterior view; a literal enactment of the camera obscura in motion, as a model of mind and perception.

The reduction to flatness in *Zoom Lapse*, as in his other films, is a painterly trope. David Hall, by contrast, was originally a sculptor. He was almost exclusively a film, video and installation artist from the 1970s onwards, having abandoned modernist sculpture when he made *Displacement (Removal Piece)* which involved sanding the floor of the ICA (as a commissioned work in 1970) and thereby turned his back on objecthood. In one of his few LFMC-type films, *Phased Time²* (1974), a camera slowly pans round a domestic living space in a series of cycles keyed to Steve Reich-like tones of different pitches on the soundtrack (see Colour Plate 6). These drones, which act as markers of distinct areas of the room, eventually fuse as the film constructs, or reconstructs the space, with its chairs, carpet, LPs, a door and a glimpse of a cat. The sense of this film is more sculptural than Du Cane's

FIGURE 22 *Zoom Lapse* (1975) John Du Cane.

Zoom Lapse: each element is measurable in space, and retains its qualities of depth and exact relation.

Peter Gidal's *Hall* (1968) is one of the few room films which explicitly loads its content with direct reference to the world beyond its walls (Figure 23). It is more literally a corridor film, to emphasize the element of transition and threshold characteristic of this seminal filmmaker. Facing the camera, in the shallow space of an entry hall, are photographs of a specific era: notably, a colour supplement image of Godard with the Rolling Stones (an equivalent to the Situationist wisecrack, 'Godard? He's just another Beatle'). There are other pictorial icons, such as a hand-scrawled note about drawing and a series of emblematic objects that include a lamp (referring to light) and wires (that perhaps refer to the insistent ringing bell on the soundtrack). All these parts are subjected to intense scrutiny over the ten minutes of the film, asking the viewer to assess and relate what they see. Extreme close-up and continual reframing by the lens construct new configurations. Objects and shapes at the edge of vision when held in long-shot are suddenly abstracted or fill the screen, suggesting that in cinema we only see what we are shown. This may be self-evident, but here the point is focused through the recall, or review, of the material. Looking evokes memory as well as seemingly direct perception. In his

In cinema we see only what we are shown

FIGURE 23 *Hall* (1968) © Peter Gidal 2019.

later work, such as the explicitly titled *Room Film 1973*, which partly provoked the whole genre, this sense of instability and lack are dealt with at greater length.

A visitor to Warhol's Factory, and in 1971 the author of a key book on the artist, Gidal evokes in *Hall* a variety of references to the other arts. Writing, drawing, photography, sculpture, painting, even design, are all present in this early work, perhaps to underline the specificity of the film medium which records and reworks them in various unstable kinds of relationship. It equally asserts the authority of film. Gidal made other such allusions throughout the 1970s: *Kopenhagen/1930* (1977), for example, employs images made by his uncle, the German photographer George Gidal (a rare biographical instance in the filmmaker's work). But in even later films, there is a shift of attention. Laying aside allusion to other art forms (in the manner of Man Ray), the films concentrate on puzzling the viewer as to the source of the image they are watching, to ask whether we are looking at a direct image of something or a refilming of its photograph. This simple but insistent paradox is expanded to intense visual scrutiny in a range of films including *Flare Out* (1992), which incorporates photographs of Egypt.

By contrast, in *Leading Light* (1975), yet another NELP graduate John Smith, in an early and still largely structural film, discovers equivalents for painterly surfaces and illumination in a series of slow pans around a domestic space (Figure 24).

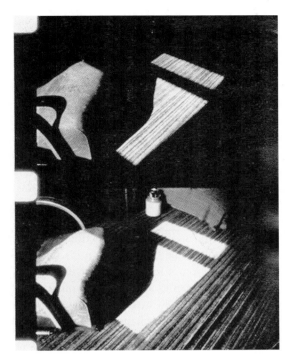

FIGURE 24 *Leading Light* (1975) John Smith.

Of all the works in the genre, this one explicitly emphasizes the objects in the room, and what they tell us of the person who lives there. It has an almost teasing aspect, which would later come to the fore in Smith's invention of an 'unreliable narrator' in his semi-narrative films. Here, however, the film strikes a pictorialist vein, which Smith was to absorb into the later films but rarely used again for its own sake. The film opens with an emblematic shot through a window onto plants and greenery, its source of light, before tracking the sun around the room over the course of a day (it is implied). As it unfolds, creating many rooms from just one by the variety of its shots, the film also plays with sound and space. A plaintive song, perhaps Celtic, accompanies some of the shots, like a conventional music soundtrack. The comforting or familiar wrap-around effect, corresponding with the normative use of music in film, is soon exposed because the sound rises or falls when the shots are at greater or lesser distances from the apparent source of the music, a disc on the record player. The volume of the music also changes with the varying illumination of the record player. This dispels the near-reflex response the viewer is encouraged to have when hearing 'film music'.

The painterliness of Smith's film is made even stronger today by the unfamiliar tone and richness of the projected print. It was shot (like many films of the period, in all countries) on stock that no longer exists. In this respect, there are material

the material substrate of film changes— film that is no longer in stock

analogies between the painter's and the filmmaker's craft, since both use substances that change, not only for commercial reasons but also because they are subject to decay and the effect of time, no matter how one tries to 'fix' them.

Most of the filmmakers discussed here were active members of the LFMC, then making their earliest work, and some were recent graduates. David Hall (born 1937) is the major exception, since he was already an established sculptor by the time he took up film and then video. Peter Gidal (born 1946) is a partial exception, due to his time in America. Hall had few connections to the Co-op and increasingly stood against its film-based stance and its aesthetic position. Gidal, by contrast, was a Co-op stalwart and a vocal defender of filmmakers' rights, often with Malcolm Le Grice, in a variety of contexts that included the BFI Production Board, where they represented not only artist-filmmakers but also (in the alliances of the period) independent, political filmmakers.

One of the youngest of the second-wave structuralists, Nicky Hamlyn, has adhered the most persistently to the 'room-film' in his mature work, up to the present day. His first films were not in fact made at the LFMC, but at Reading University, one of the few universities at the time to offer a degree in Fine Art. Time-based work was then organized by Ron Haselden, a maker of 'expanded sculpture' which incorporated process, chance and large-scale real objects. The video and installation artist Judith Goddard was a later graduate from the same course. Hamlyn's first films, some double-screen and in a variety of formats, were pleasurably process-based: one depicts roller-skating fellow students, partly shot by a roller-skating cameraman who follows them with camera in hand. But the film has no more than that in common with the 'skateboard' film genre: it is a witty display of a film being made in action, as a series of interwoven spaces.

Hamlyn soon abandoned this particular way of making a 'moving picture' and took up the characteristically patient and often near-static account of pictorial space, which for a long time was his hallmark. Here again, there is a painterly aspect to his films, characterized by intense colour fields that owe much to the example of Barnett Newman. *Silver Street* (1975) compares, like John Smith's *Leading Light*, views and scenes in a 'student' room over the course of a day. In a series of films made in the later 1970s and through the 1980s, Hamlyn focused on interiors and walls – here the filmic equivalent of the painter's flat surface. *Guesswork* (1979) exemplifies this, by showing close-up abstract shapes and colours which eventually reveal their source in such simple objects as radiators and floor tiles. In his most concise film (made for the BBC television programme *The Late Show*) the one-minute *Minutiae* (1990), he focuses and defocuses the camera on an emblem of media culture, the television presenter's chair, and turns it into a whirl of abstract light play.

Some longer films in his earlier manner were perhaps less successful. Working without a system, and dependent on montage, their duration seemed more arbitrary, especially since (unlike Gidal) he had no intention of provoking the

audience by works of great length and minimal content. However, and this time like Gidal, some opened with rather imposing on-screen philosophical quotations. Were they inside the film or anterior to it? Content or commentary? Gidal's own usage provokes the same questions, and both filmmakers were to drop this rather alienating device. In retrospect, Hamlyn's long films proved to be a step in a new and luminous direction. Admitting like many younger filmmakers at the time to Gidal's inspiring example, Hamlyn had to fully explore that form-world before finding his independent voice. This has expanded in recent years with a number of works that bear comparison with the best of any gallery artists of his generation (as can also be said of Guy Sherwin and John Smith, both rather belatedly receiving some of the attention, as artists, that they have long deserved).

White Light (1996) is solely made up of reflections in a bathroom tap, an unpromising subject, which actually – like Stan Brakhage's ashtray film *Text of Light* (1974) – offers a rich vein of vision (Figure 25). The images flow in analogy with water from a tap, but are in fact the product of stop-frame motion. Each frame is a single shot, the focus and angle subtly altered from one image to the next. In projection, these static images are given the illusion of movement, which actually

[handwritten margin notes: STOP FRAME motion of reflec flows in a bathroom tap simulate the flow of water]

FIGURE 25 *White Light* (1996) Nicky Hamlyn.

and only takes place in the spectator's eye. The film is like a massive expansion of those shots in *Ballet mécanique*, where Léger and Murphy can be glimpsed turning the handle of their camera while reflected and distorted in the curve of a reflective bowl. Hamlyn is similarly glimpsed in his own film, constructing the fluid patterns of light and rhythm that bring the film close to the structures of musical form (although, like most of his work, it is strongly optical and indeed silent).

While the iconography of this film alludes to painting (the distorted reflection is a major motif of Western art, as in van Eyck's *Arnolfini Portrait* and the 'room paintings' of Vermeer, such as *The Art of Painting*) its rhythms are directly linked to the pulse of the single frame as the 'ground bass' of filmic illusion. Semi-animated drawings of the bathroom objects and surfaces also feature in *White Light*, while in the intensively concentrated *Matrix* (1999) Hamlyn explicitly deploys the frame of a garden lattice as a device to flatten the image. Cross-patterned weaving of plants and fences set up abstract patterns which instantiate the act of looking as creative rather than receptive on the spectator's part. In *White Road* (1999), shot in Italy, these features are expanded into landscape space, overlaying glimpses of trees and pathways.

While the 'classic' landscape film was objective, freed from the human eye as locus of meaning, Hamlyn's vision is more personal even as it asserts the impact and form of the camera's mechanical process. Human figures as such rarely appear, but the subject matter is always local, domestic or – as in *White Road* – saturated with human traces. He only shoots what he knows, making the viewer 'see again' (or perhaps for the first time) the differences in light and angle which make up our unquestioned habits of vision. Here nature is not other to the spectator (the tendency of most landscape film). It draws close to the 'real time' in which the films are shot, however fragmented the final result is on the screen.

In these ways, Hamlyn and some other filmmakers incorporate a personal voice and vision, without assuming the position of authority (or its counterpart, self-abasement) which characterizes more grandly styled forays into new narrative cinema and much gallery and installation art. Most importantly, they are highly optical works, pushed to the pitch where optics yield concepts. Here they differ from the classic lyric films to which they are otherwise related, since they are more cognitive than metaphysical. At the same time, they always reinforce the impression that their source is personal, in the also classic if slightly strange sense that they are made by a filmmaker peering through the small and dim eyepiece of a Bolex camera.

FILM OBJECTS

photogenic qualities of film as a medium →
• everything in cinema is a shadow•
• turns everything into film grain or pixel•

Objects, when filmed, become phantasmagoric. They change their state, become magical, just as they shrink and grow in the space of the screen. When the French film director and cinema poet Jean Epstein said that in film 'objects have attitudes', he pointed to the ways in which 'the camera transforms what it sees'.[1] These were two of his favourite themes in his writings of the 1920s and 1930s, which focused on what the French school called the 'photogenic' qualities of the film medium, its 'photogénie'. For all its apparent realism, the film image was also a sign for an object dislocated from its original place and set among a sequence of images to give it new meaning. The bond to its referent is further severed by a basic property of the film medium, which turns everything in front of the camera into the stuff of film grain or digital pixels. For Stanley Cavell, in *The World Viewed*, everything the camera records is given the same ontological status, wiping out, for example, the differences between people and things.[2] Everything is equally a shadow in cinema.

Certainly, the thing in the world is not its film image, an idea spectacularly announced in the opening credits of David Lynch's *Wild at Heart* (1997). A match is lit, grandly magnified, in close-up, slow motion and stereo sound. It ignites the swirling fire that rolls and grows as the credits appear. Mao's famous revolutionary slogan – 'A single spark can start a prairie fire' – is here literalized as a cinematic metaphor of motion and light. Yet, the source of this wonder is no more than a humble matchstick, blown up in scale to new dimensions and powers.

The 'photogénie' that transforms objects is paralleled by cinema's other great disruptive property, montage editing, which developed in Soviet Russia at the same time as Epstein was writing. But Epstein's notion of the 'camera eye' led him to the subjective film as surely as Dziga Vertov's very different conception of the 'kino-eye' led the Soviet filmmaker to radical documentary. For Epstein, the close-up made the world more mysterious, and objects were signs of wonder before the camera's gaze. Vertov was more analytic and materialist. For him, the object was a humanly manufactured thing, further shaped for film by the editor's hand. Each agreed, however, on the value of the scientific film, which respects the integrity

② *montage editing → objects in film*
move in time & space that does
not work in real life

of its subject matter while revealing hitherto invisible processes which only the camera can record. The time-lapse studies of flowers growing and fading, shot and hand-coloured by F. Percy Smith and others around 1912, are an example, as are microscopic and telescopic imaging.

Drama filmmakers also 'cheat' appearances by the deft use of objects to create an illusion of the real, but whose only reality, in fact, is purely cinematic. In *The Godfather* (Francis Ford Coppola, 1972), a grateful pastry cook extends his hands in friendship to the Mafia boss. He is holding a cigar in one hand, a glass in the other. In the close-up reverse-shot, these objects have disappeared, and the two men clasp hands (Figure 26). Cutting to the original viewpoint, the glass and the cigar are back in place. The deception is so fluid, the narrative drive so strong, that this blatant trick is never noticed in normal viewing. Objects in film move in time and space by turns that the real world forbids, but which are cinema's essence.

In yet another sense, objects acquire attitudes by becoming emblems, often in the form of a repeated motif, like the Christmas trees in different locations in *Eyes Wide Shut* (Stanley Kubrick, 1999) or the hat which blows away at the beginning of *Miller's Crossing* (Joel and Ethan Coen, 1990) and echoes the hero's tribulations

FIGURE 26 *The Godfather* (1972) Francis Ford Coppola.

throughout the film. Antonioni provides an extreme example in the long final section of *Zabriskie Point* (1970), where exploding objects – mostly consumer goods, standing for culture as a whole – dissipate and collapse in slow motion (Figure 27). Here again, the camera spectacularly transforms what it beholds. For Hitchcock, another sceptic of vision, the object was the always missing 'McGuffin': the microfilm or stolen letter that impels the plot but is really an empty and arbitrary sign (because any other would do).

*[handwritten margin note: * The Good Fight *]*

The more sinister side of this equation inspired Hitchcock's mentors, the Surrealists, to open the object to dream and association. It led them to a kind of counter-montage, a mirror image of the Russian editors. Rather than using montage to associate distinct images (e.g. people queuing for bread intercut with tanks being built, to suggest exploitation as in Eisenstein's *October*) the Surrealists sought disjunction and rupture. Reaching its purest state in Man Ray and the imagined but unmade films of Antonin Artaud, this interruptive cinema is best seen in *Un Chien andalou* (Buñuel and Dali, 1929). Here, the signs do not connect. The striped tie and boxes, which permeate the film, defy a systematic relationship. Night and day are interchangeable, fetish objects are incommunicable, time has no unity and vision cannot be trusted to produce meaning. It is the reverse of the object-world, underlined by the abrupt editing and illogical intertitles, coupled with the fact that the two male leads disconcertingly resemble each other. The fragmented editing, which P. Adams Sitney described as 'cubist', reflects these themes of the anxious object.

[handwritten margin note: Interruptive (surrealist) film is the oppo site of the object world]

Different anxieties – and many pleasures – are explored in the animated film, a genre replete with self-proclaimed Surrealists of all shades. Jan Švankmajer, a signed-up member of the Czech group of Surrealists, is a prolific transformer of objects. In *Dimensions of Dialogue* (1982) he takes a recurrent theme. Two lumps of clay confront each other, and act out the human saga, alternately destroying and creating each other. In his drama films, objects interact with humans as in Alice's descent of the staircase in *Down to the Cellar* (1983). Below stairs, a grinning stoker

FIGURE 27 *Zabriskie Point* (1970) Michelangelo Antonioni.

repeatedly turns coal into food and back again. This is the universe of rebellious objects also exemplified in the films of Jan Lenica, Walerian Borowczyk, Patrick Bokanowski and the Quay Brothers. It descends directly from the tradition of an early cinema showman, Georges Méliès, and its phantasmagorias reach back to the origins of 'The Great Art of Light and Shadow' (the historian Laurent Mannoni's term for the pre-cinema).[3] Characterized by the use of puppets and masks, objects with soul, animation is put to political effect, especially in pre-1989 central Europe, where it critiques the prevailing orthodoxies of control and conformity.

Similarly influenced by Surrealism, in his case by direct contact with the last days of the movement in 1950s Paris, the American artist Robert Breer takes the animated line in a quite different direction. As early as 1953 he explored the outer-fringe of speed vision with *REcreation* (1956) and other films, shooting a new image for each frame. In *A Man and His Dog Out for Air* (1957) the two suggested figures appear only briefly from the abstract tangle, to suggest that it is the line and not the dog which is taken for a walk. In *69* (1969) the soundtrack and colour graphics evoke city spaces and journeys, which then melt back into abstract line-play. In these films, Breer has taken the surreal magic object and put it in the colour-field space of the New York School and modern painting. But tellingly the object is always retained, and Breer has made no purely abstract films since he animated his own paintings in the 1950s.

Animated mayhem is explored in *Der Lauf Der Dinge* (The Way Things Go, 1987) – a telling title in this context – by the contemporary Swiss artists Peter Fischli and David Weiss. Here, a seemingly endless chain of Heath-Robinson objects achieves an inspired reduction to absurd causes and effects. An oil drum rolls to a table, releasing inflammable liquid which powers a pendulum that crashes into some cans which release a catch that spins a wheel ... and so on (Figure 28). The effects are real, and very funny, but edited so as to cover the gaps in linear time. By contrast, Len Lye's unreleased Chrysler advert of 1957, *Rhythm*, cuts up the assembly of a car into a one-minute montage film, to evoke and display the distinct edits and the choppy soundtrack (of African drumming) as a single coordinated process. Montage is still the basis of the rock-promo and the television ad, which in the hands of Chris Cunningham or Pedro Romhanyi has become an art form in itself, creating 'impossible' realities, including a memorable cyber-version of the singer Björk in the video *All Is Full of Love* (Cunningham, 1999).

Digital editing – the basis for nearly all current promo and post-MTV videos – offers a huge potential for this kind of expanded cinema, but with a difference. The 'camera eye' is no longer privileged as the major source for turning real things into images. The digital object is far more malleable than its straight cinematic counterpart, changing scale and flipping angle in multiple perspectives. Even more radically, there is no longer an object 'in itself' for digital space. It shares the same screen space as words, diagrams, insets, streaming text and sound, all powered by the same pixels in a force field of icons and frames. Artists who have

FIGURE 28 *Der Lauf Der Dinge* (1987) Peter Fischli and David Weiss.

ventured into this highly commercialized territory (paradoxically the part-product of experimental art from Cubism, Futurism, Dada and even Fluxus) include Beryl Korot in the United States, the veteran underground filmmaker David Larcher who was based in Germany for some time, the Japanese group X and, in the United Kingdom, Stephen Partridge and David Cunningham. As yet, digital culture is more a technology than a medium, taking its codes from older media (including film and video) and combining them in new ways, but still seeking its unique voice in the production of meaning.

DIGITAL culture is more a technology than a medium

Although Lev Manovich, in *The Language of New Media*, argues that Vertov's multi-levelled *The Man with a Movie Camera* (1929) is the master text for this new digital sphere, another paradigm is perhaps the section of Eisenstein's *October* in which General Kerensky is first compared to a peacock, through intercutting, and then shown brooding on his Napoleonic fantasies. As Kerensky explores the sumptuous and costly objects in the former Tsar's suites, they become metaphors for his own dream: rows of glasses evoke military power; statues of Napoleon echo the pieces on a chessboard (Figure 29). Next, the White slogan 'For God and Country' is undermined by a lavish display of gods from many diverse cultures, each one more and more remote from Western ideology and imagination. Finally, the fear of the monarchy's return is shown in reverse motion: the giant statue of the Tsar, which was pulled down at the start of the film, is flipped so that it stands again.

However emotive in effect, Eisenstein's goal was an 'intellectual montage' which would invoke abstract concepts as visual ideas. The object was the starting point only. At the opposite end of the scale the object is celebrated as an icon,

FIGURE 29 *October* (1928) Sergei Eisenstein.

suffused with light as in the films of Josef von Sternberg, or lovingly depicted in the costume drama as an image of authenticity. Von Sternberg, a great non-realist who preferred painted sets to mere things, was led to high artifice. The sweeping pan over the Russian wedding-feast in *The Scarlet Empress* (1934) reveals a sinister and incongruous assembly of baroque data: chicken bones alongside icons; memento mori among greasy bowls of food (Figure 30). The opposite approach is seen in British 'nostalgia films' of the 1980s and 1990s, with their obsessive hunt for period objects to buttress this or that lost world, from Regency England to imperial India and wartime Egypt. Here, the props are employed to add historical aura to the well-known contemporary faces and gestures of the leading players, giving touches of the real past to cinema's present-tense narration.

A more sceptical attitude to the authority of things, and hence a hallmark of modernism, is seen in the art cinema of Rossellini through to Godard and Straub-Huillet. Each of these has also coincidentally made historical films, replete with factual detail: Rossellini in *The Taking of Power by Louis XIV* (1966) and his late films on other enlightenment figures; Godard in the reconstructed paintings for *Passion* (1982); Straub-Huillet most influentially in *The Chronicle of Anna Magdalena Bach* (1968). But this strict historicism is not used to seduce the eye and create a fake atmosphere. Characterized by a starkly objective use of the camera, especially the long frontal take, such films announce the gaps in time

FIGURE 30 *The Scarlet Empress* (1934) Josef von Sternberg.

FIGURE 31 *I Know Where I'm Going* (1945) Michael Powell and Emeric Pressburger.

create a space to think & reflect beyond narrative

which conventional costume dramas attempt to conceal. A distance is created between the constructed film-world and the viewer's temporality. In this gap, this post-war European school of left-wing directors tried to create – in Brecht's spirit – a space to think and reflect. This space tends to be crowded out when objects take over and 'become spectacle' (in Guy Debord's phrase).

Nonetheless, opposites can merge as in the visionary cinema of Michael Powell and Emeric Pressburger, who are (among many others) synthesizers of

the montage tradition and the camera-eye school. The title of *I Know Where I'm Going*, a 'home-front' wartime film of 1945, is undermined by the growing confusion of the heroine as she nears her impending marriage to a business magnate. Travelling to Scotland on the overnight express, she dreams her future in a witty display of Surrealist trick-film devices, in which objects (her wedding-dress, the train-whistle, a telephone) are animated to reflect her state of mind (Figure 31). She awakens in Glasgow to change trains for the islands, but the sequence does not end here in a 'simple' reality, for the stationmaster's top hat dissolves into the similar looking steam train chimney which is immediately behind him. Cliché is redeemed by the magic of film, and distant objects are drawn together in a new fusion.

PROJECTION SPACE

Historically, artists have tried to control the conditions for showing their work, and each medium has its special conditions. Where the scale is fixed, as in a painting or a sculpture, the frame edge or the standing base will secure the boundaries within which the work is seen. In the context of modern painting, from Georges Seurat to Howard Hodgkin, the frame itself has been painted as an additional marker. The canvas can also be shaped (as in paintings by Edouard Vuillard to Frank Stella). Similarly, the edge of a painting might be determined by its distance from the viewer and its internal rhythms as in Jackson Pollock and Barnett Newman. When sculpture abolished the plinth, the base became coextensive with the floor or ground. In minimalism, the base even became identical with form (as in the sanded floor pieces of David Hall, or the spread and piled felt sculptures of Robert Morris).

Museums and public art galleries are places where the variations of exhibition are played out. Since the eighteenth century, museums have taken individual artworks from their original site, or ensemble, and put them into new contexts. They have been condemned for doing so by the dispossessed or those who speak for them, but the complaint is often short-sighted: to make private or cultic art into art that anyone can see is not elitist. At the same time, however, it gets harder for the individual or grouped work of art to assert and control its range of meaning for the spectator. Whether subsumed under a rubric, attached to a concept or logo, flattened out by explanations on the wall or pushed together so that, for example, Richard Long confronts a painting by Monet (as in the 'Landscape Art' gallery at Tate Modern when it opened), or when the sculptures of Antonio Canova hook up with Kiki Smith (as in Thierry de Duve's exhibition *Look! 100 Years of Contemporary Art* at the Palais des Beaux-Arts, Brussels, 2002), the individual work fights to keep its integrity.

By contrast, the pioneering galleries of early modernism, often run by artists themselves in the name of self-propelled groups like the Futurists, Dadaists or Constructivists, made space for experiment of a different kind. El Lissitzky's

Proun installations and Vladimir Tatlin's corner reliefs of the 1920s brought into play unexploited and decentred aspects of the gallery space. The 1942 Surrealist exhibition in New York festooned the gallery with string so that it was near impossible to see the works on the walls. Jackson Pollock artfully banked rows of his small paintings between larger ones, multiplying the relations between them, for the Betty Parsons Gallery in 1951. In *This Is Tomorrow* (at the ICA, London, in 1956) pop art and the new brutalism appeared alongside Robby the Robot from the film *Forbidden Planet*.

Suitably trimmed or tamed, these artist-led interventions have long been imitated in the age of curator power, but rarely surpassed. When they have been equalled, however, the media frames have often broken down, and screen projection interrupts the established sight lines of paintings on the wall and sculptures on the floor. Impelled by a mixture of Constructivist art and Soviet propaganda, the 1971 *Art in Revolution* show transformed the Hayward Gallery, in London, into a multidimensional space-frame. On a massive scale, and in the same era, *Paris-Berlin 1900-1933* (Centre Pompidou, Paris, 1978) and *Paris-Moscow* (Centre Pompidou, Paris, 1979) similarly included film and photography by artists. In the exhibition itself, work on screen or large panels was included among many other media, to question the boundaries of art disciplines. More recently, exhibitions of kinetic art and sonic art (the *Force Fields* and *Sonic Boom* exhibitions at the Hayward Gallery, London, in 2000) have also dealt with a mixture of media that resist the white walls, finding new ways to display the arts of light and sound in movement.

This is a quite different trend from the over-theorized musings of the New Museologists, whose dead hand is revealed in the explanatory texts on the walls and the solemnities preserved in vitrines, art's own pickle-jars. These tactics may be intended to distance the viewer from the work on show, to cut the art off from its sensuous appeal to eye and body. In reality, art of the last fifty years or more is quite able to perform that trick on its own, in a strategy of engagement through displacement (as in Warhol's paintings, for example). The last thing it needs is a form of exhibition that redoubles the alienation effect along with the entry ticket, when the price of entry to alienation is often enough in the art itself. This is why neat rows of Duchamp ready-made duplicates sit so uneasily in exhibitions of conceptual art; they got there first.

Every artist or group mentioned so far has had a connection to film or photography. But film as a gallery art form, or even as an art form at all, has had a curious history, all the more so now that it has become a group member of the expanded field of time-based arts in the digital age. The diversity of media in artists' time-based work poses serious problems for exhibition. The first generation or two of experimental or artist-filmmakers, from the 1920s to the 1940s (from Viking Eggeling to Mary Ellen Bute, for example) shared the same 35 mm film technology as the industrial cinema. Their films were shown in artist-led film

societies and art-house cinemas across Europe and the United States, and in a few venturesome museums such as MOMA (by an English modernist film curator, Iris Barry). The 16 mm film projection was growing for schools and smaller clubs, but 16 mm avant-garde filmmaking, which was cheaper and more flexible, only became standard from the 1940s, as in Maya Deren's campaign for her Cinema 16 distribution group, which showed work that was generated, as well as screened, in that format.

check CINEMA 16

From then on, only a few artists with classy connections, like Kenneth Anger and William Burroughs, worked in 35 mm, with the important exception of the Film Form Workshop in Łódź, a dissident 1970s offshoot of the Polish National Film School that included Wojciech Bruszewski, Zbigniew Rybczyński and Józef Robakowski. At the other end of the scale, artists who work in 8 mm 'home movie' film formats have included Jeff Keen and Stan Brakhage in the 1960s through to Tacita Dean, who has made 8 mm films (transferred to 16 mm), and other contemporary makers devoted to the medium.

35mm

8mm home movie

An interesting experiment in curating was seen in _Experiments in Moving Image_ exhibition organized at the 'old Lumière cinema', part of the University of Westminster (now the Regent Street Cinema) in London 2004. The films and videos in this exhibition were shown as far as possible in their original formats and in roughly chronological order. The exhibiting artists came from many different traditions, from the structural to the personal, and from single-screen filmmaking to live performance. Surprisingly, the private galleries and public museums that are now regular venues for screen and installation art know little of it. It may be that the work calls for more attentive viewing than the white cube permits. Much of it is also 'materialist' in that it acknowledges and questions its medium, and is critical rather than celebratory of its complex heritage in the moving image.

check

Gallery projection art today identifies the culture of the moving image with mass cinema and television. Reviewing installation artists, Hal Foster notes that some 'treat entire TV shows and Hollywood films as found footage' while others 'adopt a model of collaboration or experiment closer to the laboratory or the design firm than the studio'.[1] The artist as designer was also evoked, back in 1969, by Peter Wollen in his book _Signs and Meaning in the Cinema_. Like the modernists, Constructivists and minimalists who opposed the myth of the creative artist by turning to objective graphs and systems, so too the cinema author-director constructs meaning by synthesizing a film's diverse sources in the script, lighting, camerawork, acting and music.

The utopian image of the artist as director or designer sits well with much current art, characterized by Paris curator Nicolas Bourriaud as the period of 'post-production', to pun on filmic editing and the manipulation of sound and image, and on the role of art in the information age.[2] For some, the mainstream cinema is referenced directly as in Mark Lewis's installations based on films by Orson Welles and Michael Powell, or the anonymous Hollywood 'extra', Matthias

CURRENT PERIOD OF "POST PRODUC- TION" ART

Müller's edited highlights of Hollywood melodramas or Candice Brietz's citations from TV soaps and her *Soliloquy Trilogy* (2000), which reduces blockbuster films to the stars' speaking parts only. Several artists have also taken to film directing. In Pierre Huyghe's *The Third Memory* (2000) a remake of scenes from the Sidney Lumet film *Dog Day Afternoon* (1975), Al Pacino is replaced by the real bank robber who provided the original story, while in Stuart Croft's film projection *Hit* (2003) a barroom conversation between two actors is said to evoke Lynch and Tarantino rather than the 'shaky hand-held camera and blank backdrops' of 'moribund' video art (as one of the reviews put it).[3]

In disavowing its own history in the film and video avant-gardes, current video installation recycles the Hollywood film myth. This perhaps is the heart of the difference between the majority of film and video artists discussed here, and 'cinema for the gallery' in which the language of mainstream film and TV is more a datum than a problem. To establish film as an independent art form that could stand direct comparison with painting, sculpture and music was a major goal of the last century, from abstract animation in the 1920s down to the underground cinema. When the post-Second World War advent of 16 mm film put the means of film production into many more hands, it led to pioneering distribution groups run by artists themselves, as in the case of Cinema 16. Later, in the 1960s, workshop-based film cooperatives gave artists direct control over the costly and time-consuming process of filmmaking, and challenged the hegemony and ideology of the industrial cinema.

Video offered a cheap alternative as a recording medium in the 1970s. Its limited options for editing favoured the long-take documentary and sculptural aesthetic of Bruce Nauman, Vito Acconci and Dan Graham, who tellingly remain paradigms for contemporary video installation. By the 1980s, the video edit suite introduced montage techniques to video art and then, via TV adverts and prop promos, into the wider culture. In the 1990s, digital software incorporated classic techniques of the avant-gardes, but stripped them of their semantic contexts, so that 'scratch', 'split-screen' and 'negative' float free among other special effects. When combined with editing systems based on the codes of mainstream cinema, they gave rise to a new hybrid the high profile digital film. The result is a vast expansion of cinema-like spectacle in art, by artists such as Pipilotti Rist and Matthew Barney. Some have reacted to this by returning to the simpler spirit of 'documentation' in the earlier videos of Nauman, although he himself has more recently made high-tech multi-screen installations.

Installation art goes back to the light-play experiments of the Futurists and the Bauhaus, including Oskar Fischinger's five-screen films (two overlapping the other three) with live percussion from 1926. Later in the 1950s and 1960s came the environmental multi-projections of Stan VanDerBeek and Jordan Belson, the era of Gene Youngblood's enthusiastic 'expanded cinema'.[4] In the 1970s artists took to projected film or video monitors in the gallery, but with a conceptual rather

than lyrical turn, or sometimes an aggressive rather than contemplative stance. This would describe much of the work screened by long-term activists Birgit and Wilhelm Hein at the *X-Screen* retrospective of film installations and actions from the 1960s and 1970s (at MUMOK, Museum Moderner Kunst Foundation Ludwig, Vienna, December 2003–February 2004).

While much current art is rooted in this polygamous cinema of projection, the paths of filmmakers or videomakers and gallery artists have diverged since the 1970s. Some artists asserted – and still do – the specific attributes of time-based media, but the main impact of the period was to dissolve the boundaries and categories of all media. At its margins, screen art today blends into the new forms of digital and interactive environmental art that have emerged in galleries and on the internet. In some respects, the idea of the work of art encompassing spatial and performative concerns evolving from the Futurists, for example, should have changed the way we perceive the museum and the public gallery. But as industrial cinema itself also turned to digital production and editing, a degree of shape-shifting has occurred which leaves the present-day scene in some disarray. Earlier film avant-gardes and video artists were bent on transforming or opposing industrial cinema and television, or making up a lyric, personal, abstract or formal alternative. Today, techniques and technologies have fused, while domestic-scale viewing and making brings cinema closer to home. In different ways, a disapproving Clement Greenberg and an optimistic Michael Snow foresaw these trends in the 1960s, as of course did new media theorist Marshall McLuhan.[5]

Much of this has done no good to artists' film and video, since it strengthens a perception shared by curators and gallery-goers that experimental audiovisual art is automatically a kind of cinema – primarily experienced as an attraction or entertainment – and should therefore provoke the same response in the viewer as a mainstream movie. At the same time, the curator has to disavow the complex histories of cinema to preserve the special conditions and functions of the viewing of 'art' and the status of the gallery. Divided between these different expectations, many gallery film artists have responded with cinematically coded and hyper-emotive work that plays to the same sense of spectacle as its distorting mirror – the mainstream cinema itself.

While Bill Viola has gradually become the worst-case scenario in this saga, turning sentimentality into kitsch, there are few major figures untouched by the appeal of the cinema at its most manipulative and exploitative. Douglas Gordon, Peter Greenaway, Stan Douglas, Isaac Julien and even Bruce Nauman have made expanded screen works that replay the sounds, codes, words and gestures of commodity culture cinema and TV, to effectively validate the lure and control of the global image-bank. On the single-screen front, Matthew Barney's *Cremaster Cycle* (1994–2002) exemplifies this hyperbolic trend.

Critics and curators who still maintain (as most seem to do) that film in the gallery began in the 1990s are necessarily on wobbly ground as they skate over the

long history of multi-screen and expanded cinema in the artists' domain. Surveying the Turner Prize in 2003, art critic Jonathan Jones said that 'the most radical new idea has been the video and film installation as a genre in itself, independent of cinema while seeming to fill the absence of an alternative culture of the moving image'.[6] The independence is moot, but the alternative culture is less absent than ignored. Boosted by the light-show culture of the underground and the multiple-screen projections of Warhol, a newly stripped-down expanded cinema flourished throughout the 1970s. Examples from the UK include the spartan lucidity of *Line Describing a Cone* (1973) by Anthony McCall, Lis Rhodes's *Light Music* (1975), Chris Welsby's *Shore Line II* (1979), live-action projection events by Tony Sinden, Malcolm Le Grice and Annabel Nicolson, and a host of two- and three-screen films by Gill Eatherley, William Raban, David Crosswaite and many more at the London Film-Makers' Co-operative.

The big screen itself is not necessarily cinematic in the mainstream sense of spectacle and drama. Between David Hall's TV and gallery 'interventions' of the 1970s and the New Gallerists of the 1990s came a cluster of video works with origins in structural film, political art and new media technologies. Enlightened producers, some galvanized by the efforts of Anna Ridley, Jane Rigby, David Curtis and John Wyver, commissioned new work for TV or showed the classic avant-gardes at length in programmes such as *Ghosts in the Machine*, *Glasgow Interventions*, *The Late Show* and *Midnight Underground*. Major exhibitions outside the London orbit, notably inspired by Eddie Berg in Liverpool, featured a new kind of video sculpture such as the 'video walls' of Stephen Partridge, Steve Littman and others. Direct and frontal, they contrast to the imposing banks of monitors in Hall's *A Situation Envisaged: The Rite* (1989), where the screens are turned away from the viewer and pour their flickering colourful light onto the walls. Installations by Judith Goddard, Cate Elwes, Chris Meigh-Andrews and Kate Meynell similarly explored new venues for technological art: videos were shown in disused buildings and temporary galleries, as well as forests and other open spaces.

An ambitious and fiercely urbanized 1990s generation largely fled the Co-op and video art axis, even when the White Cube and the Lux Centre faced each other in Hoxton Square (for a brief time until the Lux lost out to rising costs and inflated hopes). The natural home for Steve McQueen, Tacita Dean and Jane and Louise Wilson was the conventional gallery, darkened off. But while they took over the viewing space, and ably controlled the viewing conditions for their work, they also took with them the naive assumption that the viewer was a free-floating agent in a transparent medium. The emotive appeal of their expanded cinema is coded by the norms of cinema that put identification before investigation; meaning is locked into the image, and the viewer opens it up. The primacy of the shot as reality-index is the underlying assumption, but the process of construction in editing is a kind of secondary dreamwork that makes the image mysterious again.

The romantic quest suggested by this art sits well in the idealized spaces of the contemporary gallery, which feeds a cycle of public consumption and private ownership. The fantasy factories of the gallery system have little space for the kinds of materialist cinema that challenge fantasy itself as a mode for art. The peekaboo culture of installation art, which leaves the viewer free to glance at projected work without engagement or focus, *en passant*, permits a walk-through attitude to time-based art. Not surprisingly, artists such as Catharine Yass, Dryden Goodwin and others have tended to specialize in images of the floating world, literally so with cameras hanging from balloons, turning in lighthouses, sliding down office blocks and lift-shafts or flying over institutional spaces. This uncanny personification of unanchored vision is also a metaphor. Similarly, the critical reception of the film/video installation lacks anchorage in a critical history.

Artists' responses to these developments behind gallery walls and in abstract cyberspace have been just as various. In the early 2000s, artist-led screenings by Karen Mirza, Lucy Reynolds and Peter Todd at venues in London including the 291 Gallery (Hackney) and the Gasworks Gallery (Vauxhall) and many other venues turned galleries back into cinemas, reinventing the improvised aura of the Arts Lab and the Co-op. Sometimes the process is reversed, and the cinema becomes an installation space, as in the 'Train Films' screening event programmed by Guy Sherwin at the Royal College of Art in 2001, or Steve McQueen's films when shown in the defunct, cavernous space of what was the Lumière Cinema on St. Martin's Lane (in 2002). But film and video art for the screen or gallery has a specific role and context, and artists will seek new ways to assert a context for their work as more cultural options open up and as media technologies and venues expand. Some films are for galleries, some for darkened rooms; the technology of projection does not determine meaning. Some time-based artists cross from one exhibition space to another, composing for different kinds of performance on the single screen, in the gallery or for television. Notable examples are Malcolm Le Grice, Tina Keane, William Raban, Jayne Parker, Nicky Hamlyn, Judith Goddard, David Larcher, David Hall and Lis Rhodes, among many others. For each of these artists, the space for viewing follows the statement made by the work, not the other way round, even when this is the easier route for the cinematized gallery.

[handwritten marginalia: browse function of projected work, of installation art]

[handwritten marginalia: check these venues as spaces of consum-ption]

[handwritten note: the technology of projection does not determine meaning]

TIME FRAMES

Film today articulates all problems of modern form-giving.[1]

(WALTER BENJAMIN)

Writing about Russian cinema in 1927, Benjamin looked for the 'fissures' in the new forms of art that emerge from technological revolutions, the break points which also revealed the hidden political tendencies in art.[2] 'One of the most violent fissures in artistic formations is film', he says. 'With film there truly arises *a new region of consciousness*'. This comes from the cinema's ability to depict 'the immediate environment', when familiar everyday scenes are exploded, transformed or made strange by 'the dynamite of tenths of a second', to create 'adventurous journeys among the ruins' of this 'old world of incarceration'. Not just 'the continuous changing of the image but the sudden switch of perspectives' achieves this result. These metaphors of 'prismatic' or fractured vision that both underpin and undermine the reality effect in cinema can be read just as urgently in the unexplored and 'fissured' landscape of new media technologies.

George Kubler, another German exile of Benjamin's generation, shared the idea that the real or actual in representation is grounded in gaps and transitions rather than in continuity or flow. Widely read in English long before Benjamin was translated, Kubler's *The Shape of Time* is a non-synchronic account of art history as a series of jagged and recurrent strata.[3] The geological metaphor is also Benjamin's: 'Just as the deeper layers of a stone come to light only at the site of a fissure so does the deeper formation, the "tendency", appear to the eye only in the fissures of art history (and artworks).'[4] Kubler was read by Robert Smithson, an artist much preoccupied with art as geology and as ruin, and one of the few in his group of minimalist artists who was an enthusiast for all forms of cinema, including the underground, Hollywood and the horror film.[5] The minimalists were the 'literalists' attacked by Michael Fried for asserting duration and thereby diminishing the role of 'presentness' in art.[6] Forty years on from Smithson's sudden and early death,

art historian Mieke Bal redefines the problem to locate the actual as presence in a series of quasi-cinematic gaps or intervals:

> Actuality is the most intense moment of presentness which, by definition, passes unnoticed. In Kubler's poetical account: 'Actuality is when the lighthouse is dark between flashes: it is the instant between the ticks of the watch: it is a void interval slipping forever through time: the rupture between past and future: the gap at the poles of the revolving magnetic field, infinitesimally small but ultimately real. It is the interchronic pause when nothing is happening. It is the void between events.'[7]

The lighthouse, one of the paradigms in Kubler's 'poetical account', is figured in early modernism, from Virginia Woolf's novel *To the Lighthouse* (1927) to the film *Industrial Britain* (1931) by Robert Flaherty and John Grierson, where the manufacture of the lamp in a glassworks is a surrogate for the 'film that is bringing these pictures to you', in the words of the voice-over commentary. Less self-referentially, it is André Breton's beacon of revelation in his essay on the enigmatic art of Marcel Duchamp, 'The Lighthouse of the Bride'.[8]

Kubler's other images – the ticking watch, the time interval, the magnetic field – stand in Surrealist painting and writing for the magical transformation of time and space. Cast differently, they recur in the scientific-materialist manifestos of Dziga Vertov, for whom the 'interval' was only a 'void' in that it united fragments of actual, but separated, motion. In cinema, the ticking watch and intervallic time are associated with the mechanized passage of the film frame or the shot, and hence a recognition that cinema's continuity is always underpinned by an alternating or intermittent current of pictograms that appear to viewers as a 'flow' or stream.

Another way of looking at the audiovisual image asserts exactly the sense of stability that is undermined by Benjamin's sense of 'disruptive' cinema. For Thierry de Duve a 'video (or cinema-, or photo-) camera is an instrument that automatically reproduces the kind of verisimilitude that we have come to expect from images since the invention of one point perspective in the Quattrocento'.[9] This succinct if all-inclusive summary can stand for many others that almost 'automatically' connect the realism of the camera-eye with the Renaissance invention of the lens that gives the illusion of depth. The touchstone for de Duve is Alberti's demonstration of architectural perspective using projection and a mirror. But the notion that the camera automatically underwrites the 'verisimilitude' of film and video also installs realism as their goal. How does this square with modernist and contemporary contexts, where the Renaissance ideal has otherwise long been abandoned as a model for painting and the graphic arts?

Joan Copjec introduces such a note of doubt in discussing Jonathan Crary's influential notion, in his book *Techniques of the Observer*, that film technology is not directly traceable to the master model of Renaissance vision, and is indeed

APPEARANCE
FLOW & STREAM IS result of mechanisation of film frame & shot

Alberti demonstrates architectural perspective ⟱

Fast Forward & Charades "film" & Secret Cinema

more fragmented and participatory. She states: 'Crary supposes that the truth of Renaissance perspective is provided by the classical, or Euclidean geometry which informed the construction of the camera obscura ... Renaissance perspective was not based, however, on the classical geometry of the camera obscura, but on projective geometry.'[10] Citing a 1636 treatise on perspective by Girard Desargues, Copjec continues: 'Plainly, and contrary to what Crary and film theory have argued, this method operates without referring to any point outside the picture plane; it does not depend on the eye of some supposed external observer, placed at a measurable distance from it. Instead, the field is organised around an internal point, the point of infinity.'

If Crary is mistaken in equating Euclidean geometry with Renaissance perspective, he is not alone, and certainly the two meet and mix with other models in a computer environment (as in the wireframe models used in computer-generated imagery) where the moving perspectival image becomes a factor. The computer offers a more fluid and interactive media environment than narrative cinema, and several critics have noted that it reinvents or recycles earlier technologies of the pre-cinema period, which Crary himself investigates.

From another angle, the projective geometry associated with the Renaissance also prompts certain questions about the representation of space. The architectural theorist Anthony Vidler, in his aptly named book *Warped Space*, investigates a short essay on geometry by Pascal ('De l'esprit géométrique', written in 1658) which discusses the 'void' in geometry, the equivalent, perhaps, of Kubler's temporal concept of 'the void between events'.[11] According to Hubert Damisch, whom Vidler quotes, Pascal reaches the conclusion of his essay by way of the observation that if 'a space can be infinitely extended ... it can be infinitely reduced'.[12] Pascal illustrates this paradox with the example of a ship that draws near to the vanishing point but never reaches it, which corresponds with the 'theorem of Desargues' (Copjec's source for her account of Renaissance perspective) in which a basic postulate of projective geometry is that infinity could be inscribed within the finite and contained 'within a point'. For Vidler: 'Whether or not the meeting of parallel lines at infinity would be geometrically verifiable, the "obscurity" as Descartes called it, remained: the ship endlessly disappearing toward the horizon, the horizon point endlessly rising, the ship infinitely close to, and infinitely far from, infinity.'

The paradox illustrated here suggests an 'application' to digital space and film space, which contains the 'folds' and duplicating perspectives that made Desargues a favourite of Deleuze. Also evoked is the experimental film, from Hans Richter's expanding squares in *Rhythm 21* through to the rotating and Zeno-esque spaces of digital filmmakers such as sue k. in her work *steps-89 (2003)*. In contrast to narrative cinema, these examples bring to the fore the apparatus and the processes that created the work, as directly constructed animation. And to this extent they are the reverse side of 'The Apparatus' theorized by Jean-Louis Baudry as the invisible motor of film realism.[13]

check "sue k."

REALISMS

can we (viewers) see film both as projected image AND a surface for that projection? — Q/

Theories of realism often refer to a model of perspective in which the spectator is imagined to be at the apex of an invisible cone in front of the image. But what does that viewer experience? An illusion of unmediated reality, caused by the concealment of the film technology, as Baudry proposed? Or is no illusion involved, since the viewer is aware that the film is an artifice? These questions follow from Richard Allen's essay 'Representations, Illusion, and the Cinema' which also takes in Noël Burch's claim that film's naturalism and narrativity ('the diegetic effect') stems from movement of the camera or movement in the frame, which are both signs of the cinematic presence.[1]

In contrast, Allen himself proposes that the illusion of presence in film is based on a denial that the image is an *image* of something. He illustrates this with regard to Richard Wollheim's notion of 'seeing-as and seeing-in', addressing the figure-ground relation to reveal *how* the image is represented, as well as *what* it depicts. Wollheim, whose concern was painting, suggested that the representational image and its material surface can both be experienced equally well, but not simultaneously.[2] The question that arises with regard to cinema is whether the viewer is ever able to see the film both as a projected image and as a surface for that projection. This is perhaps an impossible task in mainstream cinema, but it is often a hallmark of the experimental film. For this reason, most theorists exempt the avant-garde from the projective illusion, listing its 'non-naturalistic' codes and devices from zip-pans to out-of-focus shots, all of which deter identification. Brakhage's *Mothlight* (1963), collaged from real moth-wings and flowers, is a kind of limit case since it abandons photography altogether. Most of its viewers will be aware that they are watching the direct traces of actual objects imprinted on film.

The avant-garde imaginary, in this and many other cases, is not experienced as mediated through the eyes of another character. In the 'normative' film, where this mediation is part of that norm, Allen proposes two kinds of spectator identification. The first is identification with the camera (as in the theories of Christian Metz) so that the spectator seems to 'inhabit the world of projective

illusion through an empathetic identification with one or more characters in the fiction'.[3] This is accordingly named 'character-centred' projective illusion. In the second kind, identification with the camera leads viewers 'to inhabit the world of projective illusion by emotionally responding to the events we see as if we were witnessing them in person'. Allen calls this 'spectator-centred' projective illusion.

Michael O'Pray also offers a Wollheimian view, to different effect, in his 'non-illusionist' account of film viewing: 'In perceiving a film we see in its two-dimensional surface of light and shadow three-dimensional figures while being aware of the fact that it is a flat film surface. In other words, illusionism is not part of the film experience'.[4] In this account, the film image is a depiction – it doesn't aim to deceive or to trick, but to represent. By contrast, Garrett Stewart's study of the freeze-frame in cinema (in *Between Film and Screen*) accepts that the film in motion is an illusion which the still image punctures and arrests. The freeze-frame is 'a device that stretches the diegesis so thin as to breach its illusion, revealing below its surface the specular unconscious of all photogrammatically received images, the ground beneath all screen figuration'.[5] O'Pray deals with the reverse of this exposure of a concealed 'ground beneath all screen figuration', but like Richard Allen (and Richard Wollheim before him) he refers to the 'ground' of an image. For O'Pray, the ground is the 'bedrock' of a 'psychological-perceptual capacity' or the 'natural commonsensicality' of the resemblance view of representation in which 'pictorial representations involve perceptual recognitional capacities':

> Some of the aspects of a picture of *x* which make it a picture of *x* are the same as the aspects we recognize in seeing an *x*. This view has some of the merits of transparency, i.e. its bolstering of a form of realism in pictorial representation and especially film without its philosophical counterintuitivity that in seeing a representation of *x* we are somehow seeing *x*, which associates transparency too closely with illusionism itself.[6]

For Wollheim, an implied viewer is central to painting. In a chapter on Caspar David Friedrich, Edouard Manet and Frans Hals, in *Painting as an Art*, Wollheim discusses what he calls 'the spectator in the picture', an internal spectator who contrasts with the external spectator who views the paintings.[7] This internal spectator in a painting is not to be identified with a figure in the painting, who might be looking on at the scene. More often it corresponds with the artist's point of view. The internal spectator is part of what Wollheim calls 'centrally imagining', in which an event is imagined from the viewpoint of someone else, in order to experience the images as if one were that person. This might be a highly mobile spectator, as in Manet's paintings, without a particular viewpoint or trapped in irrational or indefinite spaces. But for O'Pray this very optical process may also cause the viewer to 'lose sight' of the 'painting's marked surface, the other condition of the two-foldedness required for "seeing-in" according to Wollheim'.[8]

In painting the whole work is present to the spectator ≠ in cinema the surface is less easy to distinguish from the image

In O'Pray's summary: 'The illusion argument for pictorial representation is met by the prerequisite that in seeing *x* in *y*, we are always aware that *x* is a painted flat surface. If the latter is removed, then illusionism of a kind reigns.'

In painting, of course, the whole work is present to the spectator, real and implied, allowing this kind of shift from surface to pictorial content. In cinema, the surface is less easy to distinguish from the image. For Garrett Stewart, this is because the frame-by-frame construction of the image is necessarily concealed in representational cinema. But Stewart finds moments in the narrative cinema when the frame 'breaks through' to the surface. This can occur in two ways: the first is the 'surrogate' frame in the form of photographs cited within the shot – Ridley Scott's *Blade Runner* (1982) as well as the French New Wave provide some notable examples – which recall the photo-frame on which cinema is based. The second is the freeze-frame, in which the suppressed photogram rises to the surface of the image, although of course by the same system of persistent and intermittent motion that determines more ordinary shots. Based in part on the frame-based experimental film, which Stewart acknowledges, it is a theory in which the limits of film literally seem to explode the frame as well as activate it. In this context he cites Jacques Derrida's influential account of the frame in painting (the 'parergon') to connect the borders of the screened image with its invisible source as a sequence of frames:

[Derrida's] 'parergon' or frame in painting is less an external verge than an internal margin, one of his signal points of sheer difference. ... We might say that the screen border – the cinematic parergon – becomes an internal supplement to the image field as well as marking its exclusions. ... It is as if magnification explodes the printed surface (this sense of 'frame') into the expanded boundaries of its own projected field of view.[9]

'Field of view' meets 'point of view' in the analysis of such emblematic films as Rossellini's *Journey to Italy* (1953), a film that begins with a frontal shot from behind the 'framed' windscreen of a moving car. Michael O'Pray's account – like the analysis by Laura Mulvey – focuses on the 'museum sequences' in which the protagonist visits and is 'carried away' by sweeping shots over classical statues (Figure 32). In his reading of these scenes O'Pray adapts Wollheim's notion of the 'implied spectator':

A fascinating aspect of the sculpture museum sequence is that we are not presented with Katherine's (Ingrid Bergman) point of view. ... We share Katherine's view with another spectator who is not occupied but with whose repertoire we are familiar. This is a pre-echo of Antonioni's embodiment in his camerawork of an on-looking 'stranger' accompanying the characters themselves, a sense of dislocation, of separateness, of isolation.[10]

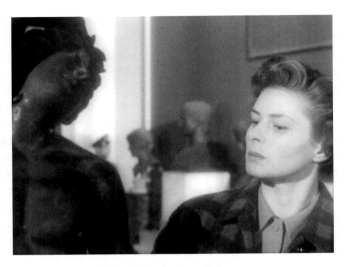

FIGURE 32 *Journey to Italy* (1953) Roberto Rossellini.

Rossellini's technique of showing Katherine and the objects of her look in the same shot, moving in small swivels or pans, makes us witnesses of her perplexed state and not identical with it. ... Similarly, Katherine's mental turmoil is 'objective'. It is not to be assimilated to any psychologism. ... The film depicts surfaces, not psychological 'depths'.[11]

Just as Wollheim's implied spectator stands for the artist, so O'Pray's implied spectator is identified with the director. In this case, the film is grounded in biographical fact, the much-publicized divorce that brought Rossellini and Bergman together. The film is one of several markers laid down between Bergman and her former Hollywood career, as she moved into the economically marginal European art cinema with Rossellini.

Sean Cubitt contrasts the neo-realist aspiration with the new Hollywood artifice of our own times, especially in the high-style and hi-tech science-fiction fantasy film. Their visual effects assert 'the triumph of self-proclaiming illusion over the ethical claims of realist and total cinema'.[12] In turn this has 'repercussions on the nature of the illusion itself'. In foregrounding 'the techniques of illusion while propagating a fictive diegesis [in which] the first effect of the effects work is that of making the illusion obvious ... the surfaces are themselves foregrounded effects, they become signifiers of illusion rather than illusory'. 'Illusory effects' and 'foregrounded signifiers of illusion' are the hallmark of electronic imaging, as Cubitt acknowledges in cutting to Vivian Sobchack's distinction between film and digital:

Sobchack's task [in her essay 'The Scene of the Screen'] is to define the cinematic over against the electronic image, and her tactic is to emphasize the

analogical nature of the filmic image, its transmission as whole frames (rather than atomized pixels), its wholeness. In the phenomenological tradition, she emphasizes the relation between film, perception and the lived body of human experience. What distinguishes cinematic from unmediated perception for her is the machine ensemble that shifts us from point of view to situated, synthesized experience. Film theory frequently takes for granted that point-of-view shots are points of identification, in which the camera, by taking the position of a protagonist, can offer us the chance of seeing with their own eyes. Sobchack's point, or part of it, is that we never see with any other than our own eyes save when we see through the eyes of the cinematic apparatus itself.[13]

Discussing an earlier book by Vivian Sobchack, Garrett Stewart (who also emphasizes 'whole frames') notes her account of screens within screens in science-fiction films, and an invasion of the screen in another sense by digital morphing, each of which suppresses the single-frame basis of the medium.[14] Stewart suggests that the 'most recognizable settings of science-fiction films have always tended to cast into relief, by their own recession, the filmic origins of their cinematic manifestations'.[15] The example he provides is a scene from *Bride of Frankenstein* (1935), where a pulley in the laboratory brings the creature into contact with the animating lightning rod: 'Such is the true tool for the multiple raising of the photographic corpse – in a metanarrative not only of this one cinematic genre but of its underlying filmic track. (Recall Noël Burch on the "Frankenstein complex" of all bourgeois mimesis, including cinematic reproducibility.)'[16]

Related examples include TV monitors from Fritz Lang's *Metropolis* (1927) and its descendent, Charlie Chaplin's *Modern Times* (1936), the H. G. Wells adaptation *Things to Come* (1936) and a scene from Stanley Kubrick's *2001* (1968) that includes three blank screens situated in a briefing room, which Stewart compares to 'an outsized gallery installation in some conceptual art exhibition'.

In one of those turns of fierce minimalism that drive Kubrick's films to the near edge of avant-garde practice, the inferential absence of every movie set's invisible fourth wall, enabling the camera's access – and opening in projection upon our screen rectangle – is internalized and tripled in the briefing room's glumly luminous wall panels cut to the measure of the cinemascope ratio yet glowing only with a dull, migraine-inducing intensity.[17]

The three screens also stand in for the unexposed 70 mm filmstrip (with its *Cinerama & 70mm filmstrip* memory of Cinerama, the widescreen process that originally involved three synched projectors) and the central image of the monolith, which appears on three occasions in the film. Stewart sees this as cinema's 'enfolded negation', 'mimesis in condensed reflexion' and 'regress'.

the physical substrate of film is unknown to wider public – and how essential to surface it? **REALISMS** **79**

FIGURE 33 *L'Eclisse* (1962) Michelangelo Antonioni.

According to Stewart, 'The inlaid screen [in these examples] is one kind of cinematic synecdoche: the rectangular part standing in (via whatever differentiations) for the enclosing whole. But the photogram on the strip is another: the rudiment of the whole, of cinema as film, without being its replica.'[18] Both are 'part-objects' in the narrative system, with the reframed single photograph a 'point of discharge for the force of this latent relation'.

In contrast, O'Pray considers that long-held shots, as in Rossellini's *Journey to Italy* or Antonioni's films, affirm a different form of stillness, especially in the 'almost hard-edged composition of the shots where abstraction threatens'.[19] For André Bazin, the incomplete reality of a film such as *Journey to Italy* is compensated because the fragments are 'filtered' but also have 'the quality of wholeness'. According to O'Pray, such wholeness is identified with not only the character of Katherine and her mental point of view but also that of the director. This thesis is summed up with reference to Bazin, who described the film in terms of 'a mental landscape at once as objective as a straight photograph and as subjective as pure personal consciousness'.[20]

O'Pray examines the 'pure personal consciousness' seemingly also at work in the 'cut up' space that opens Antonioni's *L'Eclisse* (1962) (Figure 33). In this regard he cites Geoffrey Nowell-Smith's suggestion that it not only evokes a 'disorientating sleepless night' but also believes that it

> makes us aware of its construction, of the director establishing a space in which both the characters and the spectators have different experiences, so that our own disjointed viewpoint – encouraged by the lack of establishing shot, the refusal to show the two characters together in a shot, the mismatched eyelines

and so forth – establishes a space in the room which we occupy, a space akin to but not the same as that occupied by the characters. This space is not strictly speaking a space identified within the physical space portrayed, for that is never quite coherent or unified, but an imaginary space so to speak. The camera angles themselves … suggest a disjointed but accumulative gathering together of bits of space and bits of character perceptions. … Vittoria (Monica Vitti) is without doubt the seat of consciousness in the sequence. … But we are experiencing (her) feelings and attitudes somehow in the space about her and these feelings are conjoined with others related to this space.[21]

Although this explanation is psychologically oriented, O'Pray argues that the dispersal of viewpoint negates the psychologism of characters by countering traditional narrative space. This corresponds with Dudley Andrew's assessment of Bazin. For Andrew, Bazin's 'ideas about neo-realism seem based on a simple aesthetic or political preference' but 'actually reveal a deeper metaphysical attitude. Beneath such concepts as the limitation of perception and the integrity of space lies a belief in the signifying power of nature.'[22] In Bazin's own words: 'The representation of space … opens to a world of analogies, of metaphors or, to use Baudelaire's word in another no less poetic sense, of correspondences.'[23]

ASYMPTOTE

The 'asymptote' is one such system of correspondence. A recurrent idea in the matching and difference between an image and its referent, it is also a geometrical one, with a further association to motion in the philosophy of Zeno. The asymptote appears in its modern form in a famous essay by Heinrich von Kleist, 'On the Marionette Theatre' (1810) which has been cited by (among many others) the filmmaker Peter Gidal in his book *Understanding Beckett* (1986).[1] In Kleist's essay, the asymptote describes the gracefulness of a marionette's movement, which relies on the puppeteer's control of his puppet's centre of gravity and the arc of its pendulum-like actions.[2] The term is also employed by André Bazin in his account of realism, to which this chapter will return.

A recent inventive use of the asymptote occurs in Sean Cubitt's book *The Cinema Effect* (2004). Again, the starting point is literary, but with a cinematic twist. The philosopher de Selby, of Flann O'Brien's comic novel *The Third Policeman* (written in 1939–40 but not published until 1966), looks at 'some old cinematographic films' frame by frame and finds them 'tedious' and with a 'strong repetitive element'. He has 'examined them patiently picture by picture and imagined that they would be screened in the same way, failing at that time to grasp the principle of the cinematograph'. Cubitt comments that 'de Selby's film theory builds on the ancient paradox of Zeno':

> Zeno hit on the concept of the infinitesimal, the ever-diminishing approach towards zero that, however, never reaches it: the concept of the infinitely small. ... In Zeno's example, the gap between Achilles and the tortoise reduces from 1 to 0.5, to 0.25, to 0.125, to 0.0625, and carries on reducing, always adding more decimal places, towards a zero that it never reaches. When plotted on a graph, this gives an asymptote, a curve that plunges towards zero but gradually flattens out, never quite appearing at the origin. This asymptotic curve is not composed of points and distance between them.[3]

Tracking back, the example of Achilles and the tortoise recalls Pascal's paradox, described earlier, of the ship that draws near the vanishing point while never reaching it. In Cubitt, the 'asymptote' is elaborated through the notion of the fluid vector of the graphic line and thus links it to the freedom of imagination as illustrated in the magical events in one of the earliest animated films, Emil Cohl's *Fantasmagorie* (1908). Later, Cubitt mentions Bazin's use of the term 'asymptote', which comes at the end of his short essay on the neo-realist film *Umberto D* (Vittorio De Sica, 1952).[4] Bazin's biographer, Dudley Andrew, sees this in light of his response to German Expressionist cinema, of which he did not approve, considering it 'nothing more than opinion, a personal rearrangement of the world to suit the film-maker's view of things'.[5]

> While cinema is not exactly the same as objective reality, Bazin felt, it was certainly beyond being simply one more view (or opinion) of reality. It lies somewhere between perspective and objectivity, and Bazin felt it helpful to think of it as 'asymptote', the line in geometry that progressively approaches a curve and meets it only at infinity. Film-makers who deny that cinema attains its power by reason of its special relation to reality, a relation no other art medium has, are more concerned with their views than with the discoveries of experience.

When Cubitt takes up Bazin's asymptote, it is in a discussion of realism, which he says runs two risks:

> On one side lies the sublimity of a universal vision that can take us out of meaning and therefore out of that history which it is realism's mission to bring us into. This is the moment captured in Bazin's citation from Mallarmé's sonnet on Edgar Allen Poe: realism is 'concerned to make cinema the asymptote of reality – but in order that it should ultimately be life itself that becomes spectacle, in order that life in this perfect mirror be poetry, be the self into which film finally changes it'. On the other side lies the peril of conventionalism: the realisation that 'realism in art can only be achieved in one way – through artifice', a 'necessary illusion', but one that 'quickly induces a loss of awareness of the reality itself, which becomes identified in the mind of the spectator with its cinematographic expression'.[6]

This is a quite different idea, which cannot be explained in terms of the flow and transformation that Cubitt attaches to the animated line in Emile Cohl's film nor does it correspond with the way Bazin saw realism. The differences are too great. Cubitt's theory of realism is subtended by Heideggerian and Lacanian notions of death as limit, to narrative as well as subject, here described in asymptotic terms again (with regards the vanishing point): 'Dying brings the world to heel … the

point at which all thought, all signification, stops. Because it starts from a negation of the world, realism's double negation ends where it should begin, in equilibrium, committed to the perfect present of Being, which, however, is always at the point of vanishing.[7]

Bazin's notion of death in cinema, by contrast, is more redemptive than melancholic. In the end, Cubitt's realism reads like Bazin's conventionalism: it is a kind of cinema that is aware that 'it is a construction' (which is what Dudley Andrew took to be 'the *Screen* line' – when writing his biography of Bazin in 1973 – that went 'against the grain' of the new film theory). Cubitt's central thesis is that 'cinema is neither debarred from acknowledging and critiquing the world nor bound to the choice between negation and escapism. On the contrary, that reality is an effect opens up the possibility that effects can be "real".[8]

A very 'real effect' is taken up by Frank P. Tomasulo in his essay "'I'll see it when I believe it": Rodney King and the Prison-House of Video'.[9] The TV footage of the police beating of King sparked riots in Los Angeles in 1992. Here too, the asymptote is enrolled to avoid the consequences of radical scepticism with regards history, which Tomasulo is inclined to accept as a premise. He succinctly summarizes a key sceptic, Hayden White, who proposed that 'history is defined as the discourse *around* events, rather than as those original events that prompted the discourse in the first place'.[10] Accordingly, there is no difference whether the world is real or imagined, from the point of view of historical sense, and there is no objective verification. A further historicist note is struck in Tomasulo's notion that the doctrine of 'no single meaning' is appropriate to the 'society of the spectacle'.

[margin annotation: 1992 LA Rodney King]

Nonetheless, the rerun video images of King's beating are evidence of something real enough, and Tomasulo investigates the basic question of whether they are raw data or already interpreted (because framed and contextualized by the camera and the courtroom respectively). He sees Bazin's response to this kind of problem as both phenomenological and religious in so far as he 'believed that film's photochemical and photographic base, its existential optical bond to the antecedent reality taking place in front of the camera lens, made the camera "an asymptote to reality", especially when the spatiotemporal continuum of reality was preserved in a single, uninterrupted long take'.

Tomasulo ends with a series of asymptotic questions. With respect to cinema's 2-D representation of a 3-D world – filtered through the lens of the camera, with the impact of scale and camera angle, and then editing – he asks: 'How close to the "reality axis" does the parabola of cinema get?' Is it objective? And if so, is it the photograph or the event that is the object? The essay concludes by defending the image of the real, but oddly by attacking Bazin (although he uses the concept of ambiguity and interpretation and an engaged subject, like Bazin), perhaps because he wants to save the concept of evidence (on which Bazin is cited favourably) rather than a notion of the medium. The danger might be that this conflates facts

(even 'material facts') with 'history', which is their particular inscription. But the asymptotic curve is suggestive as a non-identical conjunction between, in this case, a brutal event and its accidental recording in real time, which is one of documentary cinema's great tenets. The point, perhaps, is to save the reality of 'appearances' from relativizing scepticism.

Saving appearances may be the only common factor in various authors' uses of the asymptote. Cubitt uses it to explain the freedom of the animated image as it curves away from the reality it imitates. Bazin, more classically, sees the asymptote as a figure aligned with realism, such that the line of the camera almost meets the curve of reality. For Tomasulo, the asymptote indicates the partial but forceful encounter between an event and its depiction. In all three cases, the geometrical figure of the asymptote is more than a metaphor: it aims to be a description. Strictly speaking these examples are incommensurate. Cubitt's graphic-animation effect, freed of reality, seems a quite different affair from Bazin's defence of 'creative documentary' or neo-realism, even in Cubitt's own summary of Bazin. Each evokes an uncertainty principle, one visual and the other ethical, but at different angles to each other. Both versions appear equally distant from Tomasulo's eye for the 'raw data' of video capture, ambiguous in its crudity, laden with fact but not with value.

At the very least, even though it appears in so many and various contexts, the asymptote links together some aspirations of radical cinema, from neo-realism to animation. As an image, it is 'open'. It also conveys the idea of the partial and the unfinished in the context of cinema, suspending any final coincidence between object and screen, and similarly the notion of closure. Some of these qualities are preserved and magnified in artists' films where the asymptote figures more literally. Two examples are Anthony McCall's *Line Describing a Cone* (1973) and *Where a Straight Line Meets a Curve* (2004) by Karen Mirza and Brad Butler.

For theorists of realism, what Dudley Andrew glossed as film's 'nearly duplicating our everyday perception' is its guarantee of authenticity. Its weak spot is to identify reality with 'everyday perception', crossing a phenomenology of lived experience with the dramatic framework of cinema. It relates a seeing subject to a perceived object in a given framework of knowledge. At the same time, the asymptote's lack of final identity between the image and the referent also lends it a degree of abstraction, as Bazin saw. For the avant-garde cinema, it is this abstract non-identical gap that opens the path to a critique and questioning of realism. In this way, the same concept of the asymptote – first expressed culturally in a theory of marionettes and imitation 'at a distance' from its human source – can also be used to close the gap between them.

DIGITAL DIALECTIC

$$\frac{FILM}{\text{like painting?}}$$

Lev Manovich has been prolific in maintaining a link between the classic avant-gardes and new digital media, as well as more generally between new media and the cinema as a whole. But these supportive links are not altogether clear, and more seriously they situate the avant-garde as non-contradictory forerunners of the digital age. A concise version of Manovich's argument can be found in the essay 'What is Digital Cinema?' where he argues that the essential challenge that digital media presents to cinema concerns simulation, since cinema is based on the lens, and on 'unmodified photographic recordings of real events that took place in real physical space'.[1] Despite the use of modifiers including film stock, the quality of light or the choice of lenses, he considers film basically to be a 'record', which he considers akin to prosaic and naturalistic nineteenth-century photographs and waxworks. In contrast, the photorealism in contemporary movies that is achieved by digital manipulation to create 'something that has perfect photographic credibility, although it was never actually filmed' is traced back to hand-painted and animated nineteenth-century images, shunted into a byway of history by the film machine in the early 1900s. For Manovich, digital media are 'no longer an indexical media technology, but, rather, a sub-genre of painting'.

Here is the first example of a historical slippage that, sometimes to creative effect and new insight, has the argument both ways, since the machines of which he approves in early animation are linked to the indexical-photographic tradition. This is literally the case with Muybridge, whose photographs of running horses were redrawn and modified when they were projected on circular discs (as Manovich notes).

In *Techniques of the Observer*, Jonathan Crary makes a similar distinction between the 'optical tradition' associated with the camera obscura, which is linked to the 'plenitude' of painting, and the more fragmented vision yielded in zoetropes and other devices that give an illusion of movement. The effect is the reverse of Manovich's however, since Crary wants to show how cinema developed from this supplementary kind of animated art, and not from the 'contemplative'

photographic (and painterly) tradition. Manovich sees things the other way round, so that painting is attached to the 'fragmented' vision of animation rather than to photography, arguing that digital media have a distinct logic that 'subordinates the photographic and the cinematic to the painterly and the graphic', destroying cinema's claims to uniqueness as a media art form. A great deal depends here on whether cinema is taken to be like painting in its illusionism (although there are many kinds of illusionism in cinema) or whether painting is non-cinematic in its technique and process.

On closer inspection these distinctions do not hold firm. Early cinema, according to Manovich, was an art of motion (an illusion of dynamic reality) or projection, for a collective spectatorship. Earlier techniques for motion production were hand-painted or drawn and included magic lantern slides with moving layers, zoetropes, and Muybridge's painted versions of his photographs. The basis of these techniques, in manual movement, was then made automatic by the film machine: 'Spitting out images … all moving at the same speed, like a line of marching soldiers', an analogy that Henri Bergson also used in an early reference to cinema.[2] At the same time, the film machine also brought together space and motion, since earlier movement-imaging involved figures against an unchanging background: 'simple vectors across still fields'. This phrase could describe digital 'key frames' almost, but the reference is to more primary technologies, such as the thaumatrope, zoetrope, mutoscope and Edison's Kinetoscope, which Manovich brings together and then forces apart.

The split occurs as 'primitive' devices are relegated to animation when cinema 'cut all references to its origin in artifice'. Animation admits this, since it is patently graphic, and still uses characters against a background, with intermittent 'sparse and sampled motion' and space that is built up from several layers. Cinema, in contrast, tries 'to erase any traces of its own production process', to appear as a recording from reality. The analogy between animation and digital is clearly implied – sampling, layers and artifice are shared between them – but in other ways the same features are equally analogous to narrative cinema, even down to the characters set against a background as a staple convention of film drama. When, at the same time, Manovich himself claims that cinema is all an illusion of mattes and models, which only pretends to record reality, he perhaps senses a dilemma:

Cinema's public image stressed the aura of reality 'captured' on film, thus implying that cinema was about photographing what existed before the camera, rather than about 'creating the "never-was"' of special effects. Rear projection and blue screen photography, matte paintings and glass shots, mirrors and miniatures, push development, optical effects, and other techniques that allowed filmmakers to construct and alter the moving images, and thus could reveal that cinema was not really different from animation, were pushed to cinema's periphery by its practitioners, historians, and critics.[3]

The culprits (mostly theorists) are listed in a footnote. Now, these once hidden and marginalized devices are central in digital media. But it is hard to add up the ideas to form a whole. The charge made by Manovich is that devices associated with special effects were ignored in the interests of a direct form of realism that he claims is cinema's hallmark, but which also – as he shows here – is illusory, since it was based on the manipulation of reality by studio technologies. So the illusions he claims (positively) for the graphic-digital cinema are also the underpinning of film's illusion of reality. Can the distinction be kept up? Can it apply to a 'late-cinema' baroque style, variously looked at by Garret Stewart (*Between Film and Screen*), Sean Cubitt (*The Cinema Effect*) and David Bordwell (*Planet Hong Kong: Popular Cinema and the Art of Entertainment*)? Each of these are critics who deny that contemporary cinema effaces itself, instead claiming its assertion as spectacle.

Later, Manovich modifies his argument by explaining that cinema's 'effects' were mostly manipulations of physical reality, to be recorded by the lens, which has a dominant role. In the context of digital cinema, the post-production stage dominates or wholly merges with production. In this, it may be that he underplays pre-digital cinema's post-production as a norm, excluding the constructive role of editing in particular. The crucial 'lens-based' distinction between old and new media is here at its weakest.

The change in technologies that Manovich describes tends to efface the differences that he wants to assert. Looking at the generation of film-like scenes with 3-D animation and then at how the lost indexical link is remade by digitizing live footage, he argues that there is no difference in the computer between lens-based image, paint effect or 3-D graphics 'since they are all made from the same material: pixels', which are infinitely substitutable and alterable etc. – a state that corresponds to a 'a new kind of realism'. Cinematic and digital constructs have both now been described in the same terms, losing touch with the idea of realism, based on indexicality that was first used to distinguish them. In so far as Manovich argues that narrative film of the pre-computer age was founded on transforming the 'raw data' of the camera into the final 'product', largely through post-production, special effects and inserts, it was in this way as much a multi-medium as a medium-specific art. If the computer collapses special effects and editing, it does not follow that the 'distinction between creation and modification, so clear in film-based media … no longer applies'. In fact, the distinction has been undermined by describing aspects of the same phenomena in pre-digital cinema.

A similar conflict is seen in the notion that digital cinema is 'a particular case of animation that uses live-action footage as one of its many elements'. In this argument, animation gave birth to movies and was then marginalized, which is not the same as the earlier claim that the origin of cinema was photographic, to which animation (as a graphic art) was opposed. Animation reappears now to found the digital cinema, but again this contradicts the earlier claim regarding the long history of special effects in cinema. The circular nature of the argument

is clear when he states, in italics: '*Born from animation, cinema pushed animation to its boundary, only to become one particular case of animation in the end.*'[4] Apart from the logical problem here, cinema is wholly identified with drama, bypassing documentary and scientific films, and reflecting orthodox film histories to some degree.

EDIT THE DIGITAL IMAGE

When Manovich looks at painting, the same issues arise. Citing W. J. Mitchell on digital photography, he suggests that the tools of computer imaging for 'transforming, combining, altering and analysing images are as essential to the digital artist as brushes and pigment to a painter'.[5] The 'inherent mutability' of pixels apparently erases differences between photograph and painting, and since film is a series of photographs, Manovich extends the argument to 'digital film'. 'With an artist being able to easily manipulate digitized footage either as a whole, or frame by frame, a film in a general sense, becomes a series of paintings', which according to Manovich returns 'cinema to its nineteenth-century origins'.[6] This direction is the opposite to that of the camera's automatism. Compared too to manual tinting, similar to digital colourizing, the ultimate digital film would be 'ninety minutes of 129,600 frames completely painted by hand from scratch, but indistinguishable in appearance from live photography'.

Here, Manovich changes tack. In light of computer animation or processing, cinematic realism appears restored, even though its indexical base has been either stripped away or simulated (both are possible) in new media. Multimedia devices and image manipulation are used by cinema to 'solve technical problems while traditional cinematic language is preserved unchanged', computer effects are hidden and realism is maintained: 'Cinema refuses to give up its unique cinema effect.' The centre of gravity for the animated digital image now shifts to a new set of margins. Music videos and computer games are non-narrative and non-realist, aimed at the TV and computer screen, linking 'the 2D and the 3D, cinematography and painting, photographic realism and collage' having 'arrived at a new visual language unintentionally, while attempting to emulate traditional cinema'. Later, Manovich gives this an additional gloss, and a curious one since his aim is to formulate a new language, by saying that commercial interests are 'driven' to 'the exact duplication of cinematic realism'. So the industry is to blame apparently, rather than the process.

Manovich traces the history of the computerized film via different Apple multimedia platforms in the late 1980s and then the 1991 launch of the QuickTime movie player. Given the data rate required for moving images, early computer motion tended to be quite short in duration and could also be quite stilted, rather like the images of early cinema, he observes. The means of accommodating this shortfall were also similar, including the use of loops, which were central to pre-cinematic devices of the nineteenth century and subsequently animation and 'the avant-garde tradition of graphic cinema'. For Manovich the correspondence between modern moving-image media and the technologies associated with

nineteenth-century technologies point to a hybrid language. Indeed, the QuickTime movies of 1991 are compared to Edison's Kinetoscope of 1892, in terms of their use of loops as well as the similarly small size of their imagery, which made them fit for singular rather than collective viewing.

For Manovich, looping and other strategies of the avant-garde are 'materialized in a computer'.[7] This claim is also made in the essay 'Avant-Garde as Software', where collage is seen to be the equivalent of cut and paste commands, dynamic windows update the movable frames in El Lissitzky's exhibition designs of the mid-1920s, and montage is found in the computer's ability to link different functions and data.[8] The computer thus keeps up the 'visual atomism' of the early modernists, where visual messages are based on simple analysable elements (as in Seurat's pointillist system or Kandinsky's approach to abstraction). In contemporary terms – sidestepping history – 'atomic' pixels lead to an atomistic 3-D space (made up of polygons) and separate layers of digital moving images. Hyperlinking, the reassembly of data in different locations, or the assemblage of data from multiple sources, comprises a new form of the 'readymade'. 'The ontology of computer dataspace and the objects in this space is atomistic on every possible level.'

The invention of overlapping windows in the context of computer screens, first proposed by the American computer scientist Alan Kay in 1969, leads to 'a synthesis of two basic techniques of twentieth-century cinema: temporal montage and montage within the shot'. The examples are eclectic, spanning: the 'dream sequence' in Edwin S. Porter's *The Life of an American Fireman* (1903), the split-screen technique (dating from 1908), superimpositions in the avant-garde of the 1920s, compositional strategies in Orson Welles's *Citizen Kane* (1941), Eisenstein's *Ivan the Terrible* (1944) and Hitchcock's *Rear Window* (1954). Window interfaces bring the two modes together, but the windows of computer screen interfaces are opaque, and open one at a time, edited by the user as *monteur*, who 'synthesizes two different techniques of presenting information within a rectangular screen developed by cinema and pushed to the extreme by the filmmakers of the 1920s'. The 'clean look' of type on our computer also stems from 1920s advanced graphics and typography, while neo-formalist 'defamiliarization' techniques include interactive 3-D graphics that allow rotation or other visual representations of data to change orientation at a mouse-click. At the same time, these techniques are normalized, as if 1920s modernism is the new default. Radical vision becomes standard technology.

This challenges the accepted view that the avant-garde was stripped of its radicalism when it got to the United States in the 1930 and 1940s, to become either capitalist design or 'formalist' art. Manovich sees the avant-garde as both modernist and social, providing for a fusion of utopianist techno-societies, although the Soviets went Taylorist and the United States took over a European social avant-garde that had first been inspired by American technology. Confusingly, Manovich equates Soviet artists working for the state with artists in capitalist societies who have 'sold out', so the original avant-garde of the 1920s

whom Manovich has celebrated were not very radical, according to his own logic. Besides avant-garde strategies having been 'materialized' with digital media, Manovich also claims that they are naturalized in the post-industrial computer systems, so that depoliticized avant-garde techniques 'appear totally natural', even naturalizing 'defamiliarization' in the interests of order as in the example of music videos, which often unite constructivism and Surrealism.

In 'Cinema Redefined', a subchapter of *The Language of New Media*, Manovich explores an avenue related to painting again, but here he takes the 'concept of digital cinema as painting' in a different direction.[9] The move from analogue to digital technology is compared to the change from fresco and tempera to oils in the early Renaissance. A fresco dries fast, and has to be finished before it dries, just as a film image is thought to have limited possibilities for manipulation once it is shot. According to the analogy, medieval tempera was akin to special effects in pre-digital cinema, since it could be reworked but only slowly. In contrast, oil paints liberated artists because paintings could be made more quickly, allowing for the easier modification of large compositions, which had implications for the size of a painting as well as attendant narrative constructs. The conclusion is that by 'allowing a filmmaker to treat a film image as an oil painting, digital technology redefines what can be done with cinema'. This adds a new twist to Manovich's tale, because painting (post-Renaissance mainly) was earlier compared to digital because it bypasses photography. Now fresco painting is compared to film, and oils to digital. The links don't work, because it is never particularly clear whether he is talking about technologies, media, processes or conventions.

In this same section Manovich says that 'mediaeval and early Renaissance masters would spend up to six months on a painting only a few inches tall'. But it is not just a matter of process, let alone size, that is trivialized here. A painter might see the issue quite differently, in terms of the possibility of layering colour and form, for example, which takes time. In an interview published in the Royal Academy magazine, David Hockney says, of the portrait *Pope Innocent X* (1650) by Velázquez, that

> No photograph could ever be that real ... the way the mouth is, the eyes ... and I say a photograph couldn't be like that, because it couldn't get the layers. Now, when they [referring to Sam Taylor-Wood] did the hour-long video of David Beckham sleeping for the National Portrait Gallery, what it is is lots and lots of pictures of David Beckham, but strung out in one single line, and it's one hour. Whereas Lucian Freud put 120 hours, layered that way into the picture he did of me. Which is why it made it an infinitely more interesting picture in my view. It's a different way of looking at the time in it.[10]

Manovich's own example of time in painting is spatial, as in the depictions of 'all-over' time in Giotto's fresco cycle at the Capella degli Scrovegni in Padua (completed

around 1305), and Courbet's *A Burial in Ornans* (1850). Another dualist tripwire in his categorization of time in pictures is his contrast of *extensive* time (depicted on the total surface) and *intensive* time (contained within its layers). The terms are relative, of course, and call to mind two senses of time discussed by Michael Fried in his book *Menzel's Realism*.[11] For Fried the distinction is between everyday time, or 'time in its extension', and the intensive and dramatized time represented in an artwork (in any medium); the everyday in a strict sense being unrepresentable in its living duration. In Manovich, the terms are rendered spatial, so that extension is the layering of time-slices, themselves intensive. The cumulative effect is made from instants, not durations.

Like Manovich, Yvonne Spielmann, in her essay 'Expanding Film into Digital Media', sees cinema as merging or converging with new media in a shift, rather than a break.[12] She suggests that the 'aesthetic strategies' of film are carried over into 'non-cinematic' media and the hypermedia of digital arts. But she also stresses the distinctiveness of the different kinds of representation in this process. Analogue film and video register 'light rays on an image surface' whereas the digital image is defined in terms of its being calculated. This observation can be refined though, because the digital signal still involves scanning and the fragmentation of light. Spielmann's main concern is that the video signal consists of a layering of lines (or 'fields'). Unlike film, video does not comprise separate images, but a continuous flow. The digital or 'numeric' image (as distinct from the video signal) is not thought of as directional at all, because there is no 'incrustation' of time.

In contrast to the sequence of frames in film, which is linear, for Spielmann the scan in video implies density: continuity in time becomes 'the density of layered frames'. In this light, video is conceived as an intermediate between film time and digital simulation, which is described in terms of simultaneity, density and spatiality. Correspondingly, she refers to the 'digital space' explored in advance by Woody and Steina Vasulka. 'Both the simultaneity of layers and the reworking of the interval can be regarded as crucial categories in the computer-based convergence of media.'[13] Art forms meet in new media patterns, preserving some of their specific origins 'when specific devices (such as the interval) are used in similar ways in different media but expressed differently, so that the shape of the image changes, the different function of the device may reveal a difference in the media form.'[14]

The key contrast is between the film interval and the electronic media 'cluster', with video as an intermediate between 'the registration and simulation image types'. 'The apparatus and the inherent function of *the interval as the gap between shots* prestructure the gradual organization of images to form the principle of succession and temporal organization essentially, but not exclusively, associated with moving images of the type of film.'[15]

The simulation of film in digital media 'effaces the gap', though it survives as a representation, and in this capacity 'the temporal function of the interval is

transferred into a spatial category where the differences between single images are represented simultaneously through the use of (multiple) layers'. Joachim Paech and Raymond Bellour, whom Spielmann cites, call these instances 'entre-images'.[16] While the film interval mediates 'the spatial gap separating adjacent images' and merges their difference in projection to produce (an illusion) of movement, gaps as such are eliminated in electronics, since the cathode tube and digital encoding 'do not transmit images'. The 'new shape of the image' that transforms the 'image between the images' – meaning the interval presumably – into a 'spatial density' is called the 'cluster'.

This is a difficult logic to follow and not without its problems. In video scanning, for example (particularly the telecine of a film print), film frames are converted to fields but only because fields are structured so as to register them in continuous motion. The paused frame of a film copied onto video is not the same as the still frame in the film itself. This slippage in the material aspect of the reproduction of film on video (or vice versa) has led to experiments to emphasize that loss and difference. One example is Michael Snow's *See You Later Au Revoir* (1990), which involves a simple action shot on a high-speed video camera, transferred to film. It is also difficult to be sure where material functions (such as the interval) end, and representations (images) begin, in this account: a distinction that experimental films and videos themselves often blur.

The cluster, compared by Spielmann to the merging of single musical tones into a group, as in the compositions of Henry Cowell, is a means of layering or processing to make images, not intervals. As such they are not just produced by the technological processes associated with electronic media, but also appear in pre-digital form in painting, collage, optical printing, split-screen effects and mattes. However, the focus for Spielmann is to do with processes in video and digital media, in contrast to film: 'Although the density of the cluster represents in visual form the non-directional features of an image that nonetheless relies on registration, with digital imaging it takes on the function of representing what is effaced, since … the numeric (i.e. digital) image lacks directional features and, in contrast to video, the simulation image does not represent.'[17]

The argument that digital media contain or transfer mechanisms and processes derived from older media is perhaps a circular one, as well as implying that digital is basically neutral. What is striking though is that the interval reappears, even if repressed.

FIELDS IN BRAQUE
AND GEHR

There is also some evidence … that this peripheral system is a means of locating and relating individual features, a medium of spatial mapping over the field of a visual array.

(MICHAEL BAXANDALL ON GEORGES BRAQUE'S
VIOLIN AND PITCHER)

Gehr stakes out a little piece of the world, a stretch of corridor, a bit of street, the view from a window, and treats it as a field where, even as things are what they are, his consciousness and his craft can take effect and make a difference.

(GILBERTO PEREZ ON ERNIE GEHR'S
SERENE VELOCITY)

In the essay, 'Fixation and Distraction', Michael Baxandall begins with the illusionistic nail that appears prominently near the top of Georges Braque's *Violin and Pitcher* (1910) (Figure 34).[1] This nail is one of a series of 'real world' allusions in the picture that 'trigger[s] the beholder's consciousness into supplying from memory', the objects (mandolin, pitcher, piano) that the picture transforms and fragments. This semiotic interpretation began with D. H. Kahnweiler in 1916, possibly based on talks with Picasso and Braque, and continues down to Yves-Alain Bois in 1992, who calls it 'a device that both denies and constitutes the surface of the canvas in an indefinite struggle between illusion and anti-illusion'.[2]

Guided by scientific studies of the early stages of the viewing process, Baxandall looks at how the nail works when it is seen, intermittently, in viewing the picture. Other objects in the fragmented cubist surface appear with greater and lesser

FIGURE 34 *Violin and Pitcher* (1910) George Braque. Oil on canvas, 116.8 × 73.2 cm. Courtesy of the Kunstmuseum, Basel. © ADAGP, Paris and DACS, London 2019.

clarity, such as the piano, the wall moulding and the violin, but the nail stands apart from these. In fact, it draws attention away from them, since it is placed alone at the top of the painting, where it asserts the furthest plane of the canvas as well as intimating its function as a nail that attaches the painting to the wall.

Art theory has a long-established distinction between two types of looking, or 'dual-vision', that explains the kind of fluctuating attention that the nail attracts. The first kind is a centred viewing eye, which gets less acute from fovea to periphery as the fine colour-sensitive cones grade off into coarser wider-range rods. The second is a restless viewing eye, which moves to new attractions and new centres of acuity. This scanning eye is not necessarily more attentive, since we can attend to peripheral sight at will.

Scientists think that there are distinct but interacting modes of attention, and that central foveal vision works with 'cognitive demands for information about objects'. But a quicker and lower-level system of peripheral vision also operates, 'free of control by any higher-level search for enlightenment' which may be 'a

means of locating and relating individual features, a medium of spatial mapping over the field of a visual array'.[3] According to Baxandall, this kind of dual-vision can help to explain how nail, violin, pitcher and other forms in the 'visual array' might alternately keep, lose and engage one's attention in the process of viewing the painting. Painting's static equivalent to real-world motion is taken to be the system of shapes, sizes and markings on the canvas, which stimulate different responses in the eye depending on their place, intensity and scale in the picture.

The result is a mixed mode of seeing. Centred focal acuity, when looking at a painting, is determined by the receptor and processor cells in the retina, which filter the information, but coarsen from centre to periphery. Even so, both finer and coarser information is combined in the central zone. A too fine registration would make it impossible to distinguish, say, cracks in the painting from other kinds of discontinuities between plane and surface. A too coarse vision would be unable to distinguish sharp and soft edges where the light changes. Different modes of 'machine vision' are modelled on this same mixture of fine and coarse data, using filters, not just to emulate human sight but also the 'probabilistic discrimination between shadow edges and object edges', the kind of problem faced in computer animation and 3-D effects.

The scientist Julian Hochberg, quoted in Baxandall, has said that foveal centring and peripheral registration are both important for painting, citing the colour patches at the edge of Rembrandt portraits as 'distractors' that add an 'intermittently generalizing take' to centred, focused scrutiny. Similarly, divisionist Impressionist painting alternates between 'sharp takes on brush-strokes' and 'generalized takes on scenes'. This last point – the perception of 'scenes' rather than marks – leads Baxandall to apply the idea to more 'cognitive' questions, beyond the strictly scientific. He begins by observing that the viewer cannot 'foveate', that is take a central fix, on both the nail and other objects at the same time. Surrounding objects, such as the violin, will retreat to the periphery. But if the eye is fixed on the nail, and attends at the same time to the parafoveal areas nearby, items like the pitcher are recognizable and distinct. The violin too, although further away, even seems more present in peripheral vision. Here, an evoked mental image of violins – a useful filler in peripheral vision – is supplemented by emphatic features like scroll and strings, and by strongly defined sides and facets.

Baxandall claims two properties will help shapes to survive in peripheral vision. Firstly, 'closed forms such as polygons of moderate complexity' are better recognized than open forms like bars, graphs or charts. Secondly, solid tone or silhouette survives better than outlined forms, by contrast to central foveal vision, which is better suited to outlines. (Polygons and blocks also form the basis of Lev Manovich's account of the language of digital media.) But when centre and periphery collaborate to locate a visual fix and assess its acuity and forms, is this process, asks Baxandall, instantaneous or accumulative? To find out, we can look at typical 'scanpaths', which vary from person to person and are determined by

features of the object being looked at, and at 'short-term visual memory', sometimes known as the 'visual-spatial scratch pad' in analogy with computers.

Visual memory can be shorter, as in 'the complete persistence of a retinal image for a fraction of a second', or longer, as in images or memories that have been consciously ordered. The visual scratch-pad comes into effect at roughly ten to twenty seconds. It does not represent three dimensions or objects, but is 'the site of construction of an egocentric sketch of our spatial ambience, the figure and extension and distance and angle of slope of the planes in view'.[4] Objects like walls and pianos, turned at angles and part-shielded by other things, are constructed in full from this data. In 'the computational account of vision' it corresponds to a '$2^{1/2}$ dimensional sketch'.

The crux of Baxandall's argument applies these experimental studies to the contrasting sides of Braque's painting. On the right flank Baxandall finds 'a petering-out of the field of action, and an acknowledgement of continuity beyond the frame', but also such strong shapes as a clearly modelled dado wall, a floor and a fragmented piano. On the lower left side is a more 'persistently difficult' and 'maze-like structure', a series of shaded planes. 'The invitation to use this imagery for actual construction of form seems to have been withdrawn.'[5] Equivocal bands 'zig-zagging unstably down' remain ambiguous, to both imply and resist reversibility. Unlike the objects that retain their form in peripheral vision, such as the violin, the left-hand side maze barely registers at the periphery, 'except as a tangle'. Here he observes that the viewer is trapped between the perception of two and three dimensions with respect to forms that refer but do not cohere. The analysis of the painting concludes with the suggestion that 'the innumerable quantity of perceptions within the picture's frame' are exercised but left 'incompletely integrated or resolved'. Interpreting the painting, at least in 'some moods', he sees its 'narrative theme' as 'the intrinsically moral one of the complexity and excitement of seeking true knowledge' reminding us that the painting's 'fabric' and its 'performance is visual representation of visual knowledge, and that is a sign not transparent through to some paraphraseable semantic object somehow inside. The fabric is, precisely, scopic.'[6]

Ernie Gehr's *Serene Velocity* (1970) is shot with a fixed camera on a tripod, with a zoom lens focused on an institutional corridor (Figure 35). Gilberto Perez describes it thus:

> The velocity comes from the lens itself, the eye of the beholder. It is a zoom lens and every quarter of a second, Gehr switches the focal length between two settings, back and forth, altering our perception of distance in rapid alternation, so that the corridor seems to shake.[7]

The shaking increases as the focal lengths are set further apart, so that 'the walls and floor and ceiling seem to slide back and forth along well-oiled tracks provided

FIGURE 35 *Serene Velocity* (1970) Ernie Gehr.

by the lines of perspective converging at the centre of the picture'.[8] The illusion, which is revealed as such, is nonetheless very powerful in its affect, 'to the point of dizziness and even nausea', for Perez, who also senses a latent expressionism in the film associated with the bleak corridor ('a familiar epitome of dehumanization') and the push–pull effect as a sign of violence. But this, he argues, is also undercut by the film's 'cool geometry', making us aware of the surface of the screen and the pattern of lines and movement being projected on it, aware that we are not inside the space of that corridor but outside it, watching the play of light on the screen'.[9] This account of geometry 'in cinematic suspension from reality' is a plausible equivalent to Baxandall's conclusion about Braque's painting, as is the language of visual space and optics.

The quarter-second shift in the focal length of the camera's lens, which produces a juddering effect in *Serene Velocity* also recalls the 'tremors, drifts, flicks and saccades' that Baxandall describes in the mobile hierarchy of scanning eye movements.[10] The slowest and largest of these responses to new stimuli, the saccades, occur at an average rate of 3 to 5 per second, or faster. The quarter-second shifts in focus in *Serene Velocity* of course occur in film time only (since

the changing of focal lengths between frames at different rates of shooting would necessarily have taken longer to adjust) and saccadic jumps occur in ordinary everyday vision, but in watching *Serene Velocity* they are provoked to multiply and activate an ostensibly still image, the framing of which continually changes. Like several other films, it cannot be adequately illustrated by a single frame, in which it looks like a static emblem. Only the sequence of frames brings out the abrupt motion.

At the conclusion of the film, the double doors at the end of the corridor are brought closer and intermittently, every other quarter of a second, they are pushed farther away. The door thus appears to approach and recede at the same time, but there are several doorways and thresholds in the film. Through a first set of glass doors halfway down the corridor, the opaque doors at the back are revealed as having glass windows that get brighter as the sun rises. The dark space at the farthest reach of the shot, unrecognized in 'this enclosed space of artificial light' was 'the darkness of night outside'. The space depicted replicates the inner duration of film and echoes the space of the 'movie theatre'. Nature eventually shines through, dimly and recessively.

In his account of the film, Perez brings out a contrast between centre and periphery that recalls Baxandall's account of Braque:

As Gehr himself has observed, five movies are going on at once in *Serene Velocity*:

we can watch the fluorescent lights and red exit signs on the ceiling, or watch the reflections on the floor, or watch either of the two walls and the new objects – doors, water fountains, hanging ashtrays – coming into view from the sides as the focal length changes (coming into view only to be abruptly yanked back and come in again at the same moment), or we can focus on the center, the sets of double doors halfway down the corridor and all the way at the far end. The center is where the perspective lines lead our eyes and where the most interesting thing would normally have been placed, but, as Gehr says, here the center is the least interesting part of the picture. Our eyes are encouraged to look at the periphery, at the four margins where fascinating patterns of movement are taking shape, encouraged to roam over the picture and choose what to look at and where to go next.[11]

CLASSIC FILM THEORY AND THE SPECTATOR

The art historian Erwin Panofsky's 1936 essay 'On Movies', later revised as 'Style and Medium in the Motion Pictures' contains his famous observation that cinema uniquely involves the 'dynamization of space and, accordingly, spatialization of time'.[1] The spectator is immobile in this dynamic process, and Panofsky's description applies as vividly to someone playing a video game at a console as it does to a viewer in front of a cinema screen:

> Aesthetically, he is in permanent motion as his eye identifies itself with the lens of the camera, which permanently shifts in distance and direction. And as moveable as the spectator is, as moveable is, for the same reason, the space presented to him. Not only bodies move in space, but space itself does, approaching, receding, turning, dissolving and recrystallizing as it appears through the controlled locomotion and focusing of the camera and through the cutting and editing of various shots – not to mention such special effects as visions, transformations, disappearances, slow motion and fast-motion shots, reversals and trick films. This opens up a world of possibilities of which the stage can never dream.[2]

For Panofsky, film is a new mode of vision in which space is constructed in and through time. Thomas Y. Levin's analysis of this essay mentions that 'cinematic photograms' are 'based qua photographs on the optics that gave rise to perspectival space', but Panofsky himself does not explicitly discuss perspective, even though his earlier influential essay – 'Perspective as Symbolic Form' (1927) – had indeed linked single-point perspective with 'the new representational technologies' such that photography reinforces our habit of seeing in linear perspective. But in 1936 the model is representational painting, where the flat surface is 'repressed' or denied in favour of an 'imaginary, projected space'. This is carried over into the popular cinema, in which, according to Panofsky, 'the medium of the movies

is physical reality as such'.[3] Panofsky's attention to painting was unique at this time. For Siegfried Kracauer, the focus of film was in the documentation of the everyday; for the Surrealists and Walter Benjamin, it was the 'optical unconscious' and the yet-unseen; for Béla Balázs, it was the 'physiognomy' of the surface or face of things and for André Bazin, it was the viewer's scanning of deep space. Some of these diverse integers were prefigured in an early essay by Georg Lukács ('Thoughts towards an Aesthetic of the Cinema', 1913), where he proposes a 'fantastic realism' derived from the two aspects of cinema: its combination of photorealism and the cut.[4]

For Panofsky, the photographic image is a matter of its iconographic content. It is objective and mechanical, free of what Kracauer thought of as subjective 'frames of reference' and the showing of 'visible complexes for their own sake'. The medium is directly linked to its content. In effect, it was an argument against abstract art, a reversal of Panofsky's earlier interest in El Lissitzky (as expressed in a note to 'Perspective as Symbolic Form')[5]. Accordingly, it is the content, or signified, that is materialist in film not the signifier or technical apparatus. But this all depends on how content is specified. For some the basis of cinema in photography is objective; for others it is phantasmagoric or illusionistic. Not included in Panofsky's account of cinema is the lesson deduced by later filmmakers who emerged from the abstract movement in painting, notably Malcolm Le Grice and from a different direction Peter Gidal, who argue that materiality includes the physical substrate of film as well as its lens-based representation.[6]

In *The Language of New Media* Lev Manovich sees Panofsky's earlier distinction between 'aggregate' Greek space and 'systematic' Renaissance space as reflecting different aspects of digital media: Cartesian coordinates are built into computer graphics, as in Panofsky's paradigmatic grid; but in 3-D polygonal modelling, the patterns are more haptic and aggregate, and hence represent a vacuum with added objects, not space as an entity.[7] Manovich contrasts this with the modernist space of Constructivist art as well as the art of Georges Seurat, Alberto Giacometti and Willem de Kooning, the kind of abstract art that Panofsky (in 1936) wanted to disassociate from cinema, and in which there is no distant object or empty space. For Manovich these artists 'depicted a dense field that occasionally hardens into something that we can read as an object'.

According to Manovich, this space-medium is not yet central to the computer graphics 'mainstream', where the focus currently deals with superimposing elements over a separate background that includes reflections, shadows and other interactions:

Although 3D computer-generated virtual worlds are usually rendered in linear perspective, they are really collections of separate objects, unrelated to each other. In view of this, the common argument that 3D computer simulation returns us to Renaissance perspective and therefore, from the viewpoint of twentieth-century

abstraction, should be considered regressive, turns out to be ungrounded. If we are to apply the evolutionary paradigm of Panofsky to the history of virtual computer space, we must conclude that it has not yet reached its Renaissance stage. It is still at the level of ancient Greece, which could not conceive of space as a totality … The ontology of virtual space as defined by software itself is fundamentally aggregate, a set of objects without a unifying point of view.[8]

Panofsky's realism of the shot, although set in dynamic motion to construct a new experience of space, is in oblique contrast to his contemporary Rudolf Arnheim. Arnheim's film criticism drew on gestalt psychology (developed in Germany between 1910 and 1920), which was exactly concerned with Manovich's 'sets of objects' in a 'unifying point of view'. (Importantly, gestalt psychology also gave rise to Max Wertheimer's analysis of motion imaging theorized as waves or pulses, which is still a key reference point for contemporary theories concerning 'critical flicker fusion'.) As Ara Merjian notes, Arnheim's writings (from the 1930s through to the 1990s) have repeatedly sought to explain how the mind processes percepts or visual ideas as well as concepts, in a series of organized 'constellations' or 'networks of relations'.[9] He argued for 'visual thinking', and like Merleau-Ponty, who was also influenced by gestalt psychology, saw film as a reflection of the perceptual faculties.[10] Images thus convey ideas via a non-linguistic model of meaning, but Arnheim's account of representation is not a simple reflection theory. Art and film shatter visual wholes, and 'only partly reassemble them' for the viewer to complete.[11] The spectator's activity is required, since film suggests relationships between things, not least of all through montage.

Writing in the 1933 book *Film*, Arnheim stated that 'montage, in the real sense of the word, requires that the spectator should observe the discrepancy among the shots that are joined together; it is intended to group slices of reality in an integrated whole'.[12] This 'integrated whole', which nevertheless derives from recognizably different parts, is key. In contrast, Arnheim disapproves of interrupted continuous shots where the 'unity of action is so strong that one does not notice that montage has been employed, and, therefore, perceives the resulting phenomena as actual happenings'. A key example that he gives is that of a shot of a man walking: 'If several frames are omitted from a scene showing a man going for a walk, the impression on the spectator is that the man has suddenly with lightning rapidity been picked out of his stride and pushed onward; one does not notice that this effect is achieved merely by joining together disconnected pictures.'[13]

The 'proof' of continuity, as if to confirm that the avant-garde makes new meaning from upturning the rules of film grammar, is strikingly enacted in William Raban's *Fergus Walking* (1978), which literalizes an aspect of Arnheim's 'man going for a walk'. Since the event is clearly constructed – it is 'montage in the real sense of the word' in so far as the viewer can 'observe the discrepancy among the shots that are joined together' – Arnheim might just have approved. He wanted montage to group

'slices of reality in an integrated whole', whereas his imagined walking man 'changes the nature of one continuous action'. Unlike 'montage proper', which preserves the 'reality' of what is represented in the shot, the process of cutting within a shot can interfere to make the action appear differently, so that 'actual events are changed' and 'new realities created'. In this respect, Arnheim is enthusiastic about various 'tricks' in cinema, citing examples in Charlie Chaplin's films and the appearance of the magic wand at the end of René Clair's *Entr'acte* (1924) which makes people 'vanish' as well as a time-lapse sequence in the film *Market in Berlin* (1929) by Wilfried Basse, which shows market stalls magically assembling at high speed. This 'imperceptible montage' (in the sense used here) need not be 'supernatural': 'It is conceivable that the sudden turning of a person's head, a movement of flight, or something of the same sort, might be more impressively shown by cutting a few frames out of the strip and thus achieving a jerk within the movement'.[14]

This 'cutting a few frames out of the strip' presents a cusp. One way leads to enhanced naturalism: the kind of cutting on action that produces a seamless transition, or in some cases a more emphatic effect. Another route leads to a mode of specificity explored by the avant-garde, where the motor of action is revealed rather than hidden. Arnheim doesn't promote either model particularly, despite his invitation to the drama film to exploit cinematographic tricks.

Oddly, Arnheim nudges closer to avant-garde cinema in the next section of *Film*, entitled 'Artistic use of the Absence of Nonvisual Sense Experiences'. In everyday life we perceive our location in space by way of movement, standing and balance. In cinema, however, unless we are shown otherwise, the view provided by the camera is assumed to be static and forward-looking. Motion is primarily perceived as an image of a moving object, rather than an image of the camera in motion over a static object. In connection with this idea, Arnheim provides an elaborate example from the Russian film, *The Shanghai Document* (1928, directed by Yakov Bliokh), which involves a racecourse sequence (with the camera tracking the racehorses) intercut with the shot of a flag, which has a racing horse on it that appears to move (Figure 36). Arnheim calls this 'the illusion of an illusion; for

FIGURE 36 *The Shanghai Document* (1928) Yakov Bliokh.

the illusion of standstill which comes of the camera pursuing an actually moving object at the same pace is imitated by a cleverly taken object that is actually at rest'.[15] Arnheim's view that we cannot 'realize the correct space coordinates purely from the appearance of a picture' is, coincidentally, the actual subject of William Raban's *Fergus Walking*.

The second film in the three-part *Autumn Scenes*, sue k. comments that the premise of *Fergus Walking* 'is that a film can begin with its ending and conclude with its beginning'.[16] The film shows Fergus Early walking down a London street, shot from a car travelling at the same speed alongside him (Figure 37). There are buildings in the background, with Fergus in the middle ground, and the frame of the car window in the foreground.

FIGURE 37 *Fergus Walking* (1978) William Raban (Sequential shots, left to right).

The window shows where the filmmaker is situated, as a second implied figure within the film. The foreground implies a peripheral area beyond the screen edge, heightened by the car's motion that seems to shift the frame as the car and camera try to match Fergus's pace and keep him centred, so that the figure-ground relationships are all in conflict, from walker to frame to window.

The film alters the apparent direction of travel within the frame to create conflicts between figure and ground, seen in the movement of the boarded windows and doors of the background buildings. Both the buildings and Fergus appear to travel from left to right within the frame, even though the direction of the background implies that the figure is travelling in the opposite direction of right to left. This plays with the classic notion, expressed by Arnheim, that film motion is determined by the direction of travel by a subject in the frame. A subject moving from left to right might be in motion, or the camera might be travelling past them in the opposite direction of right to left. In a tracking shot, a moving object that is the focus of the image will appear in the same spot in the frame, while the background imagery passes through it. In that regard, as sue k. notes, the background is usually instrumental in determining the path of direction of a moving object. Not in *Fergus Walking* however, because Raban's metrical system of editing opens up an anomaly between figure and background: the 'paths of travel of the foreground and figure are at odds with each other' and 'what seems to occur is a forward walking motion which concludes at a point that is geographically situated in the opposite direction'.

sue k. describes a similar effect in her own video *karenintheround014* (2002) (Figure 38):

> Captured at the edge of the frame is the walking figure of Karen Mirza. The movement of the figure is set against the background of a building dotted with vent holes and signs. The direction of the vents and signs through the frame establishes the figure's direction in the initial sequence of the work. This however changes when the editing process implemented for the work weaves oppositional images, (one direction is incorporated with its mirror version). Both figures of Karen are situated facing inwards at either edge of the frame, with each background traveling in reference to its respective figure. As a result of weaving the two it becomes impossible to extract the defining ground which would inform the direction of either.

In contrast to Panofsky's 'dynamization of space', Rudolf Arnheim proposed, in his essay 'Painting and Film' (1934), that film was 'not so much the creation of the image in space as the creation of a series of dramatic events that develops over time'.[17] This sentiment might be seen as a critique of the abstract filmmaker Walter Ruttmann, whom Arnheim calls a 'rare example' of a painter turned filmmaker. Nevertheless, some still-image principles are admitted for film:

FIGURE 38 Frame sequence from *karenintheround014* (2002) sue k.

For instance, every good film shot groups the objects in the image into simple mathematical figures, eye-catching lines organize and unify the many visible objects, the spaces are balanced according to size, form, and light etc. ... these well composed shots appear one after the other as accents in short intervals, and are connected by passages of movement, or strung together by cuts.[18]

The 'well-composed shot' may sound conventional, but less so is the sense of modernist fragmentation it affirms: the 'intervals ... connected by passages of

movement', which share the language, but not the meaning, of the Soviet montage directors. The meaning is different because Arnheim emphasizes intervals not as gaps but as links. For Arnheim these 'accents in short intervals' are akin to musical vectors more than factors of the filmstrip. He invokes musical terms rather than those of the static arts as a means to identify the composition of movement in film: 'crescendi and decrescendi, staccati and legati, chromatic progressions and jumps in intervals'.

Omitting mention of Viking Eggeling, who based his films on musical models and the example of modern painters like André Derain and Wassily Kandinsky, Arnheim connects painting to film by way of 'contoured space' and set design. But the set had to be realistic for Arnheim, because of film's realism, which the artificial setting of the expressionist cinema was at odds with: 'Perhaps this has to do with the fact that natural reproduction of material is so essential to film, and that it forms one of its means of expression'. According to Arnheim, a painted set or object in a film had to make the viewer believe they were seeing that place or thing itself, not just a recognizable copy: a dragon in *Die Nibelungen* (Fritz Lang, 1924), for example, must carry conviction – a point which brings the issue close to that of the role of special effects. The argument is different, however, in the context of the animated film, which is wholly drawn and overtly so. In this regard, he envisages colour animation (which already existed when he wrote this in 1934) that could 'expand the means of painting into an art of time and motion'. Here, Ruttmann could have been let back in.

Arnheim, as Ara Merjian shows, has been labelled ahistorical, absolutist and reductivist by a diverse list of writers, from Jacques Aumont and E. H. Gombrich to Hans Jonas, Noël Carroll and Sol Worth.[19] Perhaps paradoxically, these universalist claims are in part realized by the 'globalized' cinema and the rise of new media cinema, based on a computer language of primary forms not unlike the gestalt model. In other ways, Arnheim's 'visual thinking' is a far cry from cinema's dominant convention of verisimilitude. In 'A Personal Note', the prologue to *Film as Art*, he states that 'artistic and scientific descriptions of reality are cast in moulds that derive not so much from the subject matter itself as from the properties of the medium – or *Material* – employed'.[20]

This is why cinema is a form of partial illusionism – a flat plane crossed by figures severed from their surroundings – and hence only partly mimetic. This anti-representational point is crucial to Arnheim's non-realism and relates to his suggestion that the modern art of Klee, Kandinsky and Mondrian is film's starting point, and not Renaissance perspective (although he is not always consistent on this). Arnheim avers that film always distorts, that it inherits skewed perspectives from photography and thus its power over the supposed subject. In a later essay about Maya Deren, he affirms again that film straddles three dimensionality and flatness, as in Plato's cave (and digital media, according to Manovich).[21] For Arnheim, film evokes strangeness as a form of indirect representation in an alien

material. Despite his strictures on non-dramatic and interruptive montage, he also affirms disruption as a means to sharpen perception and go beyond mechanical reproduction.

As Merjian notes, many of Arnheim's observations about film and its projection onto a planar screen, truncated from its source and restricted by its margins, are close to Michael Fried's account of 'delimitation' in modernist painting (though Fried objects to 'film as art' on the grounds of its lack of presence). This sense of the enclosed frame separates Arnheim from realists such as Kracauer and Bazin, who see reality implied outside the frame. (For Bazin the frame of a painting is 'centripetal', whereas the screen is 'centrifugal'.)[22] His theory of viewing is insistently bodily, with the nervous system as basic receptor and nexus of visual expression in cinema. Like Fried (in the 1960s) Arnheim was suspicious of the commingling of the arts, an issue that was raised by his generation in a series of essays named after Gotthold Ephraim Lessing's famous use of the classical sculpture, *Laocoön and His Sons* (in *Laocoön: An Essay on the Limits of Painting and Poetry*, 1767) to show the limits of the major art forms. These were Arnheim's own essay 'A New Laocoön: Artistic Composites and the Talking Film' (1938), Clement Greenberg's 'Towards a Newer Laocoön' (1940) and Eisenstein's 'Laocoön' (1938).

More widely, a commingling of the arts in relation to 2-D and 3-D characteristics also features in Mark Anderson's observation of Kafka's 'curious flattening of character' which 'marks the distance between them and the psychological realism of nineteenth-century novels'.

> Kafka's characters emerge in vivid, sharp detail – often present like photographic likenesses as they execute some striking gesture – but only as partial, flat surfaces without the depth of a past history or individual psychology. … A particular realistic anatomical detail … is isolated against a two-dimensional … surface.
>
> Kafka's characters are temporally flat – cut out of a historical continuum and presented to us as isolated, tantalizingly vivid, but finally opaque objects of representation.[23]

This is the same form-world invoked by Arnheim, when he defines in film 'the broken chains of time, space and causality; the fragmentation of episodes; the elusive settings, the openness and emptiness obtained by omission'.[24] But not all fragmentation is valid for Arnheim. As Merjian notes, the paintings of Seurat and Jackson Pollock, as well as Robert Smithson's Land Art, are all criticized in Arnheim's later writing, because they articulate an entropic haze, which can't yield a good gestalt of complexity against order, but instead assert undifferentiated wholes, perceptually and artistically.[25] At its centre, Arnheim's theory of montage is based on the relations of parts leading to wholes within a conflict system that is still organic. The viewer perceives the gap between images – or shots – but it is

quite different to the gap or interval that Walter Benjamin refers to, which evokes a harsher materialism associated with shocks and clashes.

Perhaps surprisingly, given Arnheim's resistance to postmodern art, Merjian's conclusion to his study of Arnheimian theory turns to contemporary art. 'Installation seems to be the site where art and film most frequently converge these days', he says, optimistically citing a Robert Storr review to show that the 'average viewer' can easily respond to it and thus suggesting that in art 'the stakes of accessibility and intelligibility have changed'. According to Merjian, 'establishing the paradigms of new artistic media ... within an all-pervasive visual culture has become an increasingly difficult task' because new media, advertising and the technology of entertainment dominate.[26] While Arnheim is praiseworthy for attacking commodity culture, it seems the collapse of high modernism changes the stakes. In this light the conjunction of 'Film Art' with gallery art and installation is intriguing, but it also evades the problems that Merjian evokes. The first of these is the chances of survival for an experimental film practice, and the avant-garde aspiration, which is largely bypassed by gallery installations that favour themed spectacle. The second is the all-too-present survival of cinematic illusionism in the commodity culture.

Unlike Benjamin and Arnheim, who believed in visual ideas, Georg Lukács, in a last (and rare) interview concerning cinema in 1968, insisted that film remained '*incapable* of expressing the serious material characteristic of drama and literature due to the primacy of its visual component'.[27] In response to a question from Yvette Biró, about the fast speed of modern films reflecting a faster tempo in daily perception, Lukács's response was: 'An intellectual problem cannot be expressed by a picture.' In 1913, during the silent era, he saw the pictorial limitations of film more positively, but it was still not able to deal with the world of ideas because it lacked speech. (It seems that speech did not in the end provide the missing ingredient.) Lukács was not even necessarily convinced of the possibility of a specifically '*cinematic* language'. At the same time, when referring to a series of drawings and engravings by William Hogarth (a favourite, incidentally, of Humphrey Jennings) Lukács did warn against reading them as a cinematic sequence, since in film 'every image is in principle the continuation of the preceding one and the preparation of the one that follows; its entire meaning resides in these connections'.[28]

A further disagreement between Lukács and Benjamin concerns the question of 'aura'. In the chapter 'Film' from *The Specificity of the Aesthetic*, published in 1963, Lukács claims that film destroys the old aura, but creates a new one. In another respect too, film is a doubling, not in an anthropomorphic sense, but rather as a 'double mimesis', combining photo-indexicality with the organization of narrative structure. Levin comments on this doubling (quoting Lukács) to explain that 'the means specific to the cinema function to *restore* an impression of "normal vision", employing various devices to approximate the "forms of appearance of daily life"'.[29]

At the same time, film is a 'faithful record' that is the sum of indexical units. For Lukács, 'film is a visually exact report about a piece of reality, a construction – a montage – of such precisely reproduced fragments of reality', and 'it is purely and only the restructuring of the individual photographs and their sequence which can prevent film from remaining caught at the level of daily-life perception and can raise it to artistic heights'.[30] Despite this address to the nature of film as a sequence of single frames, Lukács rejected the shock effect in film as disruptive, and hence manipulative. He thought that Benjamin fetishized montage and that Balázs fetishized technology. Lukács's film theory was then a kind of realism that corresponds with that of Bazin and Kracauer, though not necessarily with their redemptive belief.

FIELD AND GESTALT

Language is fine for describing diachronic/sequential events/logic, but cannot account for the integrative/holistic experience of 'field processes', namely the synchronic experience of works of art, and more specifically, visual perception.[1]

(RUDOLF ARNHEIM)

The relation of Pollock's authentic drip paintings to gravity in the field of the real is different of course from the way the pictorial image – from within its virtual field – can come to visualize our own upright bodies and their relation to gravitational force. For gestalt psychology all vertical fields will – like a kind of mirror – already be structured according to the body's own organisation, with a top and a bottom, and a left and a right. The field, they say, is anisotropic. The internal differentiation lying in potentia in the very background within which the gestalt will appear already attests, then, to the features the brain will project onto the perceptual field in order to organize the gestalt: its simplicity, its hierarchy, its balanced dynamism. The gestalt will thus be, in a sense, a projective image of our own bodies' resistance to, their triumph over, the gravitational field.[2]

(ROSALIND KRAUSS)

There are five fields in Krauss here: the real, the virtual, the vertical, the perceptual, the gravitational and, following on from those, the visual. Krauss's contention is that Pollock's paintings are so far from 'this mirrored projection of the viewer's body, they had become anathema to the gestalt psychologists, the very thing they loved to hate'. As Krauss notes, Rudolf Arnheim saw only endless monotony, 'a

kind of molecular milling everywhere', an art of 'background trivia' or noise, which we don't actually see.[3] Although the retina registers this noise, there is no psychological existence attributed to it. According to Anton Ehrenzweig, whom Krauss calls a disciple of Arnheim, this kind of background noise is repressed, a form of primal sight that is 'gestalt-free, chaotic, undifferentiated, vague, superimposed'.[4] It is oneiric, projecting 'sexual imagery uniformly onto all parts of the visual field' before meeting 'the stern resistance of the superego of *form*'. To give it form, psychologically, is like the secondary revision in dream work, a means of providing narrative shape to uncontrolled fantasy, just as free brushwork is made over into the 'form control' of the 'surface gestalt'. Identifying with Ehrenzweig's analysis of primal sight as 'depth vision' Krauss nevertheless goes on to criticize his and other latter day gestalt readings of Pollock, which project patterns onto the drip paintings. At the same time, her own descriptions of Pollock's paintings seem to imply that the gestaltists were right.

In the context of cinema, the gestalt most often corresponds with an image. Editing the notes of Humphrey Jennings, Charles Madge commented on Jennings's use of 'the image' as a key concept:

> It was a meaning personal to himself and bound up with his early researches into poetry and painting. His use of 'image' is not far off from the way it is used in psychology, in literary criticism and in surrealist theory, but it is not quite identical with any of these. It has resemblances to the psychological concept of the *gestalt*.[5]

According to Madge, Jennings took his definition of 'gestalt' not from psychology but from the 1850 diary of the physicist Michael Faraday which describes 'the combination of many effects, each utterly insensible alone, into one sum of fine effect'. This line appears in Humphrey Jennings's *Pandæmonium*, his great collection of (mainly written) 'images' chosen to illustrate the transformation in world views between 1660 and 1866. Faraday's description is based on his account of a balloon ride over London. It is, says Madge, a kind of 'image of an image'.

> The image here consists not only of the balloon, the golden cloud of dust particles, Vauxhall, the date, Faraday watching and Faraday's physical discoveries, but of the relations between these elements and other elements, all ordered into a larger universe of imagery. The individual image, and the imaginative eye that seizes it, is a point of *ordonnance* in such a universe. It is not only verbal, or visual, or emotional, although it is all of these. It is not in the elements, but in their coming together at a particular moment, that the magical potency lies.[6]

Madge goes on to quote Jennings on Surrealism, from an article published in 1931, which includes the statement: 'A new solidity as firm as Cubism, but fluid, not static,

PLATES

PLATE 1 *Wavelength* (1967) Michael Snow.

PLATE 2 *All My Life* (1966) Bruce Baillie.

PLATE 3 *Threshold* (1972) Malcolm Le Grice.

see p 34

PLATE 4 *Hand Grenade* (1971) Gill Eatherley.

see p 35

PLATE 5 *Dresden Dynamo* (1972) Lis Rhodes.

PLATE 6 *Phased Time²* (1974) David Hall.

PLATE 7 *jüm-jüm* (1967) Werner Nekes and Dore O.

PLATE 8 *Shutter Interface* (1975) Paul Sharits. © Christopher Sharits.

PLATE 9 *Scratch Free State* (1983) George Barber.

PLATE 10 *Predatory Cat/Selfish Diva* (1997) Stephen Littman.

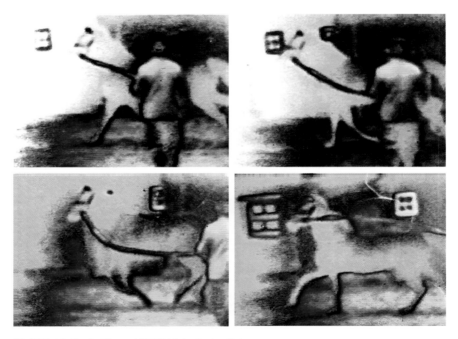

PLATE 11 *Berlin Horse* (1970) Malcolm Le Grice.

PLATE 12 *Word Movie* (1966) Paul Sharits. © Christopher Sharits.

PLATE 13 *36* (2001) Norbert Pfaffenbichler and Lotte Schreiber.

PLATE 14 *Colour Bars* (2004) Simon Payne.

PLATE 15 *Five* (2002) Bas van Koolwijk.

PLATE 16 *SICT* (2004) Doris Marten. Acrylic and MDF, 153-parts, each 20 × 10 cm, total size: 190 × 190 cm.

PLATE 17 'Film Exercise no. 5' from *Five Film Exercises* (1943–5) John and James Whitney.

PLATE 18 *Ich Tank* (1997) David Larcher.

PLATE 19 *Proun 2* (1920) El Lissitzky. Oil, paper, and metal on panel, 59.5 × 39.8 cm. Courtesy of Philadelphia Museum of Art, A. E. Gallatin Collection, 1952-61-72.

is required.' Around that time, Jennings sent a letter about his sources to the literary critic William Empson (perhaps to help with Empson's book *Some Versions of Pastoral*, published in 1935).[7] In this letter, Jennings writes that from 1580 to 1640, from the poetry of Edmund Spenser to Alexander Pope, the uses of symbolism and imagery derive from an 'ancient philosophico-magical cosmology' and the 'applications' of this system. The sources derive from ancient philosophy, but adhere in a variety of contemporaneous pursuits, whether among Freemasons, gypsies, alchemists, Kabbalists; the poetry of Walter Raleigh and Christopher Marlowe; Tarot cards; the writing of John Milton; or various popular rites and masques. According to Jennings, the system is 'a cosmological business at bottom: a statement of the shape of the universe & the relation of the microcosm to the macrocosm' and 'it seems always to be found in connection with agriculture'. In this connection, he finds a combat between hot and cold; winter and summer; night and day; the four elements and the four humours. In this same context he also finds ritual as imitation, and themes in which trials undergone by the Hero and the figure of Triumph dominate. The territory that Jennings maps out here perhaps shares the same substratum that marks the foundations and origins of the post-war American psychodrama, especially in the theme of expiation.

Jennings is linked to Walter Benjamin by more than a shared adherence to Surrealism. The 'passages' of Benjamin's *Arcades Project* are different to those of Jennings, but also rely on citation and montage, and were assembled in the same period, from the 1930s until his death, and address a similar theme. (Like Jennings's *Pandæmonium*, Benjamin's *Arcades* was reconstructed long after his death by persistent editors.) Both write about phantasmagoria and the romantic legacy in the social world of dreams and projections. Jennings's enthusiasm for 'images' has already been noted earlier; he described *Pandæmonium* as 'as series of images' in the form of 'passages describing certain moments, events, clashes, ideas, occurring between 1660 and 1885 which either in the writing or in the nature of the matter itself have revelatory and illuminatory quality: moments in the history of the Industrial Revolution at which the clashes and conflicts show themselves with extra clearness; moments of vision'.[8]

'Revelatory' and 'illuminatory' are similar to Benjamin's terms, but Benjamin saw these terms from the point of view of consumption, whereas Jennings associated them with production. The introduction to *Pandæmonium* – written up by Madge, from extensive notes left by Jennings – includes the quotation discussed earlier, but then goes on to link the series of images to filmmaking:

> I mean that they contain in little a whole world – they are the knots in a great net of tangled time and space – the moments at which the situation of humanity is clear – even if for only the flash time of the photographer or the lightning. And just as the usual history does not consist of isolated, events, occurrences – so this 'imaginative history' does not consist of isolated images, but each is in a particular place in an unrolling film.[9]

Jennings not only compared his project to a film several times but also proposed an interactive mode, to be read in parts with reference to an index that he never completed. Madge's editing of *Pandæmonium* included an index in the form of 'Theme Sequences', which facilitate an interactive mode of reading, and overall the project of organizing the publication was rather like the assembly of Benjamin's 'convolutes', or folders, for his *Arcades Project*.

MONET, LUMIÈRE AND CINEMATIC TIME

Steven Levine's essay 'Monet, Lumière and Cinematic Time' finds a 'common will' to film and art in around 1895, signalled in the word 'vues' that was applied both to Monet's paintings and to the scenes of landscape and daily life in the cinematography of Lumière.[1] The terms of comparison are complicated, since those hostile critics, who complained at what they called Monet's 'flashing colours', 'jumbled lines' and 'luminous vapour', seem, for Levine, to reflect 'the lingering assumption that painting had an ontological commitment to the precise and lucid depiction of the forms of the world … rooted in the Renaissance tradition of a clarified perspectival projection of seemingly solid bodies in an illusionistic space, a tradition preserved for film in the monocular lens of the camera'.

If film inherits this solidified space, how can it also be connected to Monet's optic of fleeting sensations and to his improvisational brushwork? The critic Louis Gillet invoked cinema as early as 1909 when he suggested that Monet reproduced 'instantaneously upon the canvas the picture of his emotions, to project as on a screen the interior spectacle, the collection of nervous shocks that makes up the visual image'. While this glides over the question of realism – and Levine's particular interests, which treat the Lumières' observational films as an analogue to late Impressionism – the Gillet quote implies a Brakhagean cinema, fifty years ahead of time. In Gillet's formulation, Monet sounds more like an expressionist than an Impressionist, and thus points to a very different kind of cinema.

Framing and projection are common to both painting and film, but the connection between Monet and Lumière is problematic, partly because of one of the original meanings of the term 'impressionist', which affirmed a fidelity to appearances and the actual stamp or impress of reality in Impressionist paintings. The role of the camera cannot be evaded, as it seems to be in Levine's statement that 'Monet and Lumière viewed the world as it presented itself to their gaze so as

to represent it to a viewing audience'. Levine believes that audiences were initially 'bewildered' by how film worked, but at the same time, he cites an explanatory note that accompanied a screening of the Lumière films at the Empire Theatre in London in 1896, which makes it very clear: 'A series of instantaneous snapshot photographs … projected by means of a powerful electric light upon the screen, the succession of images following one another in the same order and the same rapidity with which they were taken … to reconstitute the scenes they record with the most marvellous fidelity and naturalness.'

Rémy de Gourmont (in 1901) also stressed Monet's naturalism, comparing his paintings to 'the instantaneous snapshot' and to 'nature fixed in the very moment of sensation' such that 'one seems to be in front of a painting that differs very little from nature itself'. Levine, arguing for the temporality that is inbuilt to both the Lumière films and Monet's painting, here summarizes the classic analysis made by Georges Sadoul (in 1949) of the film *The Arrival of the Train at La Ciotat* (1896), which fills the screen at an 'oblique viewing angle and sharp depth of field', with people moving 'across and in line with the axis of representation'. Sadoul sees the film frame, or framed film, as comprising several shots at once, from the long-shot to close-up: 'This perpetual variation in point of view permits one to extract from the film an entire series of images as different one from the other as the successive shots of a modern montage' (Figure 39).[2]

This description evokes Eisenstein's later phrase 'montage with the frame', but in the context of Levine's essay the notion of montage arises with Monet's series of paintings of the Gare Saint-Lazare, from the late 1870s, which he

FIGURE 39 *The Arrival of the Train at La Ciotat* (1896) Auguste and Louis Lumière.

argues only make sense as a sequence. The paintings, taken from different but related viewpoints, 'develop the space of the frame as a space of change', like the 'template' of a photographer, or indeed cinematographer, finding 'views within the rectangular limits of a frame'. Like film, Monet's paintings record movement and change, displacing the gaze from frame to frame in the unfolding of the world's phenomena. Levine charts Monet working through the series of paintings made at the Saint-Lazare train station, in which each composition is related to the space taken up in the next, moving out from the station to the terminal yards, along the tracks to a bridge. He notes one which 'was painted from a point of view in the depth of the first picture' and hence constitutes a reverse angle, which reverses left and right as the painter looks back, telescoping distance in the style of the Lumières' first films (Figures 40 and 41). In addition to these filmic associations to do with angles, there is also apparent motion between different paintings in the series: 'A scale-change between two similar set-ups emphasizes the massive forward motion of a locomotive, as the field of vision is restricted at the periphery of a second image that features a closer view of the train'.

As a consequence, Levine sees the separate paintings not as frozen moments in time but as 'the durational recombination of those instantaneities into a quasi-

FIGURE 40 *The Gare Saint-Lazare: Arrival of a Train* (1877) Claude Monet. Oil on canvas, 83 × 101.3 cm. Harvard Art Museums/Fogg Museum. Bequest from the Collection of Maurice Wertheim, Class of 1906. Photo: © President and Fellows of Harvard College.

FIGURE 41 *Gare Saint-Lazare, Vue extérieure* (1877) Claude Monet. Oil on canvas, 60 × 80 cm. Private Collection. Photo © Lefevre Fine Art Ltd., London/Bridgeman Images.

cinematic narrative sequence'. This leads Levine to call both Lumière and Monet 'realists', for whom the 'flux of the world' was a source of representation. This does not quite resolve the initial crux – the absorption of traditional art into cinema – but leads to the more materialist assertion that in 'the arts of representation the boundary between nature and artifice is a line neither easily located nor unambiguously sign-posted'.

Other analogies between painting and cinema that Levine refers to include the late series of *Waterlilies* that are arranged for display against curved walls (installed, since 1927, in the Musée Orangerie) in what the politician and writer George Clemenceau called (in 1895) a 'grand circular glance', evoking a cinematic pan. One of the Lumières' cameramen, Alexandre Promio, was one of the first cinematographers to make a travelling shot (in 1896) for a film in Venice made on a gondola. This film was anticipated by Monet's series of paintings five years earlier, which derived from views tracking past a sequence of poplars in a boat. Another connection that Levine makes is related to Monet's paintings of Rouen Cathedral made over three years (1892–94) from a single window position; a series he compares to André Bazin's statement regarding the latent aspiration in the Lumières' cinema to be composed of a 'single shot as long lasting and as close-up as you like'.[3] While that comparison might suggest the stable and perspectival image that Levine argues the cinema inherited from traditional painting, he cites

again some of the early and astute critics of late Monet who refer, unabashedly, to the retinal qualities of his paintings, and in so doing anticipate a very different cinema to come, not least of all the 'flicker film'. Clemenceau wanted to see Monet painting in a manner such that 'at each beat of his pulse he might fix on the canvas as many moments'. Similarly, he thought the Rouen Cathedral in sunlight offered as many images 'as man would be able to make divisions in them. The perfect eye would distinguish them all, since even for our present-day retina these divisions are summed up in discernible vibrations'. The critic Roger Marx (in 1909) imagined Monet saying that these paintings 'discover, as in a microcosm, the existence of the elements and the instability of the universe that is transformed at each moment, under our eyes' and compares his 'originality' to 'the receptivity of a super-sensitive organism and to … a short-hand method that projects on the canvas, as on a screen, the impression received by the retina'.

In contrast to the retinal-oriented avant-garde film – whether with regard to certain films by Brakhage or to the 'flicker film', including particular works by Nicky Hamlyn or Rose Lowder – Levine ends with a reference to the films of Andy Warhol, whose aim, he considers, was 'to reconstitute from the unending movement of frames the enduring passage of time'. Correspondingly, Jonas Mekas thought that Warhol took 'cinema back to its origins, to the days of Lumière' so that 'the world becomes transposed' and 'we see it sharper than before'.[4] Mekas also dedicated his own film *Walden: Diaries, Notes and Sketches* (1969) to Lumière, even though it is far more fragmentary – comprising short bursts of shooting – than any of Warhol's films. Then again the terms upon which claims for realism are made are different, as was the case with Monet and his critics.

DISPLACEMENT, SCULPTURE

In an interview conducted at the Edinburgh Film Festival in 1975, and partially transcribed in *A Journal from the Royal College of Art*, Jean-Marie Straub and Danièle Huillet explained that the singers in their film *Moses and Aaron* (1973) were asked to look at their interlocutors as well as the musical director during filming.[1] The intention was that the direction of their looks would always be 'slightly displaced' (Figure 42). In arranging the singers (Moses, Aaron and the chorus group) like this, so as to 'de-psychologize the relations of power between them', the film tries to 'establish relations of power between singer and the group … and between the group and the singer. These relations of power concern the moral but first of all the physical place of the spectator.' In Huillet's account of the production, she explains that the singers, while directed to address the musical director – who couldn't in fact hear them, but could only hear the pre-recorded orchestral tape over earphones – were also addressing 'the spectator who is behind the director because he is behind the camera'.

In the same issue of the journal, Peter Gidal's preceding notes caution against films that 'repress precisely the practice of filmmaking as a production in and of itself, rather than as a reproduction of externally existent reality which is merely documented through film'.[2] In this light he questions the 'degree of distance' that is achieved by *Moses and Aaron* in its production strategies, including the variously directed (and displaced) looks attributed to the film's actors/singers. Gidal thinks the film deploys a 'truly Brechtian theatrico/filmic distancing construct' but argues that it is not 'evident in the finished film'. The viewer has no reason to question the direction of the actors' speech, singing or gestures, hence Gidal's assertion of the 'inability of the [Straub-Huillet] films to produce themselves as material operations', means that they always end up as stories. For Gidal,

The works don't produce themselves, their meanings, their operations, on the material level of film, *as works of film*. Whatever disconnections exist (out-of-

FIGURE 42 Günter Reich and Louis Devos in Straub-Huillet's *Moses and Aaron* (1973). Courtesy of Grasshopper Film.

frame allusions; space-compressions; actors' placements) in the end recuperate into a homogenous whole, a narrative completion within which there are stylistic variances but no actual breaks which foreground the film practice, or set up a complex of film interaction of material labour (presentation) and the internal event (representation).

A quite different route to 'primal cinema' is suggested by the film projection events of Anthony McCall.[3] McCall sees the filmstrip as a stencil. The projected lines and planes that constitute his works point to the presence of the projector's light, but in effect it is the absence of light that matters for McCall. This recalls Eggeling's use of stencils in *Diagonal Symphony* (1924) and indeed McCall's background (and current profession, in addition to his art practice) is as a graphic designer. But his work has often been understood, especially since the mid-2000s, as 'film sculpture'. In an important statement, McCall adopts the following terms for his work:

In *Long Film* [*for Four Projectors* (1974)], there is a *field* created by the film (Figure 43). It surrounds the visitor. As long as you are in the room, you are within the film. Every point in the room presents a different aspect; it's necessary to walk around, to pass through the planes of light. It can't all be taken in at on glance. The film is in constant motion. It is composed out of the shifting relationships between each of the four planes: their speed of movement, the direction in which they travel, the orientation of each plane to the perpendicular, and the modulation of their surfaces.[4]

FIGURE 43 *Long Film for Four Projectors* (1974) Anthony McCall.

Not long before *Long Film*, McCall had been lighting fires in real fields, in *Landscape for Fires* (1972). In an extensive catalogue essay, George Baker sees *Long Film* as spanning spatial and temporal media in an 'all-encompassing cinematic and spatial field'.[5] In contrast, *Four Projected Movements* (1975) is described as more visceral and architectural – with a strong push–pull effect on the viewer – and as more dominating, like the 'disciplinary' aspect of architecture itself. In McCall's best-known work, *Line Describing a Cone* (1973), Baker sees 'absorption', 'incorporation' and an 'inversion of cinematic conventions' in so far as the audience are asked to look back at the beam of light. In this connection he refers to the 'still-residual modernism' in a statement by McCall (from 1975) that attacks 'representational or narrative content'. The beam is not communication, 'a carrier of coded information', but deals with projected light which 'contains no illusion' and is described as a 'primary' rather than 'secondary' experience.

Like other normative critics, Baker doubts that 'any film could escape the condition of the medium's dedication to the production of "illusion", no matter how directly it might analyse the condition's illusion'. (Here he mentions the flicker film but he could also be alluding to the films of Peter Gidal, for whom 'condition of illusion' was a film title in 1975.) Baker's reasoning is that cinema relies on 'the persistence of vision', or our inability to perceive the individual still-frames – consisting here, in *Line Describing a Cone*, of the animation of a line that slowly extends to becomes a circle – as 'anything but the illusion of continuity and unimpeded flow'.

Baker also finds that narrative is 'foregrounded' in the film via the term 'describing', in title, 'as if McCall recognized film's inability to divorce itself of a narrative dimension'. McCall himself agrees with this association, in a Scott MacDonald interview of 1992, and even suggests an anthropomorphic reading of the film, with the line being described as an 'actor'.[6] Baker finds that later works, including *Long Film for Four Projectors*, 'confront' and 'frustrate' conventional readings more fully, because they expand the 'uniform and unified' viewing experience, encouraging the spectator to move around the work more. In McCall's words, 'every viewing position presents a different aspect'. But these works are less critical than absorptive: viewers are lit as they engage with the beam in a 'projection scenario' where viewers are literally 'in' the film. The aesthetic is not only anti-illusionistic but also a 'new "realized" form of immersion or continuity'. For Baker, the paradox of *Line Describing a Cone* and subsequent works is that through 'extreme analytic work' on film as medium and material, 'the medium achieves a real (as opposed to represented) spatial dimension; film itself accedes to the condition of sculpture'.

The significance of Baker's essay is that it argues for medium-specificity (and the nature of disparate mediums more broadly), and it does so in terms of metaphors corresponding to 'fields'. The works themselves also invoke fields, in terms of their palpable limits and thresholds, but just as the case for the specificity of McCall's work seems able to be asserted, it is absorbed by another medium.

Lisa Le Feuvre's essay 'The Continuous Present' (in the same catalogue) is more focused on time, and refers to McCall's version of the distinction between 'clock time' and 'cloud time', where the former relates to regular repetitive events and the latter to a continuous and overlapping mode of experience.[7] This double stream of time is particularly pertinent to his work since 2003. In the 1970s, McCall used circular or straight lines whereas his later works often involve a 'hybrid' of the two, which he calls a 'travelling wave': in *Doubling Back* (2003), for example, two identical waves slowly advance through each other, forwards and then in reverse, as single mutating curves; *Turn* (2004) combines a wave and a straight line that start out in parallel before the wave travels through the flat plane as they simultaneously rotate. At the end of the cycle the wave and line separate once more, at which point the film starts over again.

Although Le Feuvre writes that *Line Describing a Cone* 'appears to have solid properties', and occupies 'a room in a way that could be read as sculpture', she argues that 'a purely sculptural nature ... is denied in the temporal nature of the work'. In a conversation with McCall, which Le Feuvre refers to, he agrees that his films are 'unlike sculpture' in that they lack weight, gravity and are, very importantly, shown in darkness. Similarly, he suggests that duration is their 'primary plastic element' and 'their meaning does ultimately depend on them being looked at as film'. This modifies other statements where McCall has in fact been more than willing to

grant the films a sculptural dimension or status. Le Feuvre's own conclusion is that the relation to sculpture is a dialectical one, in which 'the three-dimensionality of the light is *produced* by the addition of time and vice versa'. In the case of *Line Describing a Cone*, the viewer becomes aware of 'solid light as the cone develops a tactile form occupying space', and interacts with the 'the negative space around it'. Actually, the black space is more active and palpable than this quotation suggests, even though the work relies on positive–negative relationships, as all primal photography does.

BODIES IN MOTION

In Phillip Prodger's essay 'In the Blink of an Eye', he notes how painters will depict the moment of a moving subject in relation to its most recognizable and memorable instant, often when the direction of movement changes. In the example of a walking figure, the moment usually depicted is that of the figure's legs between strides. This phase, like the moment at which a swinging pendulum is at its apex, is the most clearly perceived he suggests. In contrast to the clarity with which a walking figure is depicted, Prodger suggests that 'in the case of leaping or falling figures, paintings look more natural when rendered with minimal detail. The reasons for this are psychological. A person cannot actually see rapidly moving objects clearly. By replicating the indistinctness associated with seeing figures in motion, an artist may evoke in the mind of the viewer the sensation of witnessing such a subject.'[1]

Later in Prodger's essay he states: 'It has long been accepted among historians that the medium [of photography] represented the culmination of years of experimentation that had its intellectual origins in the Renaissance. During this period artists and scholars became increasingly interested in making pictures that were perspectively correct – that is, in which space was defined according to geometric rules and optical principles.'[2] In this regard Prodger refers to Beaumont Newhall's *The History of Photography* (1937), and his use of Leon Battista Alberti's essay 'On Painting', of 1435, which 'described the human eye as the apex of a cone to which light comes in rays.'[3] According to Prodger, this description of perception 'enabled artists to think of the world around them in linear terms; a picture, according to this scheme, is little more than a plane in which the rays have been recorded'. Correspondingly, the perspectival image has been central to the definition of photography. But Prodger also notes that recent scholars, including Geoffrey Batchen in his book *Burning with Desire* (1997), have suggested the story is incomplete, since it was really photography's capacity to imply or to capture movement that was new, given that geometrical perspective had already been perfected in painting.[4] The difference between perspectival imaging in painting and photography is that the latter is a function of mechanization.

According to Prodger, one origin of cinema lies in stereo-photographs that showed a subject at slightly different moments in time and asked the viewer to blink between them, 'seeing two phases of activity in rapid succession'. Longer sequences in motion were produced by devices such as Eadward Muybridge's zoopraxiscope, which was used to project a short loop of photographs.[5] In fact, the images on the surface of the zoopraxiscope disc were hand-drawn, elongated drawings made from photographs. The photographs themselves would have appeared compressed and distorted when projected because the machine used two spinning discs that projected the left- and the right-hand sides of each image at slightly different times. Prodger attributes the perception of motion associated with the zoopraxiscope to the 'persistence of vision' – a term that has its drawback for numerous theorists[6] – but just as important are the different aspects of the motion effect that are inscribed in the names of some of these pre-cinematic devices. Muybridge's zoopraxiscope was an 'animal action viewing device'; his zoogyroscope an 'animal spinning viewing device'; Joseph Plateau's phenakistoscope was a 'deceitful viewing device'; Henry Heyl's phasmatrope was a 'phantom turner'; John Ayrton Paris's thaumatrope was a 'magical turner'; Jules Duboscq-Soleil's bioscope was a 'life viewing device'; Ottomar Anschütz's tachyscope was a 'speed viewing device'; and Jane and Leland Stanford's megalethoscope was a 'big truth viewing device'.

In addition to the motion effects of Muybridge's zoopraxiscope, another pre-cinematic aesthetic in his photography is the cropping of pictures to distinguish a specific 'field of view', as in the two sequences of his *Movement of a Hand Lifting a Ball (Mr Tadd)* (1885). One sequence shows the eponymous figure from the waist up, while the other sequence is the hand and ball in a series of close-up shots (Figure 44). Another proto-cinematic device relates to the angles. According to Prodger, Muybridge never seems to have made foreshortened images of his subjects, but he did photograph them from the front and rear, at the same time, and also at angle of forty-five degrees. As a practical measure, this prevented one or the other of the cameras appearing in the corresponding alternate 'field of vision', but Prodger also notes that this method of shooting was a conceit that foreshadowed 'the use of the shot/counter-shot technique' which was later used in cinematography.[7]

In a different take on motion from stillness, Philippe-Alain Michaud has discussed an experiment of 'controlled hallucination' that Goethe conducted with the classical sculpture, *Laocoön and His Sons*, and described in his essay 'Observations on the *Laocoön*' (1798) (Figure 45). The experiment involves standing in front of the group of contorted marble figures and attacking snakes, blinking one's eyes alternately to animate them. The same effect would also be achieved by flickering torchlight. In this regard, Michaud suggests that Goethe calls on an 'artificial perceptual stimulus to activate the image unfolding before his eyes as if by a flicker effect'.[8] It contrast to the art historian Johann Joachim Winckelmann, who saw static serenity in the *Laocoön* sculpture – calm in face of the assault – Goethe's account of viewing the sculpture affirmed a 'dislocation of

FIGURE 44 'Movement of the hand lifting a ball' from the *Animal Locomotion* series (1872–85) Eadweard Muybridge.

FIGURE 45 *Laocoön and His Sons*. Vatican Museums. Tarker/Bridgeman Images.

the principle of composition stipulating that the plastic arts and painting depict one action alone, at the very moment this action takes place.[9] That principle is largely attributable to Gotthold Ephraim Lessing's account of the sculpture in his *Laocoön: An Essay on the Limits of Painting and Poetry* (1767). But what Goethe sees is akin to a 'flash of lightning fixed' or a 'wave petrified', in other words he sees duration represented in the figures of the sculpture.

The same essay by Goethe is also central to Peter Wollen's 'Time, Image and Terror' (though it is a 1799 translation that Wollen refers to, rather than the more recent translation by John Gage, which Michaud uses).[10] In his commentary on the Goethe essay, Wollen picks out an additional form of temporality and animated motion that Goethe attributes to the *Laocoön* group. Accordingly, there are three separate moments in time depicted by the sculpture of the father and the two sons, with each figure representing successive stages in the serpents' attack. On the one hand, Wollen explains that the 'fugitive moment' that Goethe refers to is comparable to what Lessing called the 'pregnant moment' – and might be compared to a freeze-frame – but Wollen also sees them as quite different conceptions. Lessing admitted the potential to depict a temporal dimension in painting and sculpture, via the 'pregnant moment', so that 'what precedes and follows will be most easily apprehended' though the moment itself was one of repose.[11] In contrast, Wollen reads Goethe's account of the 'fugitive moment' in terms of an accelerated sense of time, and one that is directed towards terror rather than harmony. While Lessing wanted to abolish the transitory in the reading of the *Laocoön*, Goethe sees it intensified by way of flicker and the fugitive image.

The effect of the figures of Laocoön and his two sons, which are shown in different stages of response to the snakes' attack, is inherently dramatic and terrifying; a factor that, for Wollen, is equally central to cinema. The examples he cites include D. W. Griffith's *Birth of a Nation* (1915), specifically the scene that includes close-ups of Lillian Gish cowering in the corner of a room before intruders burst in. The close-up is an abstracted image that features as a fugitive moment in the terrifying action of the scene as a whole. Another example is the series of close-ups of Janet Leigh in Hitchcock's famous shower scene in *Psycho* (1960).

Like these isolated moments in cinema, the *Laocoön* sculpture also stands in for larger events in the context of a wider narrative. In Virgil's *Aeneid*, Laocoön's downfall prefigures the fall of Troy, but his death is also something of a non-event in that story. Laocoön was a priest who saw through the Trojan horse ploy, and sought to warn the city, but the Greek gods sent the snakes to prevent him from doing so, and hence the Trojan horse was welcomed into the city. In contrast to Lessing's account of the *Laocoön*, which centres on repose, Wollen suggests that Goethe 'wants to vitalize it, to animate it, to create a lively sensation of the dramatic nature of the event. ... He wants, in fact, to cinematize it, to see there in movement the dramatic climax of a tragic narrative.'[12]

INTERVALS

[handwritten marginalia:]
interval
[SHOT] → [SHOT] Eisenstein more holistic
montage theory
[FRAME][FRAME][FRAME][FRAME] Vertov more fractured
interval

Both Eisenstein and Vertov discussed montage theory in relation to the intervals or gaps between each montage-unit. But what is that unit? In film theory shorthand, Eisenstein is taken to understand the interval as a linkage between shots, while Vertov is supposed to see it as a gap between frames. Because the shot is a more substantive unit than the minimalistic frame, and because Vertov often uses single-frame shots and flicker effect – at least in his best-known film, *Man with a Movie Camera* – while Eisenstein does so only rarely – as in the machine-gunner scene of *October* – this makes intuitive sense. This distinction is one of the reasons why Annette Michelson, a powerful advocate of Vertov in the United States, has contrasted Eisensteinian 'symbolism' with Vertovian 'materialism'. Eisenstein's montage is thought of as more holistic and Vertov's more fractured.

This perception may be accurate, given that Vertov draws attention to film in ways that Eisenstein did not: reproducing images of the filmstrip on screen to show the film being edited; or making 'frozen' frames spring to life. However, the distinction is not totally borne out in their respective theories. Their shared concept of the interval may in fact have been taken over by Eisenstein from Vertov, but either way it is only rarely that Vertov refers to the frame as a unit between intervals. Vertov's primary unit, like Eisenstein's, is the shot, even though Eisenstein homes in on the 'metrical' and frame-determined rhythm of Vertov's films to attack them in his famous polemics. To make things more complicated, the film scholar François Albera insists that 'Eisenstein locates the minimal space of filmic articulation between frames, rather than between shots', given his ideas about sequence and progression.[1] Albera thus connects Eisenstein to the frame-based filmmakers Paul Sharits and Peter Kubelka as well as the systematic works of Werner Nekes, just as Michelson, who was an early advocate of experimental cinema, links them to Vertov.

Michelson herself admits that the interval is 'shadowy, ambiguous … volatile and polysemic'.[2] Of the two sources that she cites for a definition of the interval, the first is Eisenstein's essay 'A Dialectical Approach to Film Form':

I also regard the inception of new concepts and viewpoints in the conflict between customary conception and particular representation as dynamic – as a dynamization of the 'traditional' view into a new one. *The quantity of interval determines the pressure of the tension.* (See in music, for example, the concept of intervals. There can be cases where the distance of separation is so wide that it leads to a break – to a collapse of the homogeneous concept of art. For instance, the 'inaudibility' of certain intervals.) *The spatial form of this dynamism is expression. The phases of tension: rhythm.* This is true of every art form and, indeed, in every form of expression.[3]

Eisenstein is a complex writer, and equally complex is the history and transmission of his texts. 'A Dialectical Approach to Film Form', for example, was widely available in the West in a version translated from the original that had been written in German in 1929. And it is this version, which was authorized by Eisenstein and published in the collection of essays *Film Form: Essays in Film Theory* (in 1949), that Michelson quotes from.[4] A more recent translation, by Richard Taylor, is subtly different. The first of the italicized lines in the quote – '*the quantity of interval determines the pressure of the tension*' – is translated by Taylor as '*the basis of distance determines the intensity of the tension*'. The second set of italicized lines – '*the spatial form of this dynamism is expression. The phases of tension: rhythm*' – is translated as '*the spatial form of this dynamic is the expression of the phases in its tension – rhythm*'.[5] Taylor's notes also record that the following line was erased from Eisenstein's original typescript: '*The temporal form of this tension (the phases of tension) is rhythm*'.[6]

The line may have been cut because it was redundant, since the 'spatial dynamic' is defined by 'phases in its tension', which are temporal and rhythmic by definition. Whether cut to avoid repetition or circularity, the line invokes the ideas, if not the very words, of the abstract animators, including Hans Richter, whom Eisenstein met and befriended in Switzerland and London at this time, but whom he also attacked as purist aesthetes. Taken on its own, the line could have come from a manifesto written by Richter, relating to his abstract films of the 1920s, which were known as the 'Rhythm' series. Richter was the dedicatee of an essay and film proposal by Kazimir Malevich, the leading Soviet abstract artist who had earlier attacked cinema as superficial drama in terms that Eisenstein thought were naive.[7] But by 1932, Richter had long abandoned abstract film, and was shooting a political docu-drama, *Metal* (1933), in the USSR with Eisenstein's wife, Pera Attasheva, as producer.

A resolute modernist himself, Eisenstein seems to refer negatively to the 'disintegrative' aspect of Western culture in 'A Dialectical Approach to Film Form', written at a time when the 'party line' on abstract art and avant-garde culture was shifting to outright hostility. His reference to musical intervals where 'the gap is so wide that it can lead to a break, to a disintegration of the homogeneous concept

of art' might have evoked the most extreme example of its kind in the late 1920s, the Vienna School of composers comprising Arnold Schoenberg and his disciples Alban Berg and Anton Webern. For this group, and above all for Webern, the gap or silence between the notes of the tone-row (with the structuring grid and strict pattern behind each composition) as well as the dissonances between the notes themselves, were primary factors.

For many, as perhaps for Eisenstein in this context, Schoenberg's group was both hermetic and anarchistic. In contrast, defenders such as Theodor Adorno supported the new school's antagonism to pleasure and consumption, and its dedication to the autonomy of art. Eisenstein's 'homogeneous' concept of art is more defensive of art's autonomy than may appear from this seeming nervousness at where 'high art' was going in the hands of Western artists and composers. For the next decade he was often attacked himself as a 'formalist'. In any event, when he cited musicians to illustrate his theories it was often Debussy and Scriabin that he referred to.

Annette Michelson's second source for a definition of the interval is Vertov's 'WE: Variant of a Manifesto' from 1922: '*Intervals* (the transition from one movement to another) are the material, the elements of the art of movement, and by no means the movements themselves. It is they (the intervals) which draw the movement to a kinetic resolution.'[8] Vertov's statement on intervals conveys a similar sense of disruption and anti-naturalism as Eisenstein's later formulation that 'montage is not an idea of successive shots stuck together but an idea that *derives* from the collision between two shots that are independent of one another'.[9] In some respects the emphasis of Vertov's manifesto is less 'modernist' than that of Eisenstein's essay. The line stating that camera-eye 'cinematicity' is '*the art of organizing the necessary movements of objects in space as a rhythmical artistic whole, in harmony with the properties of the material and the internal rhythm of each object*' and the subsequent sentence on the 'organization of movement' as 'the organisation of its elements, of its intervals, into phrases … a composition is made of phrases, just as a phrase is made of intervals of movement' concern coherent, harmonious compositions, rather than conflict.[10] In any case, it is Annette Michelson, in her introduction to Vertov's writings, who refers to 'intervals' in terms of the gaps between frames.[11] For Vertov himself (at least in this translation) intervals correspond with movement.

Eisenstein crystallized his own theory in around 1928 to 1929 while working on *The General Line* and *October*, just before he left the Soviet Union for three years. With the sound film imminent, he sought to replace his theory of hierarchical elements with more syncretic ideas – a complex. Music provided a theory of overtonal montage and hence of the interval, and perhaps reflected his thinking about the new dimension of sound in film. For Eisenstein, the interval could be seen as a means of arranging or structuring the polyphony of film in a 'fusion' of elements, corresponding with metric, intellectual and overtonal systems of

montage. In tandem with this, Eisenstein insisted that the subtleties of overtonal montage and conflict could not be seen in the static frame, but only in projection, just as music, when played, makes for an experience that is distinct from a reading of the score. In 1922, Vertov held similar views, and in this he is perhaps closer to Eisenstein's symbolism than Michelson claims when she distinguishes Eisenstein's 'musical' model of the interval from Vertov's 'mathematical' paradigm.

Where Michelson suggests that Vertov's concept of the interval is taken from mathematics and physics, rather than music, she uses an asymptotic image. In light of Vertov's statements on 'the analysis of movement and rates of change, the notion of the interval is applied to the ever-divisible gap between two points along a defined continuum', she sees his theory as akin to the use of calculus in determining motion and time, whether in terms of fluids, electric currents or the vibration of subatomic particles.[12] The aim here is to distinguish Vertov's scientific inspiration from 'idealist' speculations associated with the symbolists, who are cast as anti-revolutionary.

As Michelson's own genealogy of Russian modernism implies, music and mathematics cannot be easily unprized from both modernist and symbolist ideas in the period before and after the revolution. She traces the combination of music and visual overtones and intervals, as feeling and affect, in terms of a loosely labelled fourth dimension for which there was much enthusiasm at the time. This follows Linda Dalrymple Henderson's exhaustive account of the first wave of symbolists, to the radical 'trans-sense' poet Velimir Khlebnikov (a creative numerologist and devotee of complex time-lines), and the 'hyperspace' philosophy of Theosophists who integrated aspects of Relativity into their essentially visionary accounts.[13] What remains unexplained, however, is how the same impulses, along with some of the same people, come to be characterized as analytical materialists in the 1920s.

Vertov's theory of intervals is not only 'a response to the demands of scientific method' as Michelson characterizes it. His proposition regarding the 'geometrical extract of movement through an exciting succession of images' and the organization of the 'necessary movements or objects in space as a rhythmical artistic whole, in harmony with the properties of the material and the internal rhythm of each object' is tinged with the prevailing and rich late-symbolist climate as well as with post-Cubist materialism in the narrower sense.[14] Like Eisenstein's 'extended notion' of montage, Vertov wanted to broaden the montage principle into the whole production and construction process of a film. Though Michelson claims Vertov's position was very different to Eisenstein's, because of the focus upon 'the organization of the gaps between movements and between frames', it is difficult to find this so expressed by Vertov himself, for he almost always speaks of shots.

By 1929, when Eisenstein was developing his theory of 'synthetic' montage, Vertov had described a new mathematical model of the interval, in the extensive

statement 'From Kino-Eye to Radio-Eye' (written in 1929, but not published until 1966). In this context he argues that montage occurs at every level of production, but that the final 'central montage' stage is 'a numerical calculation of the montage groupings. The combining (addition, subtraction, multiplication, division, and factoring out) of related pieces.'[15] In 1926, in the article 'Kino Eye', he had similarly spoken of the final stage of editing as 'co-ordinating similar elements, and finally, numerically calculating the montage groupings.'[16] Back to 1929, and in the context of a spirited history of his group 'From the History of the Kinoks' Vertov refers to 'editing tables containing definite calculations, similar to systems of musical notation, as well as studies in rhythm, "intervals" etc.'[17] Tables here must mean diagrams. In the same breath he mentions that he is writing a book related to these systems, but sees its publication as 'dangerous' because he imagines formulas to result in nonsense if 'indiscriminately applied'.

The same memoir begins with a story of an early Kinoks film, *The Battle of Tsaritsyn* (1919). 'The montage was already done in frames. Measurement went not according to the metrical system, but like a decimal series of frames: 5, 10, 15, 20 ... roughly like that.' According to Vertov, when he passed the film to his editor, the longer shots were cut together, and the shorter shots were thrown out as waste. Vertov put the film back together as planned, he says, but the 'Artistic Council and the government responded negatively' meaning that he 'could not count on repeating experiments like that again'.[18] At the same time as stating that *The Battle of Tsaritsyn* was an ancestor of *The Man with a Movie Camera*, he is cautious about doing so. In a document discussing the reception of *The Man with a Movie Camera*, which was unpublished at the time, he argues that the film is not just a 'higher mathematics of facts', as one critical viewer (perhaps Eisenstein) called it; 'in fact, the film is only the sum of the facts recorded on film, or, if you like not merely the sum, but the product.'[19] The aim, for Vertov, was to construct meanings with visual linkages, without intertitles, so that 'the final sum of all these linkages represents, therefore, an organic whole'. Eisenstein could well have said the same about his own films.

Vertov's later statements about the interval also have an organicist tone, perhaps in reaction to the charge of 'formalism' that dogged his career. In a diary entry of 1944, he talks of his aim to achieve an 'organic interaction between shots, one in which shots enrich each other, combining their efforts to form a collective body'.[20] This distinguishes the 'art of writing in film-shots' from the earlier notion of 'montage', even while his words recall the article 'From Kino-Eye to Radio-Eye' in which he wrote: 'Montage means organising film fragments (shots) into a film-object. It means "writing" something cinematic with the recorded shots.'[21] In a later diary entry, of 1953, he writes that 'shots enter into organic interaction; they enrich one another, combine their efforts, form a collective body, thereby releasing surplus energy'.[22]

METHODS OF MONTAGE

for narrative concerns

edit → visual elements

→ graphic elements

In his exhaustive study of *The Man with a Movie Camera*, Vlada Petrić explains that instead of restricting editing decisions to narrative concerns, Dziga Vertov and Elizaveta Svilova edit for visual and graphic elements, so that the meaning and theme emerge in the film's overall structure. For Petrić, the most important part of Vertov's theory of intervals is 'its emphasis on the perceptual conflict that occurs between two adjoining shots as the result of cutting "on movement", so that the sequence functions like a musical phrase, with its rhythmic aspect, peak and decline', which makes for 'a high degree of cinematic abstraction' through visual conflict, to produce a kinetic or kinaesthetic effect, uniquely cinematic.[1]

Petrić takes his terms from advertising's version of montage as expressed in Slavko Vorkapich's essay 'Film as a Visual Language and as a Form of Art' and indeed from Vorkapich's own montage sequences for several Hollywood films.[2] At the same time, he also links the 'theory of intervals', aimed at creating primarily visual impulses by 'a movement between the pieces (shots) and frames', to Osip Brik's suggestion that 'the rhythmic beat of a poem or a sequence not only supports the thematic meaning but acts as an autonomous structure with its own impact and signification'.[3]

Vertov was loyal to the Cubo-Futurist tradition, mentioning 'Zaum' or transsense poetry (which originated in 1916) as late as 1935, in the context of a discussion of film sound. Petrić extends the link by comparing the 'verbal flashes' of Zaum poetry to the filmic 'flicker' that occurs in the alternating of black, grey and transparent frames in sections of *The Man with a Movie Camera*, which he thinks of as an irritating avant-garde effect.[4] Such passages also exemplify what Petrić describes as 'disruptive-associative montage', and he connects them to Eisenstein's attempt to 'resolve the conflict-juxtaposition of the psychological and intellectual overtones' through 'conflicting light vibrations' that affect the viewer physically as well as revealing the 'dialectical process of the film's passage through the projector'.[5] These quotes are from Eisenstein's essays 'Methods of Montage' (1930) and 'The Filmic Fourth Dimension' (1929) respectively. In the original context,

Eisenstein's point is less about flicker than his belief that overtonal montage can only be perceived in the projected film. It does not refer to flicker effects as such, but to changing light values within the frame:

> Real cinematography begins with the collision of various cinematic modifications of movement and vibration. For example, the 'pictorial' conflict of figure and horizon (whether this is a conflict in statics or dynamics is unimportant). Or the alternation of differently lit pieces solely from the viewpoint of conflicting light-vibrations, or of the conflict between the form of an object and its illumination, etc.[6]

Petrić thinks the difference between the two filmmakers is that Eisenstein's dialectic produces emotional overtones by the 'optical pulsation' of projected images, while Vertov uses inserts to disrupt sequences. He points to the fact that some of the shots in *The Man with a Movie Camera* open with a black frame, for example. Petrić's analysis also refers to compound shots, made abstract by distortion that arises from the distance between camera and subject (in close-ups, for instance) and by the graphic interaction of images. In this he detects patterns that involve circles as well as vertical and horizontal lines, which correspond with links that Vertov makes between the eye/lens and industrial or urban reality.[7] Circles are found in the images of the camera lens, eye, film cans, projectors, wheels, lamps, typewriter keys, carousels, footballs, motorcycles, hoops, cranks and editing table plates. Verticals are imaged in windows, scaffolds, buildings, posters, carts, poles, bottles and pedestrians. Horizontals appear in landscapes and cityscapes by way of bridges, roads, tramlines and railway tracks. The filmstrip is a horizontal and vertical, depending on its orientation. In combination with diagonals these forms take part in what Vertov referred to as 'the art of organising the various movements of objects in space', through 'dynamic geometry, the race of points, lines, planes, volumes'.[8]

Petrić glosses Vertov's 'theory of intervals' by stating that they instance an 'optical clash … at the juncture where one movement "touches" another, and thus "pushes the movement towards a kinetic resolution"'.[9] 'Touches' is signalled as a quotation, but the word is not to be found in the version published in *Kino-Eye* translated by Kevin O'Brien. According to Petrić, Vertov had the 'kinesthetic' in mind here, rather than 'kinetic', and he equates this with what Vertov calls the 'poetic impact' of a film sequence in so far as 'the intervals are conceived and understood as a "geometrical extraction of movement through the exchange of images"'. These quotations are from 'WE' again, specifically Petrić's version. In contrast, the O'Brien translation has 'the geometrical extract of movement through an exciting succession of images'.[10] 'Succession' is not quite the same as 'exchange'.

Petrić claims *The Man with a Movie Camera* as a 'Constructivist' film partly in terms of its 'recognition of the physiological impact of the cinematic image', which

[margin handwritten note: patterns & forms]

derives from its experiments in geometric interaction (to expose the action of film's language) that relate to the associated exploration of the phi-effect and 'persistence of vision', which are the grounds for the illusion of movement. His analysis of the 'Street and Eye' sequence in *The Man with a Movie Camera* describes the attendant phi-effect in terms of an 'oscillation' which 'generates a stroboscopic pulsation (flashes) that excites the viewer's retina on a purely perceptual level'.[11]

The sequence consists of close-up shots of a blinking and then roving eye (which moves from left to right and vice versa, or up and down and vice versa) that collide with fast horizontal and jumping diagonal panning shots of various street scenes and images of traffic shot from a range of high and low angles (Figure 46). The divergent movements of the eye and the camera increase in pace, while the length of each shot is decreased until 'the image of the street (with its horizontal and diagonal lines) is seen "superimposed" over the eye, cutting across its circular

FIGURE 46 The Street and Eye sequence from *Man with a Movie Camera* (1929) Dziga Vertov.

shape'. This links back to the graphic interaction of circles and lines mentioned earlier, and makes for an abstract cinematic statement: the circle representing the act of seeing and the lines representing the physical movement of the traffic. The structure of the sequence also constitutes a narrative thread with the closed eye at the end signalling the traffic accident. For Petrić the chain of events in this sequence is 'expressed through visual symbolism and brought to a climax by means of a specific cinematic device (the phi-effect)'. In this respect, 'Vertov's idea of developing "an ultimate international language" is thus conveyed via pure cinematic means generating an impact that no other medium can achieve.'

Besides Petrić's account of organizing graphic principles in *The Man with a Movie Camera* he also notes that Vertov was 'probably acquainted' with the fovea: 'a sphere smaller than a pinhead near the centre of the eye's retina which appears to be the major source of consciously induced visual information' and which 'permits only a small amount of visual data to be filtered into awareness'.[12] This recalls Baxandall's foveal reading of a Braque painting, but Petrić cites literature on the visual language and means of manipulation associated with advertising. And it is in this light that he sees Vertov as aiming to hit the 'unconscious' directly, via 'the periphery of vision'.

It is just as important, however, that the supposedly subliminal intervals in Vertov's films approach the threshold of awareness by means of the instantaneous conflict between two opposing movements. The 'Street and Eye' sequence is specifically a conflict of different graphic compositions and light distributions, rather as Eisenstein had described, but here figured as an eyeball's 'micromovements' which stimulate 'sensory-motor activity'. Petrić associates these movements and repetitions with kinesthetic, psychological and emotive affects, such as the subliminal arousing of fear before the traffic crash occurs, or making the viewer empathize with the floating cameraman.

In what Petrić calls the 'Working Hands' sequence, human movements are graphically ordered by way of alternating horizontal, vertical and diagonal movements.[13] Correspondingly, interval beats match cuts between moving shapes, and shots have a 'graphic design' that refers to the activity that they depict. Sometimes the design of one shot prefigures or pre-empts the content of the next. One example is the circular movement of a hand cranking the camera, shot from side-on, that is followed by an image of the camera from front-on, which describes a square. Another example is that of a telephone operator reaching for a phone, in a diagonal movement that ends vertically. Here there are also horizontals in the shape and position of the telephone receiver.

In a later passage of Petrić's analysis, he describes an oneiric use of intervals in Vertov's film, associating them with the 'hypnagogic', particularly with regards the sleeping consciousness of the young woman in the 'Awakening' section of the film.[14] Another sequence, which suggests a visual analogy between a girl and a train is linked to the editing of 'certain new American filmmakers'. Presumably, he

means Brakhage here, another filmmaker who appeals to 'hypnagogic vision'. In making ties to other filmmakers, Petrić sees the 'Optical Music' sequence – which involves shots of a loudspeaker, an ear, spoons being played, piano-playing and tapping feet – as linked to the French cineastes of the 1920s, including Germaine Dulac and Fernand Léger, whose films also used musical analogies. The sequence uses numerous three-frame cuts between sonorous objects and listeners, in a form of metric editing, to create an aural impression. In some respects, the effect is akin to reading (or watching) a score.

This mode of 'metric montage' was a chief cause of Eisenstein's attack on Vertov in 1929, in the essay 'The Fourth Dimension in Cinema'. Eisenstein accuses him of being governed by absolutist shot-lengths that are formulaic, fractional (contradicting the 'law of prime numbers'), irregular and crude in their effect. Furthermore, 'the metric module' (translated as 'beat' in the Jay Leyda *Film Form* version) is 'mathematically so complex that you can only determine its pattern "with a ruler in your hand", i.e. by measuring rather than perceiving'.[15] For Eisenstein, the result is a 'chaos of perception rather than a distinct emotional tension'. Instead, he favours another category of montage, which he designates as 'rhythmic montage' and illustrates with reference to examples that include the contrast between the movement of marching soldiers and that of the careering pram in the Odessa Steps sequence of *Battleship Potemkin*. Further nuanced models of editing include the 'vibrations' of 'tonal montage', which is not surprisingly linked to tonal lighting *tonal* and music. Vertov would not have seen his films as limited to the category of *montage* 'metric montage' that Eisenstein ascribed. Correspondingly, Petrić refers to many 'tonal' instances to explain Vertov's graphic sense.

The argument between Eisenstein and Vertov goes back to 1925. It partly relates to Vertov accusing Eisenstein's *Strike* of having followed the example of Vertov's *Kino-Pravda* series.[16] In his defence, and by turning the Constructivist claim to have left art to 'enter life' against Vertov, Eisenstein argued that he had appropriated art for materialism. At the same time, Eisenstein characterized the Kinoks' art as a disparaged form of 'primitive Impressionism'. In italics, he writes: '*With a set of montage fragments of real life* (of what the Impressionists called *real tones), whose effect has not been calculated, Vertov weaves the causes of a pointillist painting*.'[17] In contrast to his later charge of mathematical staleness – in the 'Filmic Fourth Dimension' essay – here he is arguing that Vertov does not intervene enough; that his films do not interpret or break up 'the inevitability of the statics' of causal relations between objects. There is too little ideology and too much reflection, or the mere 'fixing' of phenomena. At one point in the essay he even uses the dangerous word 'Menshevik' in connection with Vertov. In rejecting his own theatrical background, he says his own plan is cinematic, re-carving the statics of drama by montage.

There are two (troubled?) footnotes in 'The Problem of the Materialist Approach to Form'. In one, he draws attention to an 'abstractly *mathematically* successful'

montage sequence in one of the *Kino-Pravda* films, which involves the raising of a flag.[18] Eisenstein describes how the sequence provides an examination of the static components of the process, but fails emotionally because the short sequences of close-ups, with triangular and quadrilateral qualities, are lacking in dynamism. According to Eisenstein, the montage is a 'dynamic of static fragments' because the combinations are weak. Perhaps this is an argument against abstraction, which combines ideology with symbolism and modernism. In the second footnote, he has more positive words for a *Kino-Pravda* film about Lenin, but says it 'tickles' the emotions and offers motiveless moods.[19] Vertov ought to be able to supply the audience with a 'predetermined emotional charge', he argues. This is a surprising accusation in light of later readings of Vertov, and perhaps reflects a perception that – whatever Vertov's determinist aims or pretensions – the films are too open, too ambiguous and intuitive. Eisenstein's final attack in this essay is the accusation that the Kinoks perform tricks without reason, in this context an anti-modernist jibe. Later, in 1930, he spoke of Kinoks more neutrally, as naturalistic filmmakers who 'fix the movements and the expressions just as they are in daily life'.[20]

Eisenstein's later writing concerning a psycho-physiological theory of art was published in a troubled period in which he was in semi-exile from teaching and directing. In the essay 'Laocoön' (1938), he describes all cinema as montage, starting with the fundamental succession of frames that pass through a projector, which he calls 'micro-montage': 'Now we perceive even the still shot as a montage process, as the first link in a continuous chain of montage that extends throughout the entire work.'[21] From here he moves to higher levels with respect to shots and scenes. Taking the frame as a 'fixed contour' and the shot as a 'record of movement', he turns to painting to find how movement is suggested in artists spanning Tintoretto to Daumier and the Futurists. He also finds proto-cinematic figures in literature, including the example of a running horse lit by lightning flashes, described in a scene from Tolstoy's novel *Boyhood*: 'The "stopped-action" picture of a phase of motion, which makes that fragment of movement appear motionless, long predates photography; to seize a "fragment" of movement in momentary immobility mankind did not have to wait for the invention of the camera with shutter-speeds of a twenty-fifth, a hundredth or a thousandth of a second.'[22]

Some of the images that Eisenstein refers to are sequential, others combine shifts of movement in a single image, by showing different phases of the body's actions as a related whole, so that the motion is extrapolated imaginatively by the viewer. The classical sculpture *Laocoön and His Sons* 'provides a perfect example, both in the phase of external movement – the attack by the two snakes – and in the phase of the mounting intensity of suffering, expressed through the gradations of behaviour of the figures'.[23] The head of the central figure, Laocoön, shows this by 'the illusion of *mobility*, an illusion attained by depicting wrinkles of pain that *cannot* occur *simultaneously*'. Eisenstein credits this discovery to the photographs of the French neurologist Duchenne, whose experiments involved the electrical

stimulation of muscles to reproduce a range of facial expressions. The principle of Eisenstein's theory here is that montage, the basis of the 'cinematic principle' is in culture, rather than nature:

> When we say that in the fundamental structures of film aesthetics there is retained the unique nature of the cinematic phenomenon – the creation of motion out of the collision of two motionless forms – we are not dealing with natural, physical movement but with something that has to do with the way our perceptions work. ... For strictly speaking what occurs in this case is not movement; instead, our consciousness displays its ability to bring together *two separate phenomena into a generalized image*: to merge two *motionless* phases into an *image of movement*.[24]

Eisenstein's attack on Impressionism – which he had 'accused' Vertov of – is expanded here, in terms of its being dominated by the retina, the 'pictorial imprint', instead of the brain-centred 'reflected image', as seen in Cubism. For Eisenstein, Impressionists were only retinal, while Cubists measured forms against their intellectual and cognitive aspects, leading to the 'summation' of emotion in a single image. Marcel Duchamp objected to Impressionism on the same grounds. Did Eisenstein think of Duchamp, when he called for paintings that would constitute a 'dynamic fusion of a series, moving past the spectator' a phrase that evokes Duchamp's *Nude Descending a Staircase* (1912)? But painting is essentially inadequate to showing motion, which Eisenstein recognizes when he cites a line from Baudelaire, seeing it as a neoclassical refusal of painting's capacity to depict movement: 'I hate movement which disturbs the lines.'[25] Contrary to this, Eisenstein has only just shown how movement might be incorporated by painters, but he sees the 'unity of shot and montage', which he attributes to painting, as being the 'starting point' for cinema.

In the very next section of the Laocoön essay, Eisenstein states that 'the *principle of cinema* is no more than a reflection, transferred to film stock, footage, frame and projection speed, of an inevitable and absolutely basic psychological process that is common to each individual consciousness from its first steps in the absorption of reality. I refer to what is called eidetics.'[26] The editors' note at this point defines 'eidetics' as the 'ability of the human brain to retain the image of an object after that object has passed out of the observer's field of vision' and explains that 'cinema depends on this ability to create the illusion of the moving image'. Eisenstein himself explains the function of eidetics in the following terms: 'Reality consists for us as a *series* of foreshortenings and images. Without eidetics we would never be able to reduce all those "split-second photographs" of the separate aspects of phenomena into a single image.'

Describing the 'nucleus of cinematic production', Eisenstein locates two 'functions': one 'involving visual depiction', the other a succession of pictures; the

first being 'in the film' and the second 'in the perception of the spectator'.[27] The first relates to the individual stills, the second to a persisting 'image of movement'. In cinema, the image of movement can be reconstituted, he argues, so that motion is broken down into phases, or, 'by suppressing our awareness of the intervals between frames' it can 'cease to be interpretable as movement'. (And in connection with this pole he imagines a 'super-rapid' camera showing an arm slowly being raised a few centimetres, an idea that pre-empts Fluxus![28]) Eisenstein argues that it is not the event that is distorted in this hypothetical example, but the 'treatment of that event by the speed of the apparatus' which provides for our interpretation 'another image of the event'. The tempo '*objectively* restructures the *image* of the event'.

Going further in his account of the impression of cinematic motion, Eisenstein characterizes two frames in sequence from a single shot as being 'swallowed' to depict a generalized sense of movement, and then suggests that even separate shots, which depict an event – the example is a galloping horse filmed from three different angles – will similarly fuse as a complete sequence, with only a 'trained eye' noticing that it is composed of distinct shots.

> From a collision between pictures of two consecutive phases of a movement there arises *the image* of a movement (a movement which in actual fact, *is not depicted* but is conveyed by two still pictures). In the transition from combining frames to combining shots, the phenomenon and the method remain the same. … In the montage segment, the *pars* (the part) evokes an image of *toto* (the whole). Thus in the mind the fragment has already become an image of a complete picture, thence of a series of imagined pictures. And each imagined picture enters into the same relationship with the next one as the literal picture in one frame does with the literal picture in the neighbouring frame; they both generate an image.[29]

While the sequence of individual frames is actually and automatically depicted by the camera, the montage sequence is 'imagined' by viewers, and they are undoubtedly imagined differently because they each bring their own sense and interpretation to the film. At the same time, as Eisenstein saw with regards graphic art, the juxtaposed shots of a film construct linear contours in the shot – perhaps in contradictory ways – that form a track or route, which is 'traced by the predetermined route of the spectator's perception'.

FRAMES

The frame was the basic unit for a number of experimental filmmakers in the 1950s and 1960s, notably Kurt Kren and Peter Kubelka in Austria, and Gregory Markopoulos, Paul Sharits and Tony Conrad in the United States. They are loosely linked by a common interest in an abrupt, disruptive and visceral cinema with a direct physical effect on the viewer, but the different ways in which they treated the frame are significant.

Many of the films of Markopoulos and Kren could be thought of as psychodramas with overtones of myth and ritual enacted by 'personae'. They are quite distinct however. Markopoulos adapted Greek legends to underscore selfhood and the individual psyche. His fundamental structure is an Oedipal quest. Fragmentation extends to the cut-up texts that are read as a soundtrack, often with single syllables removed so that the visual frame and the spoken voice are equally interrupted and made oblique. Kren takes his drama from the live performances of the Vienna Aktion Group. Here too the 'actors' are 'types' – men in business suits playing havoc with paint and junk, for example – but there is no sense of interiority. The mayhem of the action takes place on the surface, and is subjected to a radical rapid-fire, single-frame editing system that pre-empts voyeurism. Both filmmakers, however, look for catharsis.

Markopoulos made films of extreme duration and in complex cycles (re-cutting many of them in his later years), while Kren's form is the three-minute roll of 16 mm film. Both made portraits, and both also made shorter, intensive films exploring rooms or landscapes (Kren more so, this constituting half of his output). Here too, the frame is the core unit. In *Ming Green* (1966), Markopoulos uses the single frame and rewind functions to edit the whole film in the camera. The single frames come from the act of shooting, not from the editing bench. Similarly, in films such as *Asyl* (1975), Kren exposes different aspects of a snow scene over a period of weeks with camera masks and mattes, so that the landscape is finally made up of successive exposures revealed simultaneously on-screen in projection. In Kren's films, the use of cycles and repetitions focuses their perceptual qualities.

In this regard they are more objective than Markopoulos's films which foreground associative and personal spaces.

Two filmmakers who have exploited the pure possibilities of a very basic frame-based structure, to make up a whole film, are Peter Kubelka and Tony Conrad. Both have made films in which the role of the camera is negligible or unnecessary, given that their most notable films, *Arnulf Rainer* (1960) and *The Flicker* (1966), consist of single-frame units in clusters of exposed and unexposed (i.e. black or white) frames. Like Kren's films, which employed graphs and charts, Kubelka and Conrad both constructed their films with mathematical and musical models in mind, and to this extent they were 'pre-scored'.

Kubelka's *Arnulf Rainer* – the title of the film is the name of an Austrian painter who works in monochrome – is wholly determined by its score, which was calculated so as to equalize moments of 'white noise' and silence with the balance of black and white frames in the film (Figure 47). The resulting projection of frame-clusters sometimes results in bursts of retinal after-images, but these are by-products of the process by which the film was made. Its overall form is conceptual rather than retinal. While it is definitely a film to be experienced (in a good 35 mm projection it is a unique and compelling event), it is also one of a rare number of films that can be considered as a conceptual whole in its very design. The film realizes an idea in its structure as well as in the act of screening. In fact, the mathematical programme for the film rarely leads to predictable effects: optical

FIGURE 47 *Arnulf Rainer* (1960) Peter Kubelka.

and aural mismatches often occur, reducing the viewer's urge to full participation in the bursts of light and sound impulses.

While *Arnulf Rainer* is a very physical film, it is quite different to Conrad's *The Flicker*, which is significantly longer and invites overflow from screen to eye. Also using mathematical proportions to organize the flicker rate, Conrad was interested in the generation of colour effects by alternations of black and white frames, effects which were, for Kubelka, a resultant but not a privileged aspect. Citing Greek sources of harmonics (again like Kubelka, but with a different purpose), Conrad permutates frames in quasi-musical patterns that produce colour sensations from light vibrations and retinal stimulation (Figure 48). While Kubelka's film points to a conceptual strand in the frame-unit articulation of experimental filmmaking, Conrad's *The Flicker* leads to a more expressive strobe-effect (as found in club light-shows), as much at home when projected over dancers as when it illuminates the cinema or gallery screen. In this respect it links experiments in the synthesis of colour and music from the last century (and its earlier ancestors) with a sensory-based contemporary music culture.

Like Conrad, Paul Sharits emerged from associations with Fluxus to a more structural approach. His earliest films explore single-frame cuts to pore over and eviscerate sales catalogues (*Sears Catalogue*, 1966), reducing their consumer dreams to a nightmare (*Razor Blades*, 1965–8) of personal anxiety and visions

FIGURE 48 'Exposure Timing Sheet' for *The Flicker* (1966) Tony Conrad. Courtesy: the Estate of Tony Conrad and Greene Naftali, New York.

of suicide. In some ways, Sharits succeeds to the psychodrama film of a decade before, led by Kenneth Anger, Sidney Peterson and Maya Deren, but stripped of archaism and symbolism. Many of his films evoke an identity crisis and an urge to self-destruction, but like Markopoulos – who however retained the mythic dimension by way of fragments and elliptical cuts – he adopts the frame rather than the shot as his unit of meaning. With a background in painting rather than literature, he updates the personal film in terms of colour-field, anti-illusionism and thus changes its character. It leads to a more physicalist dimension in which projected light and colour not only evoke epilepsy or other psychosomatic states but also assert the material presence of the film and its conditions of spectatorship.

Sharits explored these ideas through art theory, phenomenology and linguistics, but initially from a Buddhist or transcendentalist viewpoint. The key unit of Sharits's films is the frame, rarely treated as the product of a continuous camera-shot sequence, except when he recorded (as a form of documentary) such iconic images as Brancusi's *Endless Column* sculpture in Romania. In *Piece Mandala/End War* (1966), for example, the imagery of a couple having sex are made up of flipped and reversed photographs of the man and woman in different positions interspersed with colour frames (Figure 49). The illusion is produced as a kind of 'forced development' of the normal process by which separate successive film frames reproduce movement. In its flickering abruptness, the effect refers to the suppressed action of the projector and reveals the conditions of illusory motion even as it invokes them. The looped phrase 'destroy' on the soundtrack of *T, O, U, C, H, I, N, G* (1968) is a similarly disruptive device. Coupled with a barrage of colour frames and anxious images (genitals, scissors and an eye operation), the single word loses its meaning, to trigger randomized homophones in cyclical bursts.

With the exception of Kren, this group or cluster of filmmakers wrote extensively about their work, especially its base in the single frame as projection event. Paradoxically, perhaps, it is the more silent and enigmatic Kren who has had most attention from later artists and writers, notably Paul McCarthy, Stephen Barber and Peter Tscherkassky.[1] They concentrate on his Aktionist and 'transgressive' films, that is to say his most visceral side, but in Tscherkassky's case with due attention to the metrical and frame structure. While in the structural film era, the focus was on Kren as abstract materialist, these more recent writers turn to his expressionism and sense of physical engagement or shock, with the frame as a depth charge to convey the brisk interplay of excess in the image.

Although frame-centred filmmakers seem to be rooted in a film-as-film aesthetic, by definition, commentators often described features of their work that look ahead to imaging in a digital age. For example, in his introduction to Werner Nekes's seminal 1977 lecture 'Whatever happens between the pictures', David Lenfest cites 'techniques that range from static images to images that "stream", and to horizons, or frame lines, that break before our eyes' and lead to 'a higher picture

FIGURE 49 *Piece Mandala/End War* (1966) Paul Sharits. © Christopher Sharits.

density'.[2] With their overlays and multiple superimpositions, or layering, Nekes saw his films as audiovisual material with a 'cumulative information level' as well as an opening to subconscious association. In the lecture itself, Nekes sees film (from Lumière to the present) and other media, including TV and computers, as providing their viewers, or users, with an increasing amount of information like 'a mounting asymptote'. His example, looking back ten to twenty years from 1977, is the increased speed of the TV advert! Unlike the slow 'streaming' of early epic films, he suggests that 'nowadays we are used to superimpositions' and 'very small units of flickering frames' as advertisements pack more and more into a shorter time. This increase is a feature of all media technologies he suggests.

A collector of proto-cinematic artefacts (which were exhibited in the *Eyes, Lies and Illusions* exhibition at the Hayward Gallery in 2004) Nekes's interests were a precursor to the more recent attention paid to early cinema in its relation to new media. The 'information theory' of the 1960s and 1970s, which he refers to, shares its roots with developments in the electronic culture itself. The same could be said of the interests of Michael Snow, Hollis Frampton and Malcolm Le Grice.

In Nekes's frame-based films, all of the edits were made in the camera, with masks dividing the image geometrically, and the film having been passed through the camera as many as sixteen times. This technique – also practised by Kren and Makopoulos, in different ways, as well as by Nicky Hamlyn and Rose Lowder today – is a proto-digital method (as well as being 'filmic') in that it relies on a 'programming' approach to the act of filmmaking, rather than on intuitive or subjective principles. The biggest difference between shooting a film in this manner and working digitally is that the results of the process remain unknown until the film is completed and printed. In contrast to working with video and digital media – and leaving aside the issue of a computer's 'rendering time' – the process of filmmaking involves results that aren't immediately visible. Added to that, there is little or no 'post-production' stage in the films by the various makers discussed here, and no substantial editing, subsequent to their shooting. Perhaps this is responsible for the meticulous style of these essentially poetic and lyrical filmmakers, who choose a strict frame-bound matrix to generate extensive bodies of work in which landscape and nature are key motifs. Nekes himself looked ahead to electronic mixing and programmed multi-camera set-ups to achieve complex handcrafted shifts of camera placement. His notion of a film which might have one camera for every single frame did not have to wait for digitality, however. It is the principle of Tim Macmillan's 'time-slice' 16 mm films from the early 1980s onwards, exposing multiple frames simultaneously onto a strip of film contained in a circular pinhole camera around the subject, since reinvented and digitalized in such films as *The Matrix* (1999).

For Nekes, the film unit or 'kine' is actually two frames long rather than a single frame. Their alternation (as in the thaumatrope illusion of a bird in a cage, generated by two separate pictures either side of a spinning disc) is fundamental to cinema and is itself a form of montage. 'Cinema', says Nekes, 'is the difference between two frames': 'What an amount of information these two frames a/b give, compared with a_1/a_2 which gives the illusion of movement!'[3] The order and content of the frames in most films is usually highly predictable, but this yields less 'information' than when frames are more varied. For Nekes the 'kine' is a 'junction of different spaces and localities and also different times', and first came to the fore in Soviet montage. The example that he provides is a segment from Eisenstein's *Strike* (1924) that shows a police spy as an owl, created by alternating and blending images. A fusion of the spaces of each image or frame accordingly produces a 'gestalt' or what Nekes calls a 'gestaltsprunge', a gestalt-leap.

Like Eisenstein, Nekes argues for 'synthesis' over 'analysis', citing Apollinaire, animation and Chinese ideographs to show that 'the collision of two signs produces a third on a different level, with a new meaning'. Nekes also looks to cybernetics for a map of this 'field of information', since his model is a network of film-frame patterns in complex orders. To escape the naturalism associated with film grammar, he says, we need a new and artificial language to see how film

works. Film language itself began as an artificial language, but arguably its artifice has become less obvious.

As well as the distinction between two frames showing different images, Nekes also recognizes a distinction between two frames showing the same image, since they are never identical. The grain will be different in each picture, given that it is 'written' into the exposure, unlike TV where it is the horizontal scan lines that produce the image. For Nekes, the latent movement in a frozen film frame, which is generated from its own chemical composition, is enough to produce a new film, as in his own *Standing Film/Moving Film* (1968). But he also worked with the high speeds made possible by quick articulations between different frames, to produce a 'vibrating cinema' from the 40,000 'kines' in *Spacecut* (1971).

The optical-perceptual superimposition of frames plays a large part in Nekes's account of cinema, as it did in Eisenstein's notion of the series of a film's frames 'overlaying' each other in the eye rather than succeeding each other on screen. The emphasis here is subtly different to Peter Kubelka's focus on matching or alternating shots that occupy the same graphic space on screen (notably or notoriously in the cut from the shot of the dancing girl to a giraffe's neck in *Unsere Afrikareise*, 1966).[4] In this sense, Nekes's account of cinema is even more frame-centric than Kubelka's. For every frame projected at normal speed, the shutter 'interrupts the light beam for the transportation of the frame and also interrupts the projection of every frame once with the shutter. So every frame is projected twice.'[5] This double projection doesn't constitute a 'kine' however. It is a means of eliminating flicker and a 'constant of the technical transfer of filmic information' hence analogous to the 'interlaced' television image that is scanned for its odd and even lines: 'The taking of the picture in television equals the production/reproduction of the picture. The process of scanning is the same.'[6] Almost as an aside, Nekes notes that the exposure of a film frame, when shooting with a camera, is not interrupted by a shutter as it is in its projection. So the camera frame and the projected frame (in terms of their temporal presence) are not the same.

In commenting on the famous scene of the machine-gunner in Eisenstein's *October*, Nicky Hamlyn has argued that the sequence is a case of 'the *filmic* rather than the *filmed*', since its effect is caused by bursts of single frames to emulate the act of shooting (Figure 50).[7] This sequence in *October* is akin to the example of the thaumatrope that, when spun, fuses the separate images of a bird and a cage to show the bird inside the cage. For Hamlyn, the loop-like mechanism of the thaumatrope demonstrates the 'persistence of vision' which is central to cinema's technology. (Like all optical toys, the thaumatrope also demonstrates its own mechanical functioning, mechanisms gradually concealed in later devices from the Mutoscope and Edison's Kinetoscope to the four-bladed projector shutter.) To this observation, Hamlyn adds the comment that the concept of the persistence of vision invokes 'temporal recession' and the key frame in digital video:

The latter since it invites us to think of the moving image as starting from an initial spatial point – the key frame – so that movement is defined spatially in terms of differences between one frame and the next, the former – temporally – receding from, that starting moment. But this recession is also spatial, since it is as if we are looking at all the subsequent frames 'through' the first, key frame.[8]

Werner Nekes's lecture was written long before digital imaging as it is commonly conceived, and in this respect it is all the more notable that he describes the film frame in cybernetic terms with claims such as these: 'Every frame stores an amount of time'; and cinema is a 'tool for the storage of visual information in time'.[9] He also notes that the speed of a film, as a mode of information retrieval

FIGURE 50 Sequential shots from *October* (1928) Sergei Eisenstein.

and representation, is variable. Correspondingly, the fragmentation of time, for the purposes of its recording, can offer several alternatives to the reproduction of ordinary motion: the content of a filmstrip can be stretched through loop-printing; the sequence of frames can be reordered and different versions can be projected simultaneously, on multiple screens. Repetition in time also involves differences between the similar. (Literary forebears would be Gertrude Stein and Samuel Beckett.) But where and in what order the frame units occur will determine their meaning, as seen in films of the era such as Nekes's own *jüm-jüm* (1967, made with Dore O) (see Colour Plate 7) or Anne Rees-Mogg's *Muybridge Film* (1975), in which successive movements of a figure on a swing (in the former) or cartwheeling (in the latter) are re-cut and shuffled and thus presented out of their 'natural' order. 'As in field theory, you don't only look at one electron to describe it, because you cannot describe it only by itself; you have to see at the same time its relations to the others. Hence, you can describe the relation of the one kine to its field and the relation of this field to the other fields.'[10]

Nekes suggested that video research centres and computerization would expand the field network further. (By 1977, computerization had already been used in the context of animated films, as in John Whitney's *Matrix* films from the early 1970s, made with the assistance of IBM.) This idea is perhaps tied to the 'generative grammar' of film that Nekes envisaged, built outwards from the 'kine', as the smallest unit, but then also including the spectator in a constructive role.

Typical of many films by Nekes's from this period, *Makimono* (1974) slowly 'de-realizes' a landscape which has been shot along many different axes from a fixed camera position. This film also includes superimposition, contrasts of light and varying focal length, single-frame shooting and so on. What it represents is not a scene observed – the scene cannot be simply perceived or taken in by the viewer – it is assembled and disassembled by the viewer's active engagement in the process of watching the film. Today, most video gallery art that uses landscape adopts the opposite approach, so that the depicted scene is absorbed by the viewer with minimal disruption. Simple cuts might well expand the camera's gaze, but they rarely undermine the integrity of the landscape as an image or a(n) (apparent) fact. For Nekes, the aim is rather to have the viewer's 'attention jump between levels' with the work of the spectator reflecting 'an ambiguity of perception'.

The same principle applies to his use of sound in his films so that a gap opens up between the otherwise synchronized sound and image tracks. In *jüm-jüm*, for example, the rhythmic units on the soundtrack are similar to the length of time associated with the motion of the swing, which cuts every four frames, but they are seldom in time. In 'alternatim' (the second part of the film *Diwan*, 1973), sound is subtly transformed as imagistic shots alternate with moments of streaming or 'fluttering' that is the result of having released the camera's pressure plate. Like Kubelka, Nekes argued that ordinary synchronization in film confirms our sense of space and time as stable. When that synchronization is modified or broken 'new

topological entities' can arise. Nekes's lecture concludes with the statement that cinema is a 'tool to make something seeable that we cannot see normally' allowing us thoughts that 'we wouldn't think normally'. It has the potential to constitute a 'new reality' rather than an illusion of reality: a tool to 'make the invisible visible' (a proposition that chimes with Paul Klee's definition of art). The last line of the essay is: 'This time/space analysing instrument, film, might change our understanding of the time/space relations in the world. ... What might a broken horizon add to our intellectual horizon?'[11]

In his essay 'Lord of the Frames', Peter Tscherkassky, like other Austrian filmmakers of his generation, looks back to Wassily Kandinsky and, through him, the Western tradition of art to distinguish between naturalistic realism and formal, idealizing abstraction.[12] He maps the terrain of twentieth-century art by way of what Kandinsky referred to (in 1912) as the two poles of 'grand abstraction' and 'grand realism' and sees these as epitomized by the rigorous purity of Mondrian's painting and the extreme realism (literalism?) of Duchamp's readymades.[13] For Tscherkassky, it was not until the 1960s that the issue of distinguishing between abstract and realist tendencies entered cinema, with Kurt Kren's Aktionist films that followed on from Günter Brus and Otto Mühl's abandonment of painting to use the human body as a direct source for expression.

While Brus and his 'grandiose pathos' derives from expressionism, painting the body and the surrounding space and surfaces, Mühl was a dadaist prankster. And where Brus uses a secondary system of signs such as gauze, scalpels, razor blades and other medicalia, Mühl uses paint, food and rubbish to put staged still-lifes into direct, unallegorized action. Kren's films of these two different artists' performances reflect this distinction, says Tscherkassky. In earlier films, prior to his Aktionist documentaries, Kren 'counterposed the mimetic abundance characteristic of film with a rigid mathematical formula'. In *2/60 48 Heads from the Szondi Test*, for example, the length of a shot was determined by the sum of the previous shots: 1, 2, 3, 5, 8, 13, 21 and 34 frames.[14] Here he used the Fibonacci number series. In other films he used different prearranged scores. Whether edited in the camera, by means of the single-frame mechanism, or cut down to single frames as in later films, such 'flash editing' was a marked contrast to the 'realism' of Mühl's performances. In the first of Kren's Aktionist film, the widely seen *6/64 Papa und Mama*, he 'interlaces' repeated shots and leitmotifs, according to Tscherkassky, 'establishing a network of images that circle one another for the duration of the film'. The 'fury' in front of the lens is woven into geometrical and even ornamental patterns, the abrupt single frames turned into a distillation of time and event that is comparable to the geometrical patterns of a Mondrian painting.

But when shooting the expressionist Brus, as in *8/64 Ana–Aktion Brus*, Kren abandons seriality and flash frames for a 'grand abstraction', in which a 'wildly gestural camera undercuts the Brusian pathos and infuses the filmstrip with images of Tachist disintegration'. Such 'writing with the camera' makes the image

opaque, so that the events 'freely float in a flux of non-representational gestural traces' whereas the Mühl actions are more legible through the 'ornamentation' of the film. In short, Kren counters Mühl's 'naturalism' with expressionist abstraction, and Brus's expressionism with a purified and flowing abstraction. The distinctions between realist and abstract art that Tscherkassky makes are permeable rather than strictly analytic, but point to important features of these films, themselves the product of many cultural crossovers, from serial structure to anarchic performance. The contradictory impulses are retained as a structuring principle of the films.

In a late film, commissioned as a trailer for the hundred-year anniversary of cinema (in 1995), re-titled by Kren 'a thousand years of cinema' in a sardonic allusion to the Third Reich, he filmed tourists in Vienna videoing and photographing St. Stephen's Cathedral (Figure 51). The soundtrack is looped from a Peter Lorre anti-Nazi film of 1951, *Der Verlorene* ('We've met before, I don't know where …'), but it changes to an air-raid alert at the end of the film, accompanying a jerky camera tilt that follows the cathedral's spire upwards. Images have consumed reality, tourists 'bombard' the cathedral with their cameras to capture it in small frames that are similar to those in the film camera that Kren uses to capture (and lose) them.

FIGURE 51 *49/95 tausendjahrekino* (1995) Kurt Kren.

Among other things, the tourists are looking at and recording the medieval sculptures on the facade of the cathedral, artefacts that coincide with the birth of realism in Western art, which is still inscribed (post-Renaissance) in the camera lens. Rather than shooting with the widest lens to capture the largest possible 'view' of the scene, Kren shoots close-ups, in short shots of either two, four or eight frames, from a distance. The sometimes blurred imagery is an effect of shooting with a handheld camera with a long lens. Tscherkassky interprets this as personal 'handwriting' to convey a 'family reunion' where the realism of Gothic art meets the lens-based offspring it inspired, but with no recognition or awareness by the tourist participants (hence the looped 'We've met before … .'). A thousand years of mimesis is for Kren the cultural crisis of a hundred years of cinema.

Developments in frame-based thinking also took place outside of single-screen filmmaking, and beyond the cinema as it actually existed at the time. In 1978, Taka Iimura described as 'film-installations' his attempts to expose 'the whole system of projection', not just what was on the screen. Everything had to be visible: 'To achieve this, I use, rather than a theatre with seats, an open space like that of a gallery, where people can come and go at any time, and walk around the installation. I do not darken the space, but exhibit under normal room light where projected light is still quite visible.'[15] The films in the installations that Iimura refers to here, from 1968 onwards, were exclusively comprised of black and clear leader in loops: film as material and film as light, alternating with darkness, in projection. One tenet of these works is summed up in the following: 'The negation of an image on the screen is, itself, an object.' It is in this regard that Iimura distinguishes his installations from expanded cinema, which he saw as image-oriented (and often involving multiple screens), and also from sculpture, even when (as in *Projection Piece*, 1972) two projectors face each other while a third casts their shadows on to one of the walls. The film loops that are used in this piece decay in the course of projection, the clear film getting dirtier and darker as the dark film becomes scratched and lighter, so that the process of time is inscribed into the projection. 'Whereas in photographed film time can be manipulated because of the frames, time in black and clear film seems to progress as real time progresses, and is (almost) inseparable from it. One may call it "film time as real time".'[16]

In certain installations Iimura invokes the shutter of the projector as an immanent part, while for other single-screen films he has removed or altered it to make films in which light seems to stream. The shutter mechanism also features in the more rhythmic and chromatic multi-projection and often image-less films of Paul Sharits. In a detailed description of Sharits's films, Stuart Liebman begins with the still authoritative early studies of motion by the gestalt psychologist Max Wertheimer (between 1912 and 1923).[17] What Liebman refers to as the 'crisis of representation' in modernist art, including structural film, is prefigured (sixty-five years earlier) in these investigations of apparent motion from a sequence of static figures.

In the first instance, as Liebman recounts, the theory distinguishes a 'partial' or low threshold illusion, characterized as a 'kind of visual stutter', from phi- and beta-motion, which are often run together in descriptions of the 'phi phenomenon'. Phi-motion is described as an oscillating passage of light, which is the same as the impression of motion associated with any real object that moves so fast across the field of vision that it is contourless. In contrast, beta-motion is described as the appearance of a smooth continuous path of a defined object in that field. Beta-motion corresponds to the 'normal' cinema experience, but is not as primary as the underlying, oscillating passage of light, which effectively defines the reality effect. In the later studies, Wertheimer showed that similar if discrepant shapes in the 'total field' of view, when quickly linked, are seen as stable relative to the field as a whole if they are simpler than other competing figures. This underwrites the repeated, minimally different, sequencing of events in film frames, to replicate the real (or pro-filmic) events they depict.

In questioning the illusion of movement and stable continuous space in cinema, filmmakers have in effect challenged the veracity of beta-motion. Liebman names several methods. Some films stress the artifice of the effect with loops and repeats that denaturalize motion so that 'it is no longer the transparent carrier of meaningful actions' (the examples are George Landow's *Bardo Follies* (1967) and Malcolm Le Grice's *Berlin Horse* (1970)). Some are more investigative, and use motion blur (as in Ernie Gehr's *Field*, 1970) or remove the shutter in the camera, printer or projector (as in Le Grice's *Little Dog for Roger*, 1967) to emphasize the phi-effect that comes with pulsing light and the regular mechanics of film's systems of illusion. Others use pixilation and rapid editing, down to the single frame, to cross the threshold of phi and beta (as in Robert Breer's *REcreation*, 1956). In these instances, certain figures are given some stability when sustained by beta-motion, but that stability is then also opposed by the optical flicker and clashing phi-effect. In *Serene Velocity* (1970) different zoom positions provoke a stuttering partial motion, bringing the initially stable beta image to the edge of flickering phi-motion. Some films exploit the flicker associated with phi-motion directly, as in Tony Conrad's *The Flicker*. For Liebman, the 'flicker film' in general 'affirms the kinetic effects of the phi phenomenon as the epistemological ground for all motion perception in cinema'.[18]

In contrast to the black and white frames of Conrad's film, Liebman sees Paul Sharits as having explored the coloured frame in a 'matrix' of film elements in his 'higher drama of celluloid', retinal effects, optics and projection. From 1970 this included installed multi-screen formats that Sharits dubbed 'locational' pieces, designed for continuous projection in galleries and museums. *Shutter Interface* (1975) used four overlapping frames to play coloured light loops from projectors visible in the space (see Colour Plate 8). The loops of colour flicker films from the four projectors overlap so that seven irregular rectangles carry the colour flow and mixtures. Film colours, from dark to light and in 'painterly' hues, pulsate on the

screen (or wall). A musical analogy evokes a series of chords and intervals that arise briefly from vibrations across the colour mix. Black frames with sound beeps interact with the visual flow, to modify the dynamics of sound. In his description of the work, Liebman relates *Shutter Interface* to the synaesthetic vision of Eisenstein, who was similarly sensitive to the projected pulse of light as a basic film fact (though not to abstraction).

According to Liebman the range of colour harmonies and contrasts in *Shutter Interface* trigger a range of phi-motions: 'When the distance between similar colours is great, the more percussive saccadic pulses characteristic of partial movements appear. If closely valued hues appear in several adjacent rectangles, however, a gently rippling chromatic wave washes across the wall.'[19] In the same passage, Liebman notes that the colours in each film loop are different, with the left-hand screen using a lighter palette. This affects the direction of the movement that the piece gives rise to, 'which seems to flow from left to right, though many countering motions consistently break the momentum and reverse the direction'. At the same time that the apparent motion has velocity, the work also suspends time, chronology and sequence, marking the difference (it could be said) between Sharits's transcendentalism and the UK/European avant-garde. Liebman calls the work visionary and hypnagogic and praises its simplicity and naturalness. Anticipating some of the recent responses to Anthony McCall's solid light films, he also describes its fascination and perceptual play as erotic, so giving it a physical dimension. He also mentions an aspect of the work that he thinks unsuccessful: that is Sharits's own explanation that the black frames (which are included in each loop) signify the shutter mechanism and the 1/48th of a second of darkness that militates against flicker and allows for smooth motion. For Liebman this symbolizes an event that the projector itself cancels when the film is shown, and in this regard he characterizes Sharits's attribution to the black frame as a 'modernist gesture' imposed 'by fiat'.

The strobe or flash that interrupts the flow of light has led to much interrelated work, in both film and video, from the 1970s to the present day. These include the vidicon tube experiments of David Hall, in which a video scan of spectators in front of the monitor is held and retained on the screen as a ghostly after-image. In *Between* (1972) by David Hall and Tony Sinden, footage of a cameraman filming the screen is successively filmed and re-filmed until the pictorial field breaks down into semi-abstract colour shapes. The three-screen film *Diagonal* (1973) by William Raban generates abstract pulses of light and synchronous bursts of sound by printing from the aperture gate. Thirty years later, Raban reworked the cinema of light impulses for an installation at the 291 Gallery in Hackney, London, which was sited in a converted church. For this piece, *After Duchamp* (2003), Raban projected three asynchronous scenes of a 'nude descending' an iron spiral staircase back onto that same staircase, in an otherwise bare gallery space (Figure 52). To film this piece, Raban used a strobe light to break the fluid motion of the figure into

FIGURE 52 *After Duchamp* (2003) William Raban. Documentation by Dana Munro.

separate parts. In projection that intermittent light source makes for a flickering sequence in which the movements of the figure seem to rise and fall.

Many such works for installation or live film or video performance seem to challenge or complicate Michael Fried's assertion, in the essay 'Art and Objecthood', that minimalist art has a theatrical element (the term is used as a pejorative) in its incorporation of the spectator. For Fried, theatricality compromises the self-containment of the work of art, which is otherwise 'indifferent' to the beholder. In minimalism and beyond, the spectator is more than an implied viewer, but rather an agent to complete the work. It is true that almost all time-based artists since the 1970s have emphasized the constituent role of the spectator. This arguably points to an affinity with artists whose work Fried discusses and chides – including Donald Judd, Carl Andre, Robert Morris – and many artists' films have attracted the minimalist label. But arguably it points to some unique features in time-based art and also the specific historical context in the 1970s.

The first of these is the temporal nature of film, which Fried believed ruled out film – however experimental – as an art. That is to say, it lacks the conditions of overall revelation and formal integrity that his definition of visual art required.[20] But by the same token, film's time-base is as essential to it as frontality is to painting. It is an irreducible condition, often tested in the avant-garde by films of extreme brevity or duration. This condition also implies a spectator, since a painting or sculpture retains all its properties independently of its being witnessed. It is still what it is, even if no one is looking. Film and other time-based arts are quite different. The technical format (film, video, digital) stores the work rather like a score in music or a script in a play, since it has to be performed in order to

activate its shape, rhythm and duration, which otherwise remain latent. And while it makes sense to think of a painting or sculpture existing independently of the act of viewing – Fried's objection to minimalism being that it ignored that condition to attract the completing act of the spectator – it is more difficult to think of film in this way. Kubelka's *Arnulf Rainer* makes this point very well, since the score is fixed but the performance is context-dependent on the properties of the projector and the viewing space (and the capacity of the spectator who is confronted with flashes of light and strobe flicker).

The parallel in time between 'structural film' and 'structuralist theory', in the 1970s, also suggests a second conjunction of ideas about the role of the spectator. In opposition to formalist abstraction in art and formal analysis in literature, both of these independent but contemporaneous strands of thought led to a more rigorous interrogation of the construction of meaning by the spectator or reader. The reader is concluded to be 'in the text', and to be an implied reader in this way is also to be implicated. The aim, perhaps now seen as arcane, was to challenge the autonomy of the art object and (in film studies, born at this time) the passivity of the film spectator. Theories of spectatorship that developed around *Screen* magazine were to permeate art theory and criticism, and these emphasized the ways in which films create a viewing subject by the codes of cinema. Some avant-garde filmmakers, notably Peter Gidal, criticized the focus of film studies on Hollywood cinema. Coming from the art school nexus of the film co-ops, a distinct regime of spectatorship drew on debates about the viewer in the other visual arts, rather than cinema itself. In both cases, however, film studies and art theory agreed that the spectator should be seen as a participant rather than a subject-observer, or a member of an imaginary audience targeted in advance by commercially driven assumptions.

In a 2003 film by veteran filmmaker Morgan Fisher, a strict system is used to structure a series of brief elliptical 'inserts' from film dramas. These inserts include shots of newspaper headlines, letters and close-ups of actions or objects that fill in details of the story but have, for Fisher, an 'alien' quality. They are essential but marginal at the same time, having often been shot by a secondary crew. They have a functional and instrumental role, although – as in Surrealist 'appropriation' of isolated details – they can also seem uncanny or compelling when singled out. Fisher stated: 'I wanted to make a film out of nothing but inserts, or shots that were close enough to being inserts, as a way of making them visible, to release them from their self-effacing performance of drudge-work, to free them from their servitude to story.'[21]

The film, titled by the sign (), standing for 'in parenthesis' which is Greek for the act of inserting, was constructed by a series of rules based on the example of Sol LeWitt. Fisher says that 'the rule can be stated, and its being stateable locates the origin of the work of art outside the artist. The artist didn't make the work, the rule did.' The work is still intentional, but it is composed by way of an external decision.

Contrasting his film to the classic montage editing of Peter Kubelka's *Unsere Afrikareise*, where the aim is to maximize meaning, Fisher takes the opposite course, so that the significance of the cuts is unintended. In his notes regarding the background to the work, Fisher recalls a film from 1965 by Thom Andersen and Malcom Brodwick, entitled – —, otherwise known as *A Rock and Roll Movie*. The system is based on the title, a short line followed by a longer line. The shots are in pairs that follow these relative lengths, so that the second shot is longer than the first. In the next pair, the first shot is longer than the preceding first shot, but shorter than the second, and the second shot is longer than the preceding second shot. Each shot also has a dominant hue, arranged in the crosswise structure of a colour circle. This is less evident than the first rule, but is sensed in a gradual diffusion and extension of time and image. Fisher also goes on to cite the systems used by Raymond Roussel, drawn from clusters or lists of words and their homophones chosen from dictionaries (and calls them 'assisted readymades').

Though Fisher does not describe the system used in () – 'The important thing is what the rule does' – he does reveal that no two shots from the same films are seen in succession, and that any 'interweaving' of shots is not based on their content: 'The rule does not know what is in the shots.' But succession nonetheless emerges, he admits, as does the search for meaning, despite the film's use of chance, and thus it 'brings into play the principles of montage' inciting and rejecting narrative associations at the same time. The inserts that the film uses are from obscure movies – mainly thrillers – that often look as if they were 'made for TV' (Figure 53). At the cheap end of the found-footage market, this has nothing to do with the recent crop of re-cut and cited sequences from Hitchcock and other Hollywood directors in, for example, gallery works by Douglas Gordon and Matthias Müller. If anything, it is closer to the quoted clips of Jeff Keen, Birgit Hein and the Italian pioneers Angela Ricci-Lucchi and Yervant Gianikian, and Massimo Bacigalupo. For these filmmakers – as in part for Martin Arnold – the secrets of film drama are found at its fringe in cheap cinema and TV fodder.

Many of the inserts in (), characteristically in faded colour, look as if they date back to the 1950s and 1960s, and several feature Western saloon barrooms. Some shots in the film evoke unexpected and perhaps accidental allusions to other films, such as Bruce Conner's *A Movie* (the shot of a sheep), Maya Deren's *Meshes of the Afternoon* (a key) and Edwin S. Porter's *The Great Train Robbery* (a gun firing at the camera). The film conspicuously lacks shots that offer psychological cues: there are no faces, for example, only abstracted body parts or objects. In this it differs severely from films that rely on the literalist assembly of shots of stars, as in Christian Marclay's *Telephones* (1995) or the emotive fix of the music-driven *Feature Film* (1999) by Douglas Gordon. The film resists the viewer's identification with its fractured actions and glimpsed protagonists, as much as it invokes a hidden rule that both generates and withholds associations and narrative cues.

FIGURE 53 *()* (2003) Morgan Fisher.

Although wholly filmic in the old sense – it was shown on a single 16 mm projector in 2004 at Cubitt, a small North London gallery, screened 'on demand' whenever a small audience had assembled – Fisher's film has a quasi-digital implication. The underlying system is clearly mathematical in some sense, built on a series of alternations and substitutions. Likewise, Fisher's claims that the film's system is independent of its content relates it to the abstract function of the algorithms in computer programming. In this regard the randomized structure used by Fisher and other filmmakers is easily modelled in digital editing. Another example is the diaristic video work of Malcolm Le Grice, starting with *Chronos Fragmented* (1995), where sections of video footage are allocated a code or group word and permutated at random. In this case, the content is more primary, consisting of informal shots of family, friends and landscapes, with driving being a key moving image. The content is personal, but the principle approach to structuring is the same.

FRAMES AND WINDOWS

Switch on any computer and the screen fills with square or rectangular 'windows' which the user can move, overlay and even animate to provide and compare information. Go back to the early experimental cinema of Hans Richter or Walter Ruttmann and one finds the same 'form-language' in which very similar graphic shapes are seen to advance, recede and transform on the screen. These shapes and movements are the sole content of such films, which were made roughly between 1921 and 1925.

Is this pattern of resemblance simply on the surface, with no other particular consequences, a more or less chance meeting between the ex-Dadaists of long-ago Berlin and the ex-hippies of Silicon Valley? Almost, but not quite, is a possible answer. For the graphic art of abstract animation, no surface is simply superficial, and forms do indeed speak. More historically, connections pass from the Cabaret Voltaire and Weimar Germany to New York and California in a not altogether broken line. But the line also loops back on itself, since Dada and radical Constructivism did not stop dead in the 1930s. The neo-Dada and Fluxus art of the 1960s play a part in the story, as does contemporary artists' video today.

A clear statement about the aesthetics of this history is made in David Hall's *WithouTV* (1992), one of a series of minute-long video pieces commissioned from the artist by MTV. Shown repeatedly and at random by the music channel, these short works form part of Hall's strategy of 'intervention' or 'interruption'. In this example, a TV receiver is on a flat piece of grassy ground (in fact, near the now-emblematic site of Dungeness). The TV recedes and disappears, its space now framed by another TV set which replaces it. The process is repeated as a series of potentially infinite TV-recessions occur. The illusion of space is seen as both compelling and constructed. The final frame is coextensive with the real TV set in our own viewing space, on which the work is shown.

The first steps in the direction of the dynamic window-plane were taken with the experiments of Hans Richter and Walter Ruttmann in the 1920s. The very first attempts to make abstract art in the film medium took the form of designs

and plans round 1912 (in the case of Picasso's friend, the painter Henri Survage), and similar schemes (with some tentative try-outs which have not survived) by the Italian Futurists perhaps two years earlier. In almost all of these instances, which make up the lost *ur-cinema* of abstraction, the effects seem to have been conceived as a series of overall surface shifts and transformations. The shapes that predominate include circles, curves, stars and spirals, often in a style close to that of symbolism.

These ideas were in fact ahead of their time, even if – to later generations – the symbolic elements seemed to be regressive. Richter and Ruttmann, by contrast, who got abstract cinema beyond the drawing board and who actually shot and projected abstract films, were more easily aligned with the high modernist tradition: the Bauhaus, the post-First World War 'age of isms' and hard-edge picture making. For a long time this gave them great kudos, before 'formalism' became a dirty word. They were already canonical in the 1920s, and became even more so when they were reissued on the new 16 mm experimental art film and underground circuit in Europe and the United States thirty or more years later. In fact, the story of their relation to high abstract modernism is even more complicated and intriguing.

The early films reissued in the 1940s by Hans Richter – then in the United States – are, in part, compilations of experiments whose origins go back to the Zurich Dada period of 1916 to 1917. Around 1919 to 1921, Richter was collaborating with the older Cubist artist Viking Eggeling on a series of scroll-drawings. Their aim was to reveal the development of forms when small changes were made to the content and shaping of the abstract image. This involved the idea of process, rather than the single statement of an overall surface as, for example, in the influential paintings of Kandinsky. Consequently, the unfolding of the scrolls also implied an art of duration, just like film, and logically enough Richter and Eggeling focused their efforts on getting access to a movie camera. They sent out a battery of manifestos and statements – and it worked! With some limited but vital technical support, they made their first steps to the abstract film.

A point to underline here is that one crucial stage in the invention of abstract cinema emerged from a Far Eastern model of art – the scroll – and not from the bounded frame which characterized mainstream Western art. There is also a crude analogy between the scroll unwinding in front of the viewer and the film moving from one reel to the other.

A second point is that artists at the fringes of the industrial system had little chance to make a film. To make a film was, in fact, to engage with industrialization. Eggeling, a very pure artist, worked with a loaned camera, an occasional technician from the Askania Camera Company and finally a willing helper, Erna Niemeyer, a young Bauhaus student. His film was premiered shortly before his death in 1925, at a major screening of abstract film art under the auspices of UFA, the great German studio of the time. Then, as now, industry was able to support a pure art form on

the grounds that it constituted 'research'. Malevich in Soviet Russia mounted the same argument to defend artistic experiment against the more practical demands of the State. Like many filmmakers today, Richter was less troubled by these issues. By the mid-to-late 1920s, he was making advertising films that mixed abstract and figurative styles and was working on special effects for fiction films. But at the same time, he was a loosely attached member of Brecht's circle, promoting left-wing film clubs, proselytized for the artistic film and, when Hitler came to power in 1933, shooting an experimental documentary in the USSR.

The path to abstraction was by no means smooth. Richter's *Rhythm 23*, which is effectively a compilation of early film trials, is very much in mixed mode. Some of its linear drawing images seem to echo the Eggeling-inspired flatbed period, in which curved shapes transform but remain parallel to the picture plane. Other non-linear squares and rectangles advance, overlap and recede, sometimes abruptly, in the spirit of the more accomplished but misleadingly dated – because probably made later – *Rhythm 21* (the number refers to the year when Richter claimed the film was made) (Figure 54). Werner Graeff, then a young artist and publicist for 'the new art', recalled many years later that Richter was still wrestling with the mysteries of aspect ratio, hand colouring and the mathematics of abstract motion in 1922. Much of the material in the surviving films probably dates from between 1923 and 1924, rather than earlier, and we cannot be sure that they fully resemble their originals.

Richter's friend Graeff saw, with many others, that film was a kind of shock effect, an assault on the optical unconscious. Eisenstein in his 'montage of attractions', Walter Benjamin with his image of film as 'dynamite at a tenth of a

FIGURE 54 *Rhythm 21* (1921–4) Hans Richter.

second', Artaud and Buñuel in Surrealist cinema, all variously interpreted the violence of vision in the cinema. They believed this violence would be a powerful force to renew perception and interrogate the given world. For Graeff, writing in 1922, abstract film uses 'elementary optical means' and techniques 'to make powerful impressions of an almost physical nature (blows, ruptures, pressure etc.) upon the spectator. The calculated alternation of partial and total surprises plays the major role in this process.'[1]

Now this was a road that Eggeling decisively did not take. A painter and musician at heart, for him film was an output medium, it was not in itself the goal. The goal was the depiction of movement and tonal shifts or contrasts across time in strict relation to the actual plane of vision – not the cinematic illusion of spatial depth crafted by Richter (Figure 55). Compare their titles: *Diagonal Symphony* for one; *Rhythm* for the other. There is deliberately little obvious rhythm in Eggeling's surviving work, and the film was to be played silent (a rare stipulation when there was almost always sound accompaniment to film projection). He paid more attention to the rate of movement and change than to the rhythmic aspects of cinema explored by his fellow abstractionists. The question of music was, in some ways, displaced elsewhere – into the very construction of the work, its algorithmic and musically scored base.

The question of illusionistic depth can be similarly traced in the abstract film series *Opus I–IV* (another musical offering is in the title) by Walter Ruttmann. Apart from Oskar Fischinger, Ruttmann was the most professional of these artists at this stage, as an animator (working for Fritz Lang and Lotte Reiniger among others), and had corresponded with Fischinger on technical questions. Large parts of the symbolic battle between circles and squares in his four-part film series

FIGURE 55 *Diagonal Symphony* (1924) Viking Eggeling.

derive (in the period 1921–5) from a flat-and-frontal style, which stands for the painterly voice in early abstraction. It is only towards the later part of the series, and outstandingly in the magnificent *Opus IV* (1925), that Ruttmann takes on the push/pull or advance-and-retreat form language, which Richter had (on his own account) so painstakingly pioneered. For this film, Ruttmann used what appear to be the major resources of the animation rostrum camera, and his visual effects are staggering in their control of space and – of course – rhythm. The screen seems to explode and pulsate as Ruttmann explores its dimensions through time, creating effects (especially of running vertical patterns) that recall today's digital streaming (Figure 56). Like Richter, but even more powerfully, these films also treat the frame edge as an equal space to the now destabilized centre of the screen.

Seen on its own, as it often is, since it is the most widely circulated of the four *Opus* films, it makes Ruttmann look more of a hard-edge Constructivist or formalist than he probably was. The series actually began, with *Opus I*, on the flat plane and flowing shapes moved over it. There was at first very little illusion of depth and dimension, and the preferred drawing style was definitely more 'organic' than machine-driven. It was arguably left to Richter to complete the process of combining organic and mechanistic ideas in the abstract film, in his own mixed-mode films of 1926–8. These combine figurative with abstract imaging, light play and objects, and incorporate the human presence directly. Here he took a great

FIGURE 56 *Opus IV* (1925) Walter Ruttmann.

FIGURE 57 *Film Study* (1926) Hans Richter.

leap forward. The stumblings and (creative) crudities of the *Rhythmus* series are behind him and his grasp of visual space and logic is complete.

Ruttmann completely abandoned the abstract cinema when he took over the direction of the seminal documentary *Berlin: Symphony of a City*, in 1927, literally fading abstraction out of the picture in the opening sequence of that film, as real shapes (railway tracks, telegraph poles) replace drawn ones (abstract lines and triangles). Only the title of the film recalls its distant origin in a concept of film art modelled on music. By contrast, Richter began to edit photographic and abstract images together, inventing a new form of montage which not only culminates in the avant-garde as a lyric form but also – he might have been pleased to learn – pioneers the music and promo video of our own time. The key film in this context is arguably his *Film Study* of 1926, which cuts together the, by now, well-honed and elegant pictorial grammar of abstract shapes with a range of camera-shot images. These include labour (a man hammering, linked to an abstract wedge of light), nature (flocks of seabirds in backwards motion or inverted, linked to circles) and the eye (floating and superimposed artificial eyes, a metaphor for viewing) (Figure 57). Negative footage similarly asserts the distinctiveness of the film medium.

It is perhaps not such a big jump to see if more recent films and videos reveal whether or not the same form language still flourishes. Richter nuanced the idea of form in film when he said that there was, strictly speaking, no form in his earliest abstractions:

> I mean that by taking the whole movie screen, pressing it together and opening it up, top, bottom, sides, right, left, you don't perceive form any more, you perceive movement. … The definition of form refers to one's perception of the formal quality of a single object, or several single objects; but when you

repeat this same form over and over again and in different positions, then the relationship between the positions becomes the thing to be perceived, not the single or individual form. One doesn't see the form or object any more but rather the relationship. In this way, you see a kind of rhythm.[2]

Repetition and rhythm, rather than pure form, are the hallmarks of George Barber's *Scratch Free State* (1983) in which abstract blocks and squares of colour float over the found-footage which comprises most of this early 'Scratch' video (assembled from films and TV material) (see Colour Plate 9). The floating areas add an overtonal or contrasting montage to the video-mix which mostly fills the screen; inset birds in flight (shades of the pigeons and gulls in *Film Study*) are superimposed on underwater shots, for example. Here the soundtrack is an overt part of the composition as a whole, but as with most Scratch Video it is also selected from existing rock music rather than specially composed, as a slight throwback to improvised live accompaniments in the so-called silent cinema. In this case, the soundtrack is disco, in defiance of overly high art conventions. On the other hand, this work stands in the lineage of artists' video, rather than the more political side of Scratch (as was early recognized by David Hall). Its title may echo Mick Hartney's *Orange Free State* (1978), but more importantly the video, like other work by Barber, also directly incorporates the typical abstract shapes of the early avant-garde as a part of the graphic overlaid mix which curtains the screen. This abstract veil interrupts the full view of the movie clips behind them, and disrupts their narrative as much as the rhythmic 'cut-up' effect of rapid montage.

Over a decade later, the Greek-born videomaker Vinsky (Nikolas Tzaferidis) records a journey from Kent to London, where he rapid-shoots the city streets for *machine-ing* (1997). That, at least, is one half of the visual story. Certainly, the images are recognizable – they record a fragmented walk through the City – but over them, parallel to the picture plane and defying the illusionist depth of the image, there runs a second stream of shapes made up of grids, striations, shifting lines like those of a graph and information coded by the camera itself. The act of mapping the image is here literalized, using the form-world of the early abstract cinema, but now digitally coded. The film comments not just on its own making but on its own viewing. The fracture of sight and angle has a loose parallel to the Cubist revolution, but the logic of movement is anchored in abstract film.

A third example is video-artist Steve Littman's colour-grid 'homage' to Hans Richter (and Piet Mondrian) called *Digital Boogie-Woogie* (1997). Smoothly flowing rectangles and lines, initially in black and white, become filled with subtle colour over the ten minutes of its duration. More than any other work discussed here, this video makes the point that is central to the argument. These grids and tracks, which so much resemble the form-world of Richter and Ruttmann, are the underlying digital matrix of a wholly figurative work, *Predatory Cat/Selfish Diva* (1997) (see Colour Plate 10). Delightful in a different way, this piece shows

a pigeon – that bird again! – matted onto a complex series of interlocking spaces which seem to offer food and protection. The pigeon, a kind of pocket-sized Tantalus, can never get at the tempting objects around it. This short work, on the edge of symbolic meaning, is transformed into the equally rich language of abstraction by means of the technology that produced it. The notion of the matrix, a very powerful contemporary icon of the production of meaning and affect from the hard-line visual arts to the soft-bellied commercial cinema via colour-printing, is a related story. Ultimately, it is a mathematical concept, but in Littman's video it takes on abstract visual status through the transformation of rhythm.

A different and astonishingly forward-looking use of mathematical system is seen in the Austrian filmmaker Peter Kubelka's *Adebar*, made in 1957 (Figure 58). Kubelka was then part of a group of artists who combined the expressive vigour of the painter Arnulf Rainer (one of Kubelka's abstract films is named after him) with systems-based thinking derived from the Vienna School serial composers led by Schoenberg and Webern. *Adebar* consists of a number of very brief shots of dancers in a club – presumably the Adebar cafe that commissioned the film as

FIGURE 58 *Adebar* (1957) Peter Kubelka.

an advertisement. The shots vary from positive to negative, moving to still. The soundtrack is made up of looped, and thus repeated, pygmy tribal music, echoing the African drumming that Len Lye chose for his later and most purist abstract films, which were handmade animations in black and white. As described by filmmaker Peter Weibel: 'The film shows dancing couples in positive and negative, so shot, that they have the effect of shadows.'[3]

Adebar was composed to a strict system based on patterns of 13, 26 and 52 frames (which Kubelka believed gave a more classical sense of proportion than 48 frames, the more obvious module for a camera running at 24 fps). These shot units are then ordered according to a system like a tone-row in serial music. The basic row is permutated, inverted and run backwards until all the possible alternations are exhausted. The film is one minute and fourteen seconds long, consisting of 44.4 feet or 13.533 metres of film, or 1,776 frames. It is essential to the film that these measures can be taken and known.

This film is forward-looking in a number of ways. Although it is exceptionally 'purist', it was nonetheless a sponsored film. There is a long-standing tradition of sponsored radical documentaries going back to the 1930s, and as we have seen in the case of Eggeling there was some backing for artists in the very first avant-gardes. Later, there were to be commercial links between the purely abstract experiments of John and James Whitney, Charles Dockham, Mary Ellen Bute and other pioneers, down to our own time. Kubelka's case is, however, rare. He retained total control over the film, literally so in the editing system which he adopted. By predetermining the structure of the film – a step he took even further in the wholly abstract *Arnulf Rainer* (1960) – he both asserted his authorship and denied its subjectivity. Finally, even if in a very refined way, Kubelka forged a link through the disjunction of sound and image to the experiments which herald the rise of the pop promo, but twenty to twenty-five years ahead of its time.

In much the same way, but with a distinctly different pulse, Len Lye's 1936 film *Rainbow Dance* also deftly anticipates the fusion of popular music and radical cinema in the music video genre. It 'stars' the modernist dancer Rupert Doone and also features a guitar player in colour negative. Elaborate as it is, using the full resources of colour technology, it is still close to the 'cameraless' films of the early abstract cinema, such as Lye's own hand-painted *Colour Box* of 1935. The successor to *Rainbow Dance* was *Trade Tattoo*, in 1937, which involved hand-coloured and stencilled abstract shapes over 'found footage' clips (Figure 59). At the time, Lye was working for the film division of the G.P.O. (the UK General Post Office) and similar organizations; extracts from the G.P.O. and Empire Marketing Board films *Night Mail* (1936), *Industrial Britain* (1931) and *Song of Ceylon* (1934) are prominent and easily recognizable in *Trade Tatoo*, but transformed. Like a printmaker, Lye separates the three-colour matrix of Technicolor to remix film clips with solarized and negative shots.

FIGURE 59 *Trade Tattoo* (1937) Len Lye.

Lye was a genuinely hands-on filmmaker, and like several filmmakers who came after, such as Malcolm Le Grice, he had come to film by way of painting. Lye also had a large if idiosyncratic aesthetic theory, which promoted intuition and spontaneity, but he was more of a poet than a theorist. He worked cheaply and professionally – *A Colour Box* reputedly cost £5, the price of its materials – but he also enjoyed advanced technical facilities and high production values, including 35 mm Technicolor. Although Malcolm Le Grice's *Berlin Horse*, of 1970, is similarly handmade, its production conditions were at the other end of the scale to that of *A Colour Box*. And it exploits the limitations of these conditions as one of its major strengths. *Berlin Horse* was made on a home-made printer, and its six minutes are generated from a handful of frames (see Colour Plate 11). A few seconds of 8 mm footage of a horse being lunged in a school (in a village, not the city, called Berlin) are mixed with a fragment of 16 mm found-footage from Cecil Hepworth's *The Burning Barn* (1900). By re-filming from the screen, using negative and roughly reprinting grainy black-and-white in fulsome colour, Le Grice expands his minimal if powerful source material. Brian Eno supplied a looped soundtrack. Described by Phillip Drummond as 'a sumptuous and lyrical film', *Berlin Horse* can be shown on one, two or four screens according to choice and possibility.

The films of Kubelka, Lye and Le Grice reveal the kinds of form and process, including musical and mathematical modelling, that underlie the development of digital imaging. They expand on the power of abstract and pictorial concepts, and distance themselves from the realist cinema. Similarly, they have musical soundtracks that are in keeping with the films themselves, often based on the same systems or processes employed by the images. By these musical analogies

Berlin Horse (1970)

and similarities they implicitly oppose the fixed forms of verbal language, clearly rejecting dialogue or voice-over.

Paul Sharits, at one point a member of the neo-Dada Fluxus group in the United States, also challenged the power of language, but in a direct and very different sense, in his *Word Movie* of 1966 (see Colour Plate 12). Here, hundreds of words are rapidly animated in a series of permutations that are too fast to register, although a few seem to stand out for most viewers ('suck' and 'screw', for example). The soundtrack alternates the readings of two texts, word by word, one scientific and one from an art manual, delivered by two voices – one male, one female. Visually, Sharits turns the word into image, enforcing the unusual act of literally 'reading' a film, and confronting the authority of speech. At the same time, the film predicts the typographic revolution of contemporary video graphics, although each letter in the complex and flowing grid of words has been laboriously cut and arranged in a Letraset rub-down typeface. Today, the film looks like a running critique of automated and instant-response computer technologies.

A coincidental successor to Sharits's film is *Cowgirl*, by Graham Wood, made in 1993 (Figure 60). This video exists in several versions, issued by the Tomato design group, of which the purest (black-and-white) example is the best. Opening with the first line of Wittgenstein's *Tractatus* (dating from 1922, the age of early abstract and systems art) – 'The world is everything that is the case' – it permutates words from the soundtrack, which is a song by the group Underworld. The text is as anxious and sexualized as in Sharits, but with an additional undertone of anxiety in its punning on 'razors' and 'erasers' of 'love'. The images are in the abstract tradition of Lye, but here resembling the Mac-based shapes and style of

FIGURE 60 *Cowgirl* (1993) Graham Wood.

contemporary computer imaging. In fact, all these shapes were hand-drawn and painted to imitate digital visuals, in an interesting reversal of the usual state of affairs.

With Wood, the examples come full circle. If early abstract film both predicts and influences the most recent digital imaging, then there is also a certain amount of feedback when filmmakers and videomakers try to go back to source. This move counteracts the attempts of digital video to provide the stylistics of cinema – digital 'negative', digital 'film scratches' – but necessarily shorn of their function and material basis (since digital images have no negative and cannot be scratched). But while digital abstraction often dovetails with commercial TV and promos – many younger artists make music videos or live disco projections for an income – it also resists dominant media culture. Norbert Pfaffenbichler, one of a dynamic grouping of Austrian video artists, argues that computer 'dysfunction', including simulated faults like glitches and jumps copied from film and audio media, can generate new visual ideas.[4] 'Techno-syntactic abstraction' also translates unfiltered machine codes into sound or image percepts, to both process and construct the work. In his own *Santora* (1998, with a soundtrack by Christian Fennesz) a huddled walking figure is repeated and expanded in a multi-screen effect. Cyclic motion and intermittent gesture (echoed in the clicks and tones of the digital soundtrack), as well as graphic lights and darks, recall Kubelka's early films or Kurt Kren's *TV* (1967), which cuts up and permutates brief, serial views from a dockside cafe in Venice.

Many artists produce pure abstraction with the multicolour paintbox of computer imaging. The four-screen *Notes on Colour* (2003) and single-screen *36* (2001) by Pfaffenbichler and Lotte Schreiber (see Colour Plate 13) shift 256 colours via complex patterns, two examples of many other works that descend from Bauhaus colour experiments, colour-field paintings and such artists as Ellsworth Kelly. Kelly's panel-strip paintings, such as his Spectrum series, are echoed and transformed here, as also in *Colour Bars* (2004) by Simon Payne, which vividly samples and streams a TV colour test-pattern (see Colour Plate 14). The pixel at the heart of digital imaging is differently treated in *Pixel* (2003) by Dariusz Krzeczek, Stefan Németh and Rainer Mandl, where widescreen projection creates a 'space installation' from the algorithm used by two networked computers to generate variations from a single monochrome pixel. Randomized imaging in other recent work by digital filmmakers both asserts the selective machine logic in process and risks a collapse into unmotivated pattern-making. Images evolve but do not develop. The visible white raster/pixel grid becomes an inert ground: a surface distinct and disconnected from the images.

While some artists treat the screen as a total, all-over field to resolve this problem, others employ fragments of city life mixed with abstract and audio signals. Annja Krautgasser (also known as 'n:ja', punning on a favourite Dada phrase for 'yes/no' or 'maybe') has made work in which the automatic generation

of the picture in random cycles can be altered by the user 'in a process of writing and over-writing'. In *<frame>* (2002) a stripped-down car-ride shows passers-by and buildings turning into lines and dots, so that buildings and facades construct an anti-utopian urban geometry as a grid (Figure 61). Forward motion in depth conflicts with frontal and horizontal gliding. Maia Gusberti's *airE* (2001) is an abstraction of electric power lines to form intersecting graphic planes (Figure 62), while HC Gilje in *Crossings* (2002) overlays video frames in small clusters to make pedestrians at walkways perform new 'crossings' on the screen. Also emblematic is Michaela Grill's *trans* (2003), in which shadows, silhouettes, lines and fields flit by as static images. Stefan Grissemann comments on how such thaumatropic video exploits, in a positive sense, the static aspect of the digital frame: 'The movement does not take place within the images themselves, but between them … a work of reciprocal merging and overlapping … its main place of action is the space between two images, and its defining order is the neither-nor of two positions imagined as one.'[5]

Just as this thematizes the 'interval' or gap between shots (sometimes frames) in Vertov and Eisenstein, so the frequent images of power lines, intersections and other urban motifs evoke (but in small) the heroic age of utopian cinema. They also convey a sense of contemporary alienation, as images of instability,

FIGURE 61 *<frame>* (2002) Annja Krautgasser.

FIGURE 62 *.airE* (2001) Maia Gusberti.

motion and dystopian anxiety. But the contrast between modernist ideals and post-modernist realities is neither reductive nor dismissive. In part, these digital films seek grounding in the same radical montage concepts as the early pioneers (differing from the uncritical long-take gaze of much gallery video installation, for example, despite its ideological claims). And further, they open and renew the unfixed and unstable aspect of Vertov's cinema, its deferred utopia of vision. This troubling, metaphysical undercurrent to the collectivist optimism of *Man with a Movie Camera* was spotted in 1929 by Siegfried Kracauer. He found surrealism in the dreamlike 'dawn' sequence of disconnected empty streets and gardens, and 'Romantic irony' (i.e. disenchantment) in the freeze-frames of crowds and intersections, a death-like interruption of life. In techniques that 'probe beneath the surface, dispel any sense of certainty, and brush along the underside of daily routine' Kracauer sensed a critical and negative dialectic.[6] The opposition between stillness and motion in *Man with a Movie Camera* is understood by Sophie Küppers-Lissitzky in a more ocular way, as a form of 'rhythmatized seeing', a phrase which also has contemporary echoes.[7]

These themes run through much new film and digital work in Austria and elsewhere, including the UK, with Karen Mirza and Brad Butler, and Emily Richardson, as well as sue k., who is based in Melbourne, Australia. Another relatively recent, digitally edited film by Berlin-based Toby Cornish, *Sarajevo Vertical* (2004), has a frame-edit structure akin to the Vertov-Kubelka tradition. The film uses sixty-six separate shots (originally on black-and-white Super 8 and 16 mm), each of which contains a central vertical line, variously comprising architectural features, shadows on a fence, cables on walls and trees in open spaces.

FIGURE 63 *Sarajevo Vertical* (filmstills) © Toby Cornish/jutojo, 2004.

Some of these are 'negative' spaces, like gaps between buildings. Close viewing reveals the word 'Tito' on a road bridge, and the bridge on which Archduke Franz Ferdinand was assassinated.

The shots of *Sarajevo Vertical* are arranged by the growing thickness of the line, alternating from dark to light, so that from apparently 'chaotic' elements a continuous line ebbs and flows as it thickens and gains momentum (Figure 63). The editing structure is cumulative and based on a 'row' of permutations that gradually intensifies from three to two and then one frame cuts. After sixty-six shots the cycle starts again, gathering momentum so that each time the line shrinks it loses a frame at its thinnest point until each shot is a frame long. The location sound (edited by Owen Lloyd) is broken into sixty-six separate single-frame cuts or 'intervals' that engulf the film at its end. In a programme note, Cornish has explained that each cycle repeats the same pattern of frame durations, 'with the exception of a shot of a man crossing a bridge, where I advance the 3 frame section by one frame each time he appears, so that after several cycles he crosses the bridge'.

This 'narrative' implication connects the film and other new urban videos to a pre-digital tradition in which bridges are metaphors of history and of the frame itself (in both its cinematic senses of the border of the projected image and photogram). The tradition includes Eisenstein's *October* (1928), Vertov's *Eleventh Year* (1928) – where the camera travels over what Yuri Tsivian calls a 'constructivist dinosaur' of a bridge – Fritz Lang's *Metropolis* (1927), Richard Serra's *Railroad Turnbridge* (1976) and Kurt Kren's *TV* (in which a quayside view through a cafe window substitutes for a literal bridge). In this context, the new abstract cinema explicitly recalls the first abstract avant-garde of Richter, Ruttmann and Eggeling, who also aspired to linear patterning, and which dates from the aftermath of the world war that effectively began in Sarajevo. Strictly contemporary in its content and rapid-paced style, with glimpses of dailiness culled from 'non-places' around the emblematic bridge, *Sarajevo Vertical* is one of many works that assert a live link to the abstract tradition. Beyond surface style, early abstract cinema is a forerunner of contemporary media arts by way of a shared process-oriented methodology; a mathematical and systemic origin; a concern for simultaneous rather than singular imaging, using the whole screen and dividing it into parts, segments or zones; and an implicit rejection of a perspective-based and realist orientation of technological vision, in contrast to the mainstream currents in film and television.

CONSTRUCTIVISM AND COMPUTERS

The Austrian exhibition *Abstraction Now* (2004) took a step back to classic modernism to gain some distance on the digital present. Curator Sandro Droschl explained the show as a form of 'cognitive mapping' to suggest links across its diverse range of examples. It included eighty-five works by seventy-four (mostly younger) artists, including twenty-seven videos, twenty-five computer works and a variety of paintings, prints, photos and graphics. (Some of these artists in the exhibition, including Norbert Pfaffenbichler and Lotte Schreiber, Annja Krautgasser, Maia Gusberti and Michaela Grill, are discussed in the earlier chapter 'Frames and Windows'.) Norbert Pfaffenbichler, who was co-curator, sketches the framework of the exhibition in his catalogue essay, 'From Panel Painting to Computer Processing'.[1] In a critique of media-led reproducible illusionism and the social codes and institutions that it upholds, he recommends the use of machine dysfunctions to generate new visual ideas, including simulated faults taken over from film and audio media, such as glitches and jumps. Artists in this vein include the duo reMI, who use digital media 'garbage' data to autogenerate pictures and sounds by overloading the software, as in *uta zet* (2001). The Dutch artist Bas van Koolwijk similarly remodels video disturbances, in videos such as *Five* (2002), aiming a formalist blow at the television signal to expose its underlying illusion as 'an aggregate attack on the illusion of video itself' (see Colour Plate 15). Another tactic in the age of technical perfectibility involves the element of play where the 'author' sets the parameters of the activity but not its shape or goal, which are controlled by the user as co-creator.

Digital media allow for 'generative programmes' that recycle vast permutations of visual (and other) data, but the algorithmic motion images that Pfaffenbichler discusses are not characterized as 'filmic'. He describes them as 'abstract tableaux vivants', as a feature of the 'exponential' production of animated images. Further strategies in the context of new abstraction include the visualization of sound by data

conversion, and abstractions that are made by masking or blurring photographic or optical sources. For Pfaffenbichler, 'graphic abstraction' encompasses drawing on film through to computer animation, while 'techno-syntactic abstraction' involves the translation of unfiltered machine codes into precepts, so that the machine's logic both processes and generates the work. Finally, 'algorithmic abstraction' is wholly digital and the most unique of the activities in his list.

Most of the writers in this area want to avoid Greenbergian reductivism, but don't necessarily seem sure whether current forms of abstraction resist the supposedly autocratic modernism of the past or operate in its direct line of descent. This uncertainty accompanies an equal lack of decision about the nature of the 'medium' in the context of digital media, which both incorporate and transform data derived from innumerable sources. While theorization often goes back explicitly to Kandinsky, Mondrian and Malevich, few digital essayists refer to the pioneers in abstract motion imaging that were film and videomakers. It's also not clear how far the painters and printmakers in this hybrid school of digital abstraction expand or explode former notions of the modernist grid. The typical forms that occur in a range of prints and paintings (as well as video works) are diagrams, squares or grids. Doris Marten, Raphael Moser and Esther Stocker make grid-like paintings that are derived from 'digital drafts' (see Colour Plate 16). Others like Günther Selichar exhibit prints that emulate the colours and tonal palettes of computer software and evoke Constructivist models.

Nonetheless, one clear aim of the new abstraction is to challenge both painterly and photographic realisms of the 1990s, which in turn also came out of a graphic and mass media image revolution. While Marie Röbl associates a 'proliferation of photography and video exhibitions in the 1990s with a desire for reproductions of authentic life', she also notes a contemporaneous counter-current in the revival of the conceptual art of the 1970s.[2] Alongside this renewed interest, she also suggests that the critique of artistic hierarchies and purism associated with conceptual art, which marked its own attack on modernism, are carried over into digital abstraction, given the interactive, programmable and potential openendedness in new media art. Röbl sees this as a way of sidestepping notions of 'medium-specificity' in new abstraction, which is not necessarily concerned with physicality (although much of it does insist on making visible the means of its technical support through the recycling and breakdown of its patterns and images). Her analysis can perhaps be broadened to the wider context. Art that adopted blankness and abjection as cultural styles of resistance to corporate media was all the more easily recuperated back into the fashion world from which it emerged, once its task of updating was done. The refusal of the object in new media abstract art is a gesture against the commodity, but whether in the world or its digital simulacrum is uncertain, since digital media theory tends to blur the distinction between them.

Lev Manovich's essay in the same catalogue surveys the new abstraction manifested in the Ars Electronica and Flash Forward festivals, to ask if a 'common

theme' runs through 'the swirling streams, slowly moving dots, dense pixel fields, mutating and flickering vector conglomerations coming from the contemporary masters of Flash, Shockwave, Java and Proce55ing'.[3] Although few of the artists exhibited in *Abstraction Now* refer directly to science, he sees them as sharing certain paradigms with scientists, just as abstract artists and experimental psychologists in the last century addressed perceptual phenomena, including colour. But while the dominant trend in the generation of artists including Mondrian, Kandinsky, Delauney, Kupka, Malevich and Arp was to reduce and simplify abstract patterns and configurations, contemporary artists echo the theories of the genotype, chaos theory, fractals and neural networks to evoke interactions between 'emergent properties'. Here, order emerges spontaneously from the system and cannot be deduced from its elements, rather as a computer programme will spin intricate and unresolved patterns from simple cells. The contemporary generation thus reverses the earlier search to deduce the simple from the complex, as in the 'reductive' paintings that led Mondrian to simplify a tree into a network of lines and dashes.

But Manovich's brief history is itself simplified, since the paintings of the artists in question are far from deductive diagrams and have a high order of complexity (as acknowledged and imaginatively modelled in Stephen Littman's video *Digital Boogie-Woogie*). Similarly, the films of the era – by Viking Eggeling, Hans Richter, Walter Ruttmann and Len Lye – generate complexity in much the same way that digital abstraction does, and they are widely seen as 'ancestors' to this new development. The case that there is 'direct transfer' of ideas across the cultural frontiers within the 'same historically specific imagination' is well founded. At the same time, Manovich's account is oversimplistic, not least of all in consigning the first wave of geometric artists (whether painters or filmmakers) to a world of lines and squares, as if the curve was a digital discovery. In fact, there are many 'arabesques' in the films of Germaine Dulac, Oskar Fischinger and Eggeling, through to those of Jules Engel and Robert Breer. In this sense the new abstraction inherits from its ancestry more than is credited, just as its attention to mathematical permutation and random structures is prefigured in the practices of artists such as Max Bill, in his purist paintings, or the systems-based editing of Kurt Kren.

At its weakest, random generation in 'software-driven abstraction', even as it reflects a contemporary sense of 'dynamic networks of relations', runs the evident risk of unmotivated patterning that is emptied of aesthetic content. The stronger work in this vein overcomes that immanent decorative lure by programming or manipulating the software to produce new kinds of meaning or (in rare cases) to assert the random as a factor of viewing (as in David Cunningham's *Colour 0.8* (2003) which involves randomly generated colour fields for computer monitors) rather than just the product of a deciding algorithm. Miguel Carvalhais recognizes this in the small-scale 'drafts' that characterize much internet art, which use

[handwritten margin note: random generation of abstractions, new kinds of meaning]

simplified 'reverse engineering' and interactivity to expose the logic of the underlying system.[4] This 'evanescence' takes the user beyond sensibilia to 'the realm of immaterial things', a theory of immanence (which is not unlike Kandinsky's), rather than a cognitive activity. Carvalhais usefully shows how such aesthetics can travel over media borders, as in work by the group Norm who produce site-specific projects, books and installations. The problem, perhaps, is that when 'form factors are decided by the code lying underneath' the system chooses (and the user follows) a form and structure that reflects its own logic. Representation is then simply a function of the self-embedded means of data processing, which selects those features most adequate to it, not a creative operation but a curious formalism, prompting a question about the ways in which digital art produces meaning.

(1) There are three responses to this dilemma. The first is to contextualize digital media in relation to earlier avant-garde experiments, as Manovich does, but mostly as part of the tool-kit rather than as radical critique. (2) The second is to underline the audiovisual spectrum of digital media, as opposed to the image alone, since here the electronic register is encoded in its full sensory range. (3) The third is to use strategies of breakdown and interference to interrupt the manifested signal, to put the machine into a crisis of self-representation so that its randomizing features can no longer simply fulfil the pre-designed programme and its built-in economy.

Unlike Manovich, Christian Höller largely sidesteps the early abstract film to focus on US colourists and minimalists as precursors of digital electronic art and pop culture.[5] He cites Pat O'Neill's *7362* from 1967 (the title refers to a film stock) with its rotating dancer, oil pumps and geometric variations set to electronic sound by Joseph Byrd and Michael Moore. John Whitney's *Matrix* films (from the early 1970s) in which 'cosmic consciousness meets higher mathematics' are also included in Höller's account, as are Mary Ellen Bute, Tony and Beverley Conrad, Nam June Paik and Jud Yakult, the Vasulkas and the little-known pioneer Eric Siegel, who produced visuals to accompany the Beatles' 'Tomorrow Never Knows' in 1966 with his colour synthesizer. Echoes of these works reverberate in the club-culture graphics of electronic imaging today, and in more 'serious' single-screen works.

This lineage brings out the synaesthesia that inheres in the work of many of the Austrian abstract digital artists, and lessens the degree of an 'anxiety of influence' that may well descend on them from Kurt Kren and Peter Kubelka. At the same time, it evades the question of structure and meaning by emphasizing visual and aural pleasure, and calls on the vaguer 'cosmic' aspect of the US colour-synthesizer film rather than its analytical side. Höller might have looked, for example, at John and James Whitney's earlier *Five Film Exercises* (1943–5), which took into film the kinds of open modernism of Cage and Duchamp as well as the lessons of the Viennese School in music. Tellingly, these were the same influences that appeared in the post-war Austrian experimentation of Kubelka, Marc Adrian, Ferry Radax

and others. Perhaps they are a little too close to home for Höller. In citing the later Whitney films, he appeals to a flatter graphic abstraction that points to one of the weaker sides of the new abstract digital film; its tendency to place its shapes and colours on an insistent but inert background produced by and identified with the raster-generated screen.

The 'graphic' aspect of the earliest abstract cinema has often been used to criticize it. For Maya Deren, it simply brought the traditional arts of painting and drawing – albeit modernized – into film form, as illustration.[6] Film art was, for her, to be developed through the camera-eye and the shot, not with the cut-out and the animation bench. And while today Malcolm Le Grice recognizes few if any differences between media in the digital age, and has returned to abstract film himself since the 1980s, he too took up Deren's critique in his aptly titled 1977 book *Abstract Film and Beyond*.[7] In historical justification, it's true that few of the abstract pioneers of the 1920s persisted with full abstraction a decade later. Both Richter and Ruttmann took to documentary and montage cinema. The main exception is Fischinger, a 'transcendental' and powerful filmmaker in the lineage that Höller approves of, but who is barely mentioned in his list.

Nonetheless, it is this first avant-garde that subtends most current work in digital abstraction, acknowledged or not. The German abstract film of the 1920s was the main current of its own time and has passed down to later avant-gardes as a major example of its genre. The Whitneys consciously developed its programme, and in their early film experiments, which involved light shone through cut-out masks and direct means of recording optical sound, they found a more medium-specific equivalent of the painterly or graphic methods that some had seen as a weakness of the earlier movement.

The Whitney's *Five Film Exercises* also animate the whole surface, interactively, so that image and screen are complex and hard to 'see through' as the coloured forms in the films emerge and connect (see Colour Plate 17). By contrast, and partly due to its graphic method, much digital abstraction contains a visible white background raster or pixel grid over which the shapes appear to move. Rather than asserting materiality, this flat digital space is inert and inactive, a visible hum waiting to be called into action. Richard Shiff wrote positively of the sense in which electronic media are always 'present' even in the low pulsation of a monitor's white noise.[8] But here, the background is obdurate, distinct from the imagery, and hence without meaning with regards the whole. Flattened on the grid, the images tend to be immaterial in the sense of impoverished or weakly ephemeral.

In the club context related to this kind of optical cinema, dance and music fill out the space, and viewing is less concentrated. When projected as an independent work, however, the ground sometimes shows itself as unintegrated and static. This is partly a function of digital-media data processing, where the grid of pixels constitutes an economic order. Processing power and data rates are less if parts of the screen, designated as discrete areas of pixels, can be treated simply as a

repetition of the same information. In the codecs of digital-video formats used for DVDs or Blu-rays, for example, the static background in the scene of a movie, such as a landscape in a Western, can be duplicated for several frames, while maximum attention is focused on the change in pixel values, from frame to frame, in areas of the screen taken up by a gunfight or chase that forms the 'action'. Abstract media art can ill afford to separate the parts in this way, since here everything counts in the overall field of vision.

Dance-like elements in looped and repeated or sequenced form carry a danger that the permutations evolve but do not develop. Nicky Hamlyn has commented that the 'evolution comes to feel contrived, as if to fend off anticipated objections that the work lacks, precisely, structure'.[9] Such evolving of form may then seem unmotivated or automatic, without structure or concepts. In contrast, he has pointed to David Larcher as an example of an artist who pushes the euphoric notion that anything is possible in the digital domain at the threshold of meaning, including the loss of meaning. 'Turning dropout into images, multiplying, twisting and turning images inside out into monstrous spiralling forms with goldfish swimming through them, while his murky legs and shrunken genitals hover in a floating plane of no depth! No ideas, no meaning, no "communication".'[10] This is a description of a particular sequence in *Ich Tank* (1997) which articulates the terror of where 'anything is possible' might lead (see Colour Plate 18).

One way in which wholly computer-generated abstraction is different from its film and video cognates is in the reproduction of movement. Film and video articulate motion by the break-up of light, recorded in a series of discrete frames or a series of electronic impulses registered in a matrix of pixels where frames constitute the time-base. Sequences created directly in the computer are a kind of animation, but they constitute a series of frames that are quite different to those of film and video. The frame in which the artist (or programme) inserts or inscribes the image is, at it were, set into motion after the event. At the same time, as mentioned earlier, a digital time-based sequence involves encoding selective differences between frames. In effect, digital abstraction is geared towards beta-motion – that is, movement experienced as a distinct change in position – and less easily gives rise to phi-motion, more readily associated with the regular pulse of light that comes with film projection. Some artists turn this to good account, but for the most part – and in order to 'cinematize' an essentially additive and graphic process – the particularities of apparent motion in digital imaging is often repressed.

GEOMETRY OF INTERVALS

El Lissitzky, a close friend and supporter of Dziga Vertov, was a significant link between the factions associated with avant-garde film in the 1920s. In 1928, he and his wife Sophie Lissitzky commissioned a lecture on film form from Eisenstein, delivered in Stuttgart in 1929 at the *Film and Photography Exposition*.[1] Vertov presented his new film, *The Man with a Movie Camera*, at the same exposition, prompting Sophie Lissitzky's glowing review for the German press.[2] In 1932, when the Lissitzkys had an 'idyllic' wooden house in the countryside outside Moscow, with an intermittent electricity supply tapped from a nearby factory, it was Vertov – the maker of *Enthusiasm* (1930), a hymn to electrification! – who memorably presented them with a large paraffin lamp. That same year, ironically, Lissitzky designed the poster 'The current is switched on!' which featured a hand pulling down a power lever and a smiling portrait of Stalin.

Earlier still, Lissitzky knew of Eggeling's film experiments and had promoted his ideas about abstract cinema. He first heard about them in 1920 from a young German visitor (possibly William Herzog, fresh from the Munich revolution) who knew Eggeling and his work. There was a shared interest in the intellectual climate laid down by Spenglerian and Bergsonian ideas. Eggeling's graphic ideas may have influenced the animation-style book *Story of Two Squares*, which Lissitzky completed in 1922, the year that he met Eggeling in Berlin. At the same time he met Hans Richter and many others at international conferences in Germany, and all three were published in avant-garde magazines such as *G*.[3] Lissitzky was fired by Eggeling's work to write about him and to try to get Eggeling's *Diagonal Symphony* screened.

In the wake of Eggeling's death in 1925, rumours had already spread about the fate of his films, and about Richter's early claims to priority in the abstract cinema. Lissitzky refers to this in letters to Sophie. Refuting László Moholy-Nagy's claim to have invented the abstract photograph – Lissitzky says it was Man Ray and then himself – and he adds sarcastically that 'it is in fact the same thing as saying that Richter discovered the abstract film'.[4] This letter, of September 1925, was followed

by another in early 1926 that refers to Richter and Erna 'Eggeling', as Lissitzky called Erna Niemeyer. Formerly Eggeling's helper and companion, Niemeyer was briefly married to Richter, who was apparently 'organising' Eggeling's film.[5] 'People are always "organising"', comments Lissitzky, before asking: 'When are they going to create something?' El Lissitzky remained suspicious of Richter, hinting at plagiarism, and in his letter, he warns Sophie not to talk to Richter about his new work plans.

Viking Eggeling is one of the struts in the framework of Lissitzky's essay entitled 'A. and Pangeometry' (1925) a dense and elliptical text that can be read today as a visionary outline of new digital media, backing up Manovich's claim that Lissitzky is one of its direct ancestors through his abstract and multi-layered installations.[6] First, he traces the birth of relief sculpture and proportion, before perspective introduces the deep space copied by the photograph. Perspective is based on a firm Euclidean three-dimensional space, a pyramid aimed at the eye, whose initial single-point frontality links it to the rise of theatre design. The Western system (he also notes Eastern alternatives) limits space, but gives to art a new concept that 'each point, even one infinitely close, can be represented by a number'. In effect this is a proto-digital system for calculating proportion, scale, recession, distance and the placement of figures. According to Lissitzky, until the late nineteenth century, while science developed new cosmologies and non-Euclidean spaces, art was immune to change in its spatial regime. Then Impressionism 'exploded' perspective, and the Cubists both pulled the picture surface forward and built on it, as in collages and reliefs of Picasso and Vladimir Tatlin. For Lissitzky, the Futurist's scattering of perspective brought it to the limits of painting, Malevich's famous black square was the first painting that could be compared to the role of 'zero' in mathematics, and Mondrian's reduction of space to surface was the ultimate conclusion.

In the new abstraction, associated primarily with Suprematism, distance is measured by the placing of colour planes in a positional system that defies traditional scales of humanist measurement, breaking through 'the blue lampshade of the heavens'. Employing a system of zeroes, positives and negatives that defines depth and frontality on the spatial plane, without perspectival illusion, Lissitzky likens it to the new mathematics of imagined and negative numbers, a non-sensory logical sphere of thought. Some artists – he is thinking of those associated with De Stijl – have tried to design on this basis 'multidimensional real spaces that may be entered without an umbrella', but for Lissitzky such literalism was not the way ahead.

While classical Euclidean space is a practical system by which solid shapes can be plotted on fixed axes, the new mathematical spaces that Lissitzky refers to cannot be visualized except, he suggests, as a mirage (or by morphing?). Nor can time be simply added to the classical space of ordinary perceptual experience in order to understand post-Euclidean topology. Time applies to all spheres, physical or not,

and it is sequential and indivisible, unlike space. In an asymptote-like example, Lissitzky states that one can see a curve transform from being two-dimensional to three-dimensional (as perhaps in an abstract film when a line rotates or spirals), but he argues that we cannot perceive it transforming from there into a fourth dimension: the passage of time is only perceived indirectly, by 'the change of position of an object in space'.

In his survey of artists, Lissitzky recognizes the Futurists and Suprematists as having tried to represent the fast pace of modern times by way of dynamic 'speed-graphs', or direct means such as mechanized sculpture (as with Tatlin's revolving tower) and mobiles. Lissitzky thought these too symbolic though, and mainly served to inspire advertising designers. As an alternative he looked to cinema as a means of explaining the link between time and space and the new goal of 'creating *imaginary* space by means of material objects'. He begins by outlining the cinematic principle by which phases of movement seen at intervals of less than 1/30th of a second 'gives the impression of constant motion'. For Lissitzky, Eggeling and his successors were exploring dynamic form by way of filmic motion, 'the first step in the direction leading toward the construction of imaginary space'. Perhaps it is only the 'first step' for Lissitzky because, as he recognizes, it stops with the 'dematerialized surface projection'.

In another asymptotic example of imaginary space – one that goes back to Leonardo da Vinci – Lissitzky recounts how a single glowing point of light (such as a burning coal) in motion gives the impression of forming a line. The same principle can also form apparent solids with volume. Thus, elementary forms can be employed to 'construct an object that forms a whole in 3D space while in a state of rest'. A 'new object' results, but one that lasts only as long as its duration and is therefore 'imaginary'. Lissitzky illustrates this idea with reference to designs for rotating solids that predict the modelling of computer animation, just as he looks ahead to the virtual reality of 'infinitely variegated effects' that include colour and stereo. He also expects an art of polarized and clustered chromatic light (holography); and the 'transformation of acoustic phenomena into visual form' (as it was by Oskar Fischinger in the 1930s and is today in digital audiovisual mixing). The art that he calls for and predicts will be anti-monumental and 'essentially intangible', aiming to extend human capacity for experience and ideas. He sums it up in terms of the paradoxical 'nonmaterial (or immaterial) materialism', which might well apply to digital media in our own time.

In his account of this essay, Yve-Alain Bois (in 'From −∞ to +∞: Axonometry, or Lissitzky's Mathematical Paradigm') writes: 'What he wants to destroy is the certainty of the spectator and his usual position in *front* of the painting, in front of the horizon.'[7] Bois acknowledges Lissitzky's own recognition of Eggeling's abstract films as a first step towards an imaginary space created by virtual, rotating forms, and their 'immaterial materiality'. And he suggests that Lissitzky did not pursue this further because he realized that 'this supposedly imaginary space was no less Euclidean than

that of perspective, nor even, for that matter, of axonometry … which it was supposed to replace'. This chimes with the objection made by Erwin Panofsky in a note to his essay 'Perspective as Symbolic Form'. It is intriguing that Panofsky picked up this point from Lissitzky so early, but Panofsky seems to think that the imaginary space that Lissitzky refers to is exclusively constructed by rotating or oscillating 'mechanical bodies'.[8] He misses out Lissitzky's explicit references to cinema.

In a sense, digital imaging combines abstract mathematical mapping with Euclidean and Cartesian systems to produce just these 'virtual' spaces under discussion. But digital imaging, by definition, is not quite the 'empirical' space that Panofsky has in mind, just as it is not the 'infinite' that Lissitzky proposed.

Lissitzky's various attempts to excise the monocular viewpoint and the viewer's 'possession' of the image may have found its way into digital abstraction directly, but it is equally likely to have been routed via later articulations in painting. In an account of Frank Stella's painting, *Die Marquis Von O* (1999), Mick Finch notes the use of angled or 'exploded' projection systems including axonometrics and obliques, which are typically found in architectural drawings and analytical modelling rather than precedents in painting.[9] Coincidentally, 'The Marquis Von O' is a short story by Heinrich von Kleist (from 1808), who also wrote the essay 'On the Marionette Theatre' which describes the movement of puppets' limbs in relation to the concept of the asymptote. To describe or contextualize the role of axonometrics in Stella's painting, Finch goes to an account of Lissitzky's work, again by Yve-Alain Bois, this time in his essay 'Lissitzky, Mondrian, Strzeminski: Abstraction and Political Utopia in the Twenties'.

> The use of axonometric projection in Lissitzky's famous Proun paintings was explicitly targeted against the illusionistic device of one-point perspective … Instead of an authoritarian imaginary space, which hypnotized the spectator, Lissitzky proposed an abstract space without a single point of view. The space is still imaginary, to be sure (which is perhaps why Lissitzky abandoned painting in the mid-twenties), but the spectator is left free to reconstruct potential volumes out of the floating vectors. The viewer receives no blueprint for reading, no fulcrum for perception.[10]

Finch also finds a link to projection drawing systems in the work of Ellsworth Kelly. In that connection there is further insight to the palpable visual analogies between abstract painting – specifically to do with pure colour fields – and the new digital abstraction. But in the context of the discussion here it is the intermediary photographic image of shadows that is important. Several of Kelly's paintings refer back to photographs he took of shadows, some of which became 'schemas' for paintings. Shadows literally demonstrate projection, since a shadow is a two-dimensional shape generated from a three-dimensional form. The shadow is an index of the object that casts it – 'the object creates its own image' as Maya

Deren said of photography – and does not depend on the position of the observer. Axonometric drawings are similarly direct. Their system of representation is based on the dimensions of the objects that they depict, rather than the position of the viewer which is privileged in a perspectival image.

The difference is further explained by Yve-Alain Bois in an earlier essay than that cited by Finch ('El Lissitzky: Radical Reversibility') which distinguishes single-viewpoint perspective from the axonometric system used by architects, where receding lines remain parallel as opposed to meeting at a vanishing point.[11] Axonometric drawings use a multi-axial method that implies no fixed spectator or position, producing images that are to be read or interpreted rather than perceived or scanned. Lissitzky used it to disrupt the sense of space in his collaged *Proun* series (see Colour Plate 19). His master, Malevich, kept strictly to a third option, that of flat or planimetric surfaces avoiding depth altogether. This move meant that Lissitzky's and Malevich's works could be hung in different ways, as was the case. As a consequence, the multiplication of viewpoints brought their art closer to the 'flatbed' than to the frontal and upright easel painting. Lissitzky's designs for his *Proun Spaces*, which were movable gallery spaces or 'demonstration rooms', followed the same principle of shifting planes and sequences, so that a 'spatial viewing' was encouraged and the gallery was seen as medium of progression for the spectator, rather than an environment in itself (Figure 64).

For Jean Leering, the spatial progression in Lissitzky's demonstration rooms is also found in each of the *Prouns* individually. The viewer takes a journey through

FIGURE 64 *Prounenraum* (Proun Space). From the 1st Kestnermap 'Proun' (1923) El Lissitzky. Lithograph on paper, 61.3 × 77.3 cm. Collection of the Van Abbemuseum, Eindhoven, the Netherlands. Photograph: Peter Cox, Eindhoven, the Netherlands.

imaginary space, like 'someone passing through a large city and seeing the prominent towers and bridges from a constantly shifting point of view, and thus in a constantly different relation to each other'.[12] This is exactly the analogy proposed by Eisenstein between architecture (when approached from different aspects) and the cinema.[13] Eisenstein's goal was immersive, to draw the spectator into space but in defiance of the stability generally associated with realism (hence the persistence of non-matching cuts and oblique angles in his later films). Lissitzky's participatory art is wholly abstract, but its immersiveness is not that of absorption because a critical distance from the viewer is always maintained. The viewer isn't given a traditional window into pictorial space, through which to enter; one participates in the space of the work itself, just as participation is built into the demonstration rooms and installations that Lissitzky designed for the exhibition of his work.

Similarly, in the work of the Cubist Juan Gris, Mick Finch finds that oblique projection acts to 'place the viewer in [a] number of positions' just as Cubist collage extends the viewer's negotiation of imaginary positions. For Finch, the examples of Cubism that Lissitzky and Stella disrupt or complicate is what Leo Steinberg, in the 1970s, called 'head to toe' picture space as the record of an optical event that precedes the painting.[14] The direct simplicity of Ellsworth Kelly's colour fields or shaped canvases are also aligned with this trend – despite their flatness and bold abstraction – because their route to that point often passed through the observational lens of a camera.

According to Diane Waldman and others, the photograph of shadows cast by railings on an external metal staircase that led up to Kelly's second-floor room was taken (in 1950) at the home of Delphine Seyrig's mother in Meschers-sur-Gironde, on the Atlantic coast of France. The film actress was married to Kelly's friend Jack Youngerman, and her family helped support the two young American artists. With the photograph to hand, Kelly made drawings of the railings' shadows cast at three different times of the day, which then became the basis for three paintings with the title *La Combe*. The second of these is the nine-panelled *La Combe II* (1951) (Figure 65). 'By hinging *La Combe II*'s panels together, Kelly created an approximate equivalent of the play of light and shadows rippling across the surface of the steps through a process of visual "feedback".'[15]

Waldman's electronic word 'feedback' indicates the nexus of ideas that now come into focus. The *La Combe* paintings are linked with two other projects, and both have their analogues in contemporary computer abstraction. First is the coloured-paper collages of 1951 collectively titled *Spectrum Colours Arranged by Chance*, from which one painting was completed in 1953. The seven studies are made up of hundreds of permutated colour squares. A later related series, simply titled *Spectrum*, made between 1967 and 1970, includes *Spectrum IV* (1969) which has thirteen separate but contiguous panels whose colour values are close enough so as not to generate 'optical' shifts or reactions. The second project that these pieces can be connected to is the painting *Seine*, with the corresponding study that looks

FIGURE 65 *La Combe II* (1951) Ellsworth Kelly. Oil on wood, folding screen of nine hinged panels, 99.1 × 118.1 × 0.6 cm. Private Collection. © Ellsworth Kelly Foundation, Courtesy Matthew Marks Gallery.

like a chart or graph (Figures 66 and 67). These are from 1951 again, and like the *La Combe* pieces, which Waldman refers to as an 'approximate equivalent' to the shadows on the metal stairs, they are based on patterns of sunlight on water. The study in particular looks like a computer grid or a diagram for an abstract film, as does a contemporaneous drawing entitled *Random Dots*. The gridded paper was used to organize swatches of black and white as a series of lights and darks, working into the centre from the edges. Its subject matter and initial effect recall Pointillism, but it is in fact the reverse, since its elements – while reflecting the spontaneous patterns of light on water – were placed according to chance procedures. The study, in which forms are dashes, dots, filled-in squares and interlocked rectangles, is more free than the final painting that is more distinct in its contrast of black and white.

With these optical experiments that convert light into inked line or painted squares, without modulation, Clare Bell suggests that Kelly 'created a new way of indexing the "real".[16] Serial forms as well as chance procedures and chromatic saturation were to play a part in that too. In connection with this she cites Jean Baudrillard: 'The real is reproduced from miniaturized units, from matrices, memory banks and command modules – and it is with these that it can be reproduced an infinite number of times. It no longer has to be rational since it is no longer measured against some ideal or negative instance.'[17]

It is intriguing and indicative that art historians discuss such a 'pure' painter as Kelly in terms of quasi-digital logic and thinking. As a painter, Kelly is a direct

FIGURE 66 *Seine* (1951) Ellsworth Kelly. Oil on wood, 41.9 × 114.9 cm. Courtesy of the Philadelphia Museum of Art: Purchased with funds contributed in memory of Anne d'Harnoncourt and other Museum Funds, 2008-228-1. © Ellsworth Kelly Foundation, Courtesy Matthew Marks Gallery.

FIGURE 67 *Study for Seine* (1951) Ellsworth Kelly. Graphite and ink on paper, 4 3/4 × 15 7/8 inches. Collection Joseph J. Rishel. Promised gift to the Philadelphia Museum of Art in memory of Anne d'Harnoncourt. © Ellsworth Kelly Foundation, Courtesy Matthew Marks Gallery.

and acknowledged influence on the younger generation of digital abstract artists. Tracing the trajectory of his own practice suggests other subterranean links, for example in the shared impact of Mondrian, Dada, chance operations (random processing) and abstract images based on originally photographic sources. This interweaving alone suggests that it is inadequate to see abstract art as merely one of many inputs to the digital realm, part of its prehistory as it were. Biographically, there are also many coincidences. Kelly met Jean Arp at an opening in Paris, in 1950, of a show of paintings by Hans Richter, and the next year he tried raising funds from Hilla Rebay (of the Guggenheim Museum) who was a demanding patron of Oskar Fischinger. (He received some sympathy and a little money from Rebay, but not any sales.) The paintings that Kelly made in France are also contemporaneous with the rebirth of experimental filmmaking in Europe, by way of the Lettristes in Paris and the Vienna group, among others, though he apparently knew nothing of them.

But these connections, brief and tantalizing, lead nowhere. The real connections between Kelly's abstract art and time-based imaging, in terms of colour and procedure, are in the work itself and its circulation. In the 1950s, his methods

involved moving from photographs to drawing (or graphing) and then to painting – from 3-D to 2-D – with each step taking him to a different level of signification even as it continues to 'index the real'. This operation is analogous to the shifts of signal and code in digital imaging, where the camera image is rendered as pixels, and then processed and transformed via the equivalent of those media made available by the computer.

Finally, it is possible to return to Kelly's photograph of the staircase at the Seyrig villa, taken in 1950 (Figure 68). The high angle looks down sharply at the raked stairs and railing. The shadows are strong, in midmorning or early afternoon light. The two-dimensional 'ground' (in both senses) at the base of the stairs seems to lift up the flat earth and present it momentarily as an upright horizontal that has come to meet the vertically descending staircase. Figure and ground are briefly in conflict. The iron stairs lead away from the artist's room – since we are looking down not up – and they are familiar, but the image resists being taken in all at once by its briefly baffling collision of forms. The real is abstracted in the photograph, just as the photograph will be abstracted in the drawings and paintings that are made from it.

FIGURE 68 *Shadows on Stairs, Villa La Combe, Meschers* (1950) Ellsworth Kelly. Photograph 25.4 × 20.3 cm. Private Collection. © Ellsworth Kelly Foundation, Courtesy Matthew Marks Gallery.

The levels of abstraction here link to the period of 'heroic utopias' associated with Mondrian, Malevich, Arp and modernist abstraction. (The film and art critic Parker Tyler picked this up when writing about Kelly's paintings in 1956.)[18] This was the era that inspired Kelly, the young American in post-war Paris, although he may not have known a great deal about the Russian avant-gardes in this period of the Cold War. (Kelly said that he learnt of Alexander Rodchenko's pure colour triptych, the 'final' paintings that resemble his own, only in 1988.) On the other hand, Kelly's staircase photograph recalls the more everyday counter-utopias captured by 'oblique angle' modernist photographers in the 1920s and 1930s through to the world war that brought Kelly to Europe, first as a soldier, and then as an art student under the GI Bill. These histories are a background hum in the work. Another of the subjects of his photos in Meschers (besides the staircase at the Villa La Combe) was a 'shelled bunker', an image that perhaps corresponds with his fear of being recalled to the army at the start of the Korean War, in 1950, if the Russians invaded Western Europe.

The similarities that Kelly's photographs share with post-Bauhaus art photography are the extreme angle of the image, the notion of the expanded eye of the lens, a mode of oblique vision and the form-world iconography and style of 'making-strange' that exists in the photographs of László Moholy-Nagy, André Kertész, Tim Gidal and El Lissitzky. Kelly's image is of course more personal, and painterly, than any of these. At the same time, it shares with them an affinity to architecture and hard edges. Internally, too, the 'intervals' of lights and darks made by the stairs and shadows will be carried over into the panel paintings – which have perceivable gaps between the frames – and into the pattern of marks and gaps that make up their content. Kelly's statement that 'my paintings are not depictions of the natural world' is as strictly and literally true for him as it is for many process-led digital abstractionists, and for the same reasons.

NOTES

There are a handful of editorial comments in the Notes, but they are largely a list of the publication details of the books, essays and articles that Rees refers to. These details have required some tracking down because they were not always to hand in the manuscript drafts and were often only recorded in abbreviated form. In most cases the publication details correspond with editions of the books that Rees had in his library. Sometimes they refer to more recent editions. Occasionally, the notes list additional publication details pertaining to primary sources that Rees cites via secondary sources. Where passages of the book serially quote from relatively short articles, or sections of a book, the notes cite the page range of the source. Individual page numbers are given for longer quotations, one-off references and instances where quotations are from different sections of a single source.

Foreword

1 Frederic J. Schwartz, *Blind Spots: Critical Theory and the History of Art in Twentieth Century Germany* (New Haven: Yale University Press, 2005), 134.

Fields

1 Christopher Alexander, *The Timeless Way of Building* (New York: Oxford University Press, 1979), 233.

2 Martin Jay, *Force Fields: Between Intellectual History and Cultural Critique* (London: Routledge, 1993).

3 Charles Madge, 'A Note on Images', in *Humphrey Jennings: Filmmaker, Painter, Poet*, ed. Marie-Louise Jennings, 2nd edn (1982; London: BFI, 2014), 78.

4 Humphrey Jennings, 'Introduction', in *Pandæmonium: The Coming of the Machine as Seen by Contemporary Observers*, ed. Mary-Louise Jennings and Charles Madge (1985; London: Papermac, 1995), xxxv.

5 André Bazin, 'The Evolution of the Language of Cinema', in *What Is Cinema?* vol. 1, ed. and trans. Hugh Grey (Berkeley: University of California Press, 1967), 26.

6 James Meyer, *Minimalism: Art, Power and Polemics in the Sixties* (New Haven: Yale University Press, 2004), 3.

7 Rosalind Krauss, 'Sculpture in the Expanded Field', 8 *October* (Spring, 1979): 30–44.

8 Slavoj Zizek, *The Parallax View* (Cambridge, MA: MIT, 2006).

9 See, for example, Yve-Alain Bois and Rosalind E. Krauss, *Formless: A User's Guide* (New York: Zone Books, 1997).

10 See Clement Greenberg, 'Modernist Painting' (1960), in *Clement Greenberg: The Collected Essays and Criticism, Volume 4: Modernism with a Vengeance 1957-1969*, ed. John O'Brian (Chicago: University of Chicago Press, 1993), 85–93.

11 Michael Fried, *Absorption and Theatricality: Painting and Beholder in the Age of Diderot* (Chicago: University of Chicago Press, 1980).

12 Fried originally deployed the term 'theatricality' in the essay 'Art and Objecthood' (1967). See *Art and Objecthood: Essays and Reviews* (Chicago: University of Chicago Press, 1998), 148–73. 'Absorption' is also mentioned here, but the idea is only fully developed in the later book *Absorption and Theatricality*.

13 See Ben Brewster and Lea Jacobs, *Theatre to Cinema: Stage Pictorialism and the Early Feature Film* (Oxford: Oxford University Press, 1997), and Thomas Elsaesser, *Weimar Cinema and After: Germany's Historical Imagination* (Abingdon: Routledge, 2000).

14 John Du Cane, 'The Camera and Spectator: Michael Snow in Conversation with John Du Cane' (1973), in *The Michael Snow Project: The Collected Writings of Michael Snow* (Waterloo, ON: Wilfred Laurier Press, 1994), 87–92.

15 Michael Fried, *Manet's Modernism, or The Face of Painting in the 1860s* (Chicago: University of Chicago Press, 1996), 387–90.

16 See the 'Preface' to Henry James, *The Golden Bowl* (1904/1909; Penguin: London, 2009), 9.

Film machine

1 Mark Anderson, 'Kafka in America: Notes on a Travelling Narrative', in *Kafka's Clothes: Ornament and Aestheticism in the Habsburg Fin de Siècle* (Oxford: Clarendon, 1992), 117–19.

2 Franz Kafka, 'Travel Diaries: Trip to Friedland and Reichenberg, January–February 1911', trans. Martin Greenberg and Hannah Arendt, in *The Diaries of Franz Kafka 1910-1923*, ed. Max Brod (1948; Harmondsworth: Penguin, 1972), 430.

3 Sergei Eisenstein, 'Dickens, Griffith and the Film Today' (1944), in *Film Form: Essays in Film Theory*, ed. and trans. Jay Leyda (New York: Harcourt, 1949), 195–257.

4 Malin Wahlberg, 'Wonders of Cinematic Abstraction', *Screen* 47, no. 3 (2006): 273.

5 Anderson, 'Kafka in America: Notes on a Travelling Narrative', 115.

Film as optic and idea

1 Charles Barr, *English Hitchcock* (London: Cameron and Hollis, 1999), 64.

2 P. Adams Sitney, 'Whoever Sees God Dies: Cinematic Epiphanies', in *Modernist Montage: The Obscurity of Vision in Cinema and Literature* (New York: Columbia University Press, 1990), 207–10.

3 P. Adams Sitney, *Visionary Film: The American Avant-Garde, 1943–2000*, 3rd edn (1974; Oxford: Oxford University Press, 2002).

4 See James Meyer, 'Morris's "Notes on Sculpture"', in *Minimalism: Art, Power and Polemics in the Sixties*, 160–6.

5 Susan Sontag, *Against Interpretation and Other Essays* (New York: Farrar, Straus and Giroux, 1961).

6 One instance of Husserl's use of this phrase can be found in Edmund Husserl, *Logical Investigations*, vol. 1, ed. Dermot Moran, trans. J. N. Findlay, 2nd edn, 2 vols. (1900 and 1901; Abingdon: Routledge, 2001), 168.

Expanding cinema

1 Robert Morris's 'Notes on Sculpture' (Parts 1–4) were originally published in four separate issues of *Art Forum* (February 1966, October 1966, June 1967 and April 1969).

2 Meyer, *Minimalism: Art, Power and Polemics in the Sixties*, 160.

Film objects

1 The line 'Les objets ont des attitudes' is from Epstein's book *Le Cinématographe vu de l'Etna* (The Cinema Seen from Etna, 1926), which has recently been collected in *Jean Epstein: Critical Essays and New Translations*, ed. Sarah Keller and Jason N. Paul (Amsterdam: Amsterdam University Press, 2012), 287–311. It is translated by Stuart Liebman there as 'Objects take on airs'.

2 Stanley Cavell, *The World Viewed: Reflections on the Ontology of Film*, enlarged edn (1971; Cambridge, MA: Harvard University Press, 1979).

3 Laurent Mannoni, *The Great Art of Light and Shadow* (Exeter: Exeter University Press, 2000).

Projection space

1 Hal Foster, 'Arty Party', *London Review of Books* 25, no. 23 (December 2003), 21.

2 Nicolas Bourriaud, *Postproduction: Culture as Screenplay: How Art Reprograms the World*, trans. Jeanine Herman (New York: Lukas and Sternberg, 2002).

3 Fisun Guner, 'Hit Is a Near Miss', *Evening Standard*, 19 November 2003.

4 Gene Youngblood, *Expanded Cinema* (New York: Dutton, 1970).

5 A typically disapproving essay by Greenberg is 'Avant-Garde Attitudes: New Art in the Sixties' (1968), in *The Collected Essays and Criticism, Volume 4*, 292–303. Michael Snow arguably foresaw the trend of fusing technologies in his work, much of which could be characterized as 'multimedia' given that it has often incorporated elements of photography, sculpture, film, video, digital media and music. For the 'new media theory' of Marshall McLuhan see *Understanding Media* (London: Routledge, 1964).

6 Jonathan Jones, 'The Moving Image', *The Guardian* (Turner Prize supplement), 1 November 2003, 7.

Time frames

1 Walter Benjamin, *The Arcades Project*, ed. Rolf Tiedemann, trans. Howard Eiland and Kevin McLaughlin (1982; Cambridge, MA: Belknap/Harvard University Press, 1999), 530.

2 Walter Benjamin, 'A Discussion of Russian Film Art and Collectivist Art in General' (1927), in *The Weimar Republic Sourcebook*, ed. Anton Kaes, Martin Jay and Edward Dimendberg (Berkeley: University of California Press, 1994), 626–8.

3 George Kubler, *The Shape of Time: Remarks on the History of Things* (New Haven: Yale University Press, 1962).

4 Benjamin, 'A Discussion of Russian Film Art and Collectivist Art in General', 626.

5 For one example of Smithson's reading of Kubler see 'Quasi-Infinities and the Waning of Space' (1966), in *Robert Smithson: The Collected Writings*, ed. Jack Flam (Berkeley: University of California Press, 1996), 34–38.

6 Fried, 'Art and Objecthood'.

7 Mieke Bal, 'Sticky Images: The Foreshortening of Time in Art of Duration', in *Time and the Image*, ed. Carolyn Bailey Gill (Manchester: Manchester University Press, 2000), 94. The Kubler quotation is from *The Shape of Time*, 17.

8 André Breton, 'The Lighthouse of the Bride' (1934), in *Surrealism and Painting*, trans. Simon Watson Taylor (1965; Boston: MFA Publications, 2002), 85–101.

9 Thierry De Duve, 'On incarnation: Sylvie Blocher's *L'annonce amoureuse* and Edouard Manet's *A Bar at the Folies-Bergère*', in *Time and the Image*, 103.

10 Joan Copjec, 'The Strut of Vision: Seeing's Corporeal Support', in *Time and the Image*, 41. The book by Jonathan Crary that Copjec is critiquing here is *Techniques of the Observer: On Vision and Modernity in the Nineteenth Century* (Cambridge, MA: MIT, 1990).

11 Anthony Vidler, 'Horror Vacui: Constructing the Void from Pascal to Freud', in *Warped Space: Art, Architecture, and Anxiety in Modern Culture* (Cambridge, MA: MIT, 2000), 17–23.

12 The line from Pascal that Vidler cites here is from Hubert Damisch, *The Origin of Perspective*, trans. John Goodman (1987; Cambridge, MA: MIT, 1994), 385.

13 See Jean-Louis Baudry, 'Ideological Effects of the Basic Cinematographic Apparatus', *Film Quarterly* 28, no. 2 (Winter, 1974/75): 39–47, and widely reprinted.

Realisms

1 Richard Allen, 'Representations, Illusion, and the Cinema' (1993), in *The Visual Turn: Classical Film Theory and Art History*, ed. Angela Dalle Vacche (New Brunswick: Rutgers University Press, 2003), 226–52. The Noël Burch reference is 'Narrative/Diegesis – Thresholds, Limits', *Screen* 23, no. 2 (July/August 1982): 16–33.

2 Richard Wollheim, 'Seeing-as and Seeing-in and Pictorial Representation', in *Art and Its Objects*, 2nd edn (1968; Cambridge: Cambridge University Press, 1980), 205–27.

3 See Christian Metz, 'On the Impression of Reality in the Cinema', in *Film Language: A Semiotics of the Cinema*, trans. Michael Taylor (1971; Chicago: University of Chicago Press, 1974), 3–15.

4 Michael O'Pray, *Film, Form and Phantasy: Adrian Stokes and Film Aesthetics* (Basingstoke: Palgrave Macmillan, 2004), 21.

5 Garrett Stewart, *Between Film and Screen: Modernism's Photo Synthesis* (Chicago: University of Chicago Press, 1999), 141.

6 O'Pray, *Film, Form and Phantasy*, 26.

7 Richard Wollheim, 'The Spectator in the Picture: Friedrich, Manet, Hals', in *Painting as an Art* (London: Thames and Hudson, 1987), 101–86.

8 O'Pray, *Film, Form and Phantasy*, 101.

9 Stewart, *Between Film and Screen*, 353, note 5. For the 'parergon', see Jacques Derrida, *Truth in Painting*, trans. Geoff Bennington and Ian McLeod (1978; Chicago: University of Chicago Press, 1987).

10 O'Pray, *Film, Form and Phantasy*, 112. For Laura Mulvey's account of *Journey to Italy* see the chapter 'Roberto Rossellini's *Journey to Italy / Viaggio in Italia* (1953)', in *Death 24x a Second: Stillness and the Moving Image* (London: Reaktion Books, 2006), 104–23.

11 O'Pray, *Film, Form and Phantasy*, 120.

12 Sean Cubitt, *The Cinema Effect* (Cambridge, MA: MIT, 2004), 167.

13 The essay by Vivian Sobchack that Cubitt refers to is 'The Scene of the Screen: Envisioning Cinematic and Electronic "Presence"', in *Materialities of Communication*, ed. Hans Ulrich Gumbrecht and K. Ludwig Pfeiffer, trans. William Whobrey (Stanford: Stanford University Press, 1994), 83–106.

14 See Vivian Sobchack, *Screening Space: The American Science Fiction Film* (New York: Ungar, 1987).

15 Stewart, *Between Film and Screen*, 193.

16 The Noël Burch reference here is the essay 'Charles Baudelaire vs. Doctor Frankenstein', *Afterimage* 8/9 (Spring, 1981): 4–21.

17 Stewart, *Between Film and Screen*, 197.

18 Ibid., 194.

19 O'Pray, *Film, Form and Phantasy*, 120.

20 André Bazin, cited in O'Pray, *Film, Form and Phantasy*, 121. See André Bazin, 'In Defense of Rossellini' (1955), in *What Is Cinema?* vol. 2, ed. and trans. Hugh Grey (Berkeley: University of California Press, 1971), 98.

21 O'Pray, *Film, Form and Phantasy*, 125. For Geoffrey Nowell-Smith on Antonioni's *L'Eclisse*, see the essay 'Shape around a Black Point', *Sight and Sound* 33, no. 1 (Winter, 1963/64), 15–20.

22 Dudley Andrew, *André Bazin* (1978; New York: Columbia University Press, 1990), 121.

23 Bazin, cited in Dudley Andrew, *André Bazin*. The origin of this quotation is André Bazin, *Jean Renoir*, ed. François Truffaut, trans. W. W. Halsey II and William H. Simon (New York: Simon and Schuster, 1974), 90.

Asymptote

1 Peter Gidal, *Understanding Beckett: A Study of Monologue and Gesture in the Works of Samuel Beckett* (Basingstoke: Macmillan, 1986), 187–92.

2 Heinrich von Kleist, 'On the Marionette Theatre' (1810), trans. Thomas G. Neumiller, *The Drama Review* 16, no. 3 (1972): 23.

3 Cubitt, *The Cinema Effect*, 73.

4 Bazin, '*Umberto D*': A Great Work' (1952), in *What Is Cinema?* vol. 2, 79–83.

5 Andrew, *André Bazin*, 107.

6 Cubitt, *The Cinema Effect*, 149. For the Bazin quotations see '*Umberto D*': A Great Work', 82.

7 Cubitt, *The Cinema Effect*, 155.

8 Ibid., 158.

9 Frank P. Tomasulo, '"I'll See It When I Believe It": Rodney King and the Prison-House of Video', in *The Persistence of History: Cinema, Television and the Modern Event*, ed. Vivian Sobchack (New York: Routledge, 1996), 69–88.

10 Tomasulo here refers to Hayden White's essay 'The Modernist Event' in *The Persistence of History*, 17–38.

Digital dialectic

1 Lev Manovich, 'What Is Digital Cinema?' in *The Digital Dialectic: New Essays on New Media*, ed. Peter Lunenfeld (Cambridge, MA: MIT, 1999), 172–92.

2 For Bergson's reference to marching soldiers and cinematography, see *Creative Evolution*, trans. Arthur Mitchell (1907; New York: Dover, 1998), 305.

3 Manovich, 'What Is Digital Cinema?' 178.

4 Ibid., 180.

5 W. J. Mitchell, cited in Manovich, 'What Is Digital Cinema?' 181. See W. J. Mitchell, *The Reconfigured Eye: Visual Truth in the Post-Photographic Era* (Cambridge, MA: MIT, 1994), 7.

6 Manovich, 'What Is Digital Cinema?' 183.

7 Ibid., 265, note 24.

8 Lev Manovich, 'Avant-Garde as Software' (1999). PDF available online at Manovich's website: http://manovich.net/content/04-projects/027-avant-garde-as-software/24_article_1999.pdf. The following passage quotes from pages 7–9 of this article.

9 Lev Manovich, 'Cinema Redefined', in *The Language of New Media* (Cambridge, MA: MIT, 2001), 300–7.

10 'Interview with David Hockney', *RA Magazine* 85 (Winter, 2004), 33.

11 Michael Fried, *Menzel's Realism: Art and Embodiment in Nineteenth-Century Berlin* (New Haven: Yale University Press, 2002).

12 Yvonne Spielmann, 'Expanding Film into Digital Media', *Screen* 40, no. 2 (Summer, 1999): 131–45.

13 Ibid., 135.

14 Ibid., 137.

15 Ibid., 138.

16 The publications that Spielmann cites here are Joachim Paech, 'Das Bild zwischen den Bildern', in *Film, Fernsehen, Video und die Künste: Strategien der Intermedialität* (Stuttgart: Metzler, 1994), 163–78, and Raymond Bellour, *L'Entre-Images: Photo, Cinéma, Vidéo* (Paris: La Différence, 1990), 12. The latter has been published in English as *Between the Images* (Zurich: JRP, 2012).

17 Spielmann, 'Expanding Film into Digital Media', 140.

Fields in Braque and Gehr

1 Michael Baxandall, 'Fixation and Distraction: The Nail in Braque's *Violin and Pitcher* (1910)', in *Sight and Insight: Essays on Art and Architecture in Honour of E.H. Gombrich at 85*, ed. J. Onians (London: Phaidon, 1994), 398–415.

2 Yve-Alain Bois, cited in Baxandall, 'Fixation and Distraction', 399. For the original quotation see Yve-Alain Bois, 'The Semiology of Cubism', in *Picasso and Braque: A Symposium*, ed. William Rubin (New York: Museum of Modern Art, 1992), 184.

3 Baxandall, 'Fixation and Distraction', 402.

4 Ibid., 409.

5 Ibid., 410.

6 Ibid., 414.

7 Gilberto Perez, 'Films in Review', *Yale Review* 87, no. 4 (October, 1999): 177.

8 Ibid., 177.

9 Ibid., 178.

10 Baxandall, 'Fixation and Distraction', 401.

11 Perez, 'Films in Review', 179.

Classic film theory and the spectator

1 The account of Panofsky here follows Thomas Y. Levin, 'Iconology at the Movies: Panofsky's Film Theory' (1996), in *The Visual Turn: Classical Film Theory and Art History*, ed. Angela Dalle Vacche (New Brunswick: Rutgers University Press, 2003), 85–116. For a discussion of the different versions of this essay, see page 104, note 5. Panofsky's 'Style and Motion in the Motion Pictures' (dated 1934) is also published in *The Visual Turn*, 69–84. The line regarding the 'dynamization of space' is on page 71.

2 Panofsky, cited in Levin, 'Iconology at the Movies', 89.

3 Ibid., 93.

4 Lukács's essay 'Thoughts towards an Aesthetic of the Cinema' (1913) can be found in Ian Aitken, *Lukácsian Film Theory: A Study of Georg Lukács Writings on Film, 1913–71* (Manchester: Manchester University Press, 2012), 181–7.

5 Erwin Panofsky, *Perspective as Symbolic Form*, trans. Christopher Wood (1927; New York: Zone Books, 1991), 154, note 73.

6 See, for example, Malcolm Le Grice, *Abstract Film and Beyond* (London: Studio Vista, 1977), and various essays including 'Material, Materiality, Materialism' (1978), in *Experimental Cinema in the Digital Age* (London: BFI, 2001), 164–72; and Peter Gidal, 'Theory and Definition of Structural/Materialist Film' (1975), in *Flare Out: Aesthetics 1966–2016* (London: Visible Press), 37–69.

7 Manovich, *The Language of New Media*, 254.

8 Ibid., 257.

9 Ara H. Merjian, 'Middlebrow Modernism: Rudolf Arnheim at the Crossroads of Film Theory and the Psychology of Art', in *The Visual Turn*, 158. 'Constellations' and 'networks of relations' are Arnheim's terms.

10 Maurice Merleau-Ponty's only essay on cinema is 'Film and the New Psychology' (1945), in *Sense and Non-Sense*, ed. Patricia Allen Dreyfus and Hubert L. Dreyfus (1948; Evanston, IL: Northwestern University Press, 1964), 48–59.

11 Arnheim, cited in Merjian, 'Middlebrow Modernism', 161.

12 Rudolf Arnheim, 'Selections Adapted from *Film*' (1933), in *Film as Art* (Berkeley: University of California Press, 1957), 101.

13 Ibid., 100.

14 Ibid., 101.

15 Ibid., 103.

16 The sue k. quotations in this passage are either from her MA thesis, Suzanne Kuronen, 'The Figure in the Construction of Space as Materialist Film' (MA diss., University of Western Australia, Perth, 2004), 13–17, or an earlier draft version that she sent to A.L. Rees for comments.

17 Rudolf Arnheim, 'Painting and Film' (1934), in *The Visual Turn*, 151–3.

18 Ibid., 151.

19 Merjian, 'Middlebrow Modernism', 167.

20 Arnheim, cited in Merjian, 'Middlebrow Modernism', 167.

21 Rudolf Arnheim, 'To Maya Deren' (1962), in *Film Essays and Criticism*, trans. Brenda Benthien (Madison: University of Wisconsin Press, 1997), 227–31.

22 André Bazin, 'Painting and Cinema', in *What Is Cinema?* vol. 1, 166.

23 Anderson, *Kafka's Clothes*, 107.

24 Arnheim, cited in Merjian, 'Middlebrow Modernism', 176. The source of this quote is Arnheim's essay 'Melancholy Unshaped' (1963), in *Towards a Psychology of Art* (Berkeley: University of California Press, 1967), 181–91.

25 Merjian, 'Middlebrow Modernism', 162.

26 Ibid., 181.

27 Lukács, cited in Tom Levin, 'From Dialectical to Normative Specificity: Reading Lukács on Film', *New German Critique*, no. 40, Special Issue on Weimar Film Theory (Winter, 1987): 59. Lukács's interview with Yvette Biró, entitled 'Expression of Thought in Film' can be found in Aitken, *Lukácsian Film Theory*, 256–63.

28 Lukács, cited in Levin, 'From Dialectical to Normative Specificity', 45.

29 Ibid., 49.

30 Ibid., 49–50.

Field and gestalt

1 Rudolf Arnheim, as cited in Merjian's 'Middlebrow Modernism', 184, note 42. According to Merjian, the origin of this quote is Arnheim's essay 'The Double-Edged Mind: Intuition and the Intellect', in *New Essays on the Psychology of Art* (Berkeley: University of California Press, 1986), 21.

2 Rosalind Krauss, *The Optical Unconscious* (Cambridge, MA: October/MIT, 1994), 303. Merjian makes a link between these two quotes in 'Middlebrow Modernism', 185, note 51.

3 Arnheim cited in Krauss, ibid., 303. Arnheim's critique of Pollock can be found in the essay 'Accident and Necessity of Art' (1957), in *Towards a Psychology of Art: Collected Essays* (Berkeley: University of California Press, 1966), 172.

4 Anton Ehrenzweig cited in Krauss, ibid., 304. The Ehrenzweig essays that Krauss refers to are 'Unconscious Form-Creation in Art', *British Journal of Medical Psychology*, 'Parts I and II', no. 21, (1948): 185–214 and 'Part III' no. 22 (1949): 88–109.

5 Madge, 'A Note on Images', 78.

6 Ibid., 79.

7 Humphrey Jennings, 'Letter from Jennings to William Empson', in Kevin Jackson, *Humphrey Jennings: The Definitive Biography of one of Britain's Most Important Film-Makers* (London: Picador, 2004), 387–90.

8 See Jackson, *Humphrey Jennings: The Definitive Biography*, 366, which refers to two letters written by Stuart Legg, to potential publishers, that quote Jennings's description of *Pandæmonium*.

9 Humphrey Jennings, 'Introduction', *Pandæmonium*, xxxv.

Monet, Lumière and cinematic time

1 Steven Z. Levine, 'Monet, Lumière and Cinematic Time', *The Journal of Aesthetics and Art Criticism* 36, no. 4 (Summer, 1978): 441–7. The early critics that Levine cites in this essay (Louis Gillet, Rémy de Gourmont, George Clemenceau and Roger Marx) are all sourced from French periodicals from between 1895 and 1901. See Levine's endnotes on page 477.

2 Georges Sadoul cited in Levine, ibid., 443. The origin of this quotation is *Histoire du cinéma mondial: Des Origins à nos jours* (Paris: Flammarion, 1949), 49.

3 André Bazin cited in Levine, ibid., 446. The source of the Bazin quote is 'The Evolution of the Language of Cinema', in *What Is Cinema*, vol. 1, 27.

4 Jonas Mekas, 'Sixth Independent Film Award', *Film Culture* no. 33 (Summer, 1964), 1.

Displacement, sculpture

1 The interview, involving questions from Peter Gidal, Martin Walsh, Stephen Heath, Regina Cornwell and Jonathan Rosenbaum, is published as 'Straub/Huillet Talking', *A Journal from the Royal College of Art* (January 1976): 92–7. The editorial to *The Journal* explains that it grew out of the RCA's forerunner publication *Ark*, which 'in its heyday, was a product, a symptom of "swinging London" as The Journal is the product of today's super-inflationary and crisis-torn society'.

2 Peter Gidal, 'Short Notes on Some Contentious Issues', *A Journal from the Royal College of Art* (January 1976): 90–1.

3 Perhaps *Moses and Aaron* bears comparison with McCall's solid light films, as two forms of 'primal cinema', because of their pared aesthetics: *Moses and Aaron* involves long takes, direct sound and barren locations; McCall's works have reduced cinema to thin beams of light.

4 Anthony McCall, '*Line Describing a Cone* and Related Films', in *Anthony McCall: Film Installations* (Coventry: Mead Gallery/University of Warwick, 2004), 46.

5 George Baker, 'Film Beyond Its Limits', in *Anthony McCall: Film Installations*, 4–31.

6 The interview with Anthony McCall cited here is in Scott MacDonald, *A Critical Cinema II* (Berkeley: University of California Press, 1992), 157–74.

7 Lisa Le Feuvre, 'The Continuous Present', in *Anthony McCall: Film Installations*, 32–41.

Bodies in motion

1 Phillip Prodger, 'In the Blink of an Eye: The Rise of the Instantaneous Photography Movement, 1839–78', in *Time Stands Still: Muybridge and the Instantaneous Photography Movement*, ed. Phillip Prodger (New York: Oxford University Press and Stanford University, 2003), 50. Prodger here is picking up on observations in a chapter entitled 'Moment and Movement' in Alexander Sturgis's catalogue essay for the exhibition *Telling Time* (London: National Gallery, 2000), 36.

2 Ibid., 55.

3 For Newhall's reference to Alberti, see *The History of Photography* (1937; New York: Museum of Modern Art, 1982), 9.

4 See Geoffrey Batchen, *Burning with Desire: The Conception of Photography* (Cambridge, MA: MIT Press, 1997), 92.

5 The description of the zoopraxiscope and subsequent pre-cinematic devices follows Prodger's account in a shorter technical essay in the same publication: Phillip Prodger, 'The First Zoopraxiscope Disc: The First Motion Picture', in *Time Stands Still*, 154–61.

6 See Joseph Anderson and Barbara Anderson, 'The Myth of Persistence of Vision Revisited', *Journal of Film and Video* 45, no. 1 (Spring 1993): 3–12.

7 Phillip Prodger, 'Make It Stop: Muybridge and the New Frontier in Instantaneous Photography', in *Time Stands Still*, 208.

8 Philippe-Alain Michaud, *Aby Warburg and the Image in Motion* (New York: Zone Books, 2004), 85.

9 Goethe, cited in Michaud, ibid., 85. For the origin of the quote, see J. W. Goethe, 'Observations on the *Laocoön*' (1798), in *Goethe on Art*, ed. and trans. John Gage (London: Scolar Press, 1980), 81.

10 Peter Wollen, 'Time, Image and Terror', in *Time and the Image*, 149–58. The 1799 English translation of Goethe's essay that Wollen refers to is reprinted in *German Essays on Art History*, The German Library; vol. 79, ed. Gert Schiff (New York: Continuum, 1988), 41–52.

11 Lessing, cited in Wollen, ibid., 153.

12 Ibid., 157.

Intervals

1 François Albera, 'Eisenstein and the Theory of the Photogram', in *Eisenstein Rediscovered*, ed. Ian Christie and Richard Taylor (London: Routledge, 1993), 196.

2 Annette Michelson, 'The Wings of Hypothesis: On Montage and the Theory of the Interval', in *Montage and Modern Life*, ed. Matthew Teitlebaum (Cambridge, MA: MIT, 1992), 61.

3 Eisenstein, cited in Michelson, ibid., 61, footnote 1.

4 S. M. Eisenstein, 'A Dialectic Approach to Film Form' (1929), in *Film Form: Essays in Film Theory*, ed. Jay Leyda (San Diego: Harcourt/Harvest, 1949), 45–64.

5 Richard Taylor's translation is entitled 'The Dramaturgy of Film Form (The Dialectical Approach to Film Form)', in *S.M. Eisenstein Selected Works, Vol. I, Writings, 1922–34*, ed. Richard Taylor (London: BFI, 1988), 161–80.

6 Ibid., 318, note 53.

7 Oksana Bulgakowa cites Richter's recollection of his collaboration with Malevich, in 1926 or 1927, and his astonishment forty years later of having seen a colour publication, with notes for a film project dedicated to him. See 'Malevich in the Movies: Rubbery Kisses and Dynamic Sensations', in Kazimir Malevich, *The White Rectangle: Writings on Film*, ed. Oksana Bulgakowa (Berlin: Potemkin Press, 1997), 13. Eisenstein's criticism of Malevich's writing on cinema appears in 'Methods of Montage' written in London and originally published in 1930. See 'Methods of Montage', in *Film Form*, 79.

8 Dziga Vertov, 'WE: Variant of a Manifesto' (1922), in *Kino-Eye: The Writings of Dziga Vertov*, ed. Annette Michelson, trans. Kevin O'Brien (Berkeley: University of California Press, 1984), 8.

9 Eisenstein, 'A Dialectical Approach to Film Form', in *Film Form*, 49.

10 Vertov, 'WE: Variant of a Manifesto', 8–9.

11 Annette Michelson, 'Introduction', *Kino-Eye*, xxx.

12 Michelson, 'The Wings of Hypothesis', 73.

13 The book that Michelson refers to here is Linda Dalrymple Henderson's *The Fourth Dimension and Non-Euclidean Geometry in Modern Art* (1983; Cambridge, MA: MIT Press, 2013).

14 Vertov, 'WE: Variant of a Manifesto', 8.

15 Dziga Vertov, 'From Kino-Eye to Radio-Eye', in *Kino-Eye*, 90.

16 Dziga Vertov, 'Kino-Eye', in *Kino-Eye*, 72.

17 Dziga Vertov, 'From the History of the Kinoks', in *Kino-Eye*, 100.

18 This is the story as told by Vertov in 'From the History of the Kinoks', 93. See Jeremy Hicks, *Dziga Vertov: Defining Documentary Film* (London: I.B. Tauris, 2007) 6, for a more nuanced version. According to Hicks, Vertov's regular newsreel editors refused to edit the film as requested, but Elizaveta Svilova, whom he met in 1919, took pity on Vertov and edited the film as per his instructions.

19 Dziga Vertov, 'The Man with a Movie Camera', in *Kino-Eye*, 84.

20 Dziga Vertov 'From Notebooks, Diaries', in *Kino-Eye*, 256.

21 Dziga Vertov, 'From Kino-Eye to Radio Eye', 88.

22 Vertov, 'From Notebooks, Diaries', 272.

Methods of montage

1 Vlada Petrić, *Constructivism in Film: The Man with a Movie Camera: A Cinematic Analysis*, revised edn (1987; Cambridge: Cambridge University Press, 2012), 27.

2 See Slavko Vorkapich, 'Film as a Visual Language and as a Form of Art', *Film Culture* (Fall 1965): 1–46.

3 Petrić, *Constructivism in Film*, 27. The line 'a movement between the pieces (shots) and frames' is from Petrić's translation of Vertov's article, referred to as 'From "Film-Eye" to "Radio-Eye"', which is based on the Russian original, published in *Stat'I, dnevniki, zamysli* (Articles, Diaries, Projects) ed. Sergei Drobashenko (Moscow: Iskusstvo, 1966). Hence the issue of 'frames' and 'intervals' in translation recurs! Petrić's version clearly differs from the translation of the same essay by Kevin O'Brien, as 'From Kino-Eye to Radio-Eye' in the *Kino-Eye* collection, where there is no mention of frames. A closely related article, entitled 'Kino-Eye, Lecture II' (published in *Film Culture* in 1962, having first appeared in the American magazine *Filmfront* no. 3, in 1935, translated by S. Brody from a French version) also makes reference to frames: 'The school of Kino-Eye requires that the cine-thing be built upon "intervals", that is, upon a movement between the pieces, the frames; upon the proportions of these pieces between themselves, upon the transitions from one visual impulse to the one following it.' See Dziga Vertov, 'Kino Eye Lecture II' (1929), in *Film Culture Reader*, ed. P. Adams Sitney (New York: Cooper Square Press, 2000), 374.

4 Petrić, *Constructivism in Film*, 43.

5 Eisenstein, cited in Petrić, ibid., 96.

6 Eisenstein, 'Methods of Montage', in *Film Form*, 79.

7 Petrić, *Constructivism in Film*, 134.

8 Vertov, cited in Petrić, ibid., 138.

9 Petrić, ibid.

10 Vertov, 'WE: Variant of a Manifesto', 8.

11 The 'Street and Eye' sequence of *The Man with a Movie Camera* is analysed under the subheading 'Phi-effect and kinesthesia', in Petrić, *Constructivism in Film*, 139–48.

12 Ibid., 147.

13 Ibid., 148–55. The 'Working Hands' sequence is analysed under the subheading 'Intervals of movement'.

14 Ibid., 164.

15 Eisenstein, 'The Filmic Fourth Dimension' (1929), in *Selected Works, Vol. I*, 187.

16 See Vertov's review, 'Kino-Eye on *Strike*' (1925), in *Lines of Resistance: Dziga Vertov and the Twenties*, ed. Yuri Tsivian (Gemona: Le Giorante del Cinema Muto, 2004), 125–6.

17 Eisenstein, 'The Problem of the Materialist Approach to Form' (1925), in *Selected Works, Vol. I*, 62.

18 Ibid., 63, footnote.

19 Ibid., 64, footnote.

20 Eisenstein, 'The Principles of the New Russian Cinema' (1930), in *Selected Works, Vol. I*, 201.

21 S. M. Eisenstein, 'Laocoön' (1937/38), in *Selected Works: Vol. II, Towards a Theory of Montage*, ed. Michael Glenny and Richard Taylor, trans. Michael Glenny (London: BFI, 1991), 109.

22 Ibid., 110.

23 Ibid., 114.

24 Ibid., 119.

25 Ibid., 121. 'I hate movement which disturbs the lines' is a translation of the line 'Je hais le mouvement qui déplace les lignes' from Baudelaire's poem 'La Beauté', in *Les Fleurs du Mal*.

26 Ibid., 121.

27 Ibid., 122.

28 The Fluxus films that Eisenstein 'pre-empts' here are Yoko Ono's *Eyeblink* (1966) and Chieko Shiomi's *Disappearing Music for Face* (1966), both of which were shot at 2000 frames per second.

29 Eisenstein, 'Laocoön', *Selected Works: Vol. II*, 128.

Frames

1 Paul McCarthy's interview, 'Paul McCarthy talks to Kurt Kren', was published in the magazine *ND*, edited by Daniel Plunkett, no. 5 (Austin, Texas, 1985). Stephen Barber has written about Kren in *The Art of Destruction: The Films of the Vienna Action Group* (London: Creation Books, 2004). Peter Tscherkassky's essay, devoted to Kren, is 'Lord of the Frames' (1996) available via his website – http://www.tscherkassky.at/content/txt_by/07_lor_of_frames.html – and in a new translation by Eve Heller in *Kurt Kren: Structural Films*, ed. Nicky Hamlyn, Simon Payne and A. L. Rees (Bristol: Intellect, 2016), 241–8.

2 See David S. Lenfest's introduction to Werner Nekes, 'Whatever happens between the pictures', *Afterimage* (November 1977): 7–13.

3 Nekes, 'Whatever happens between the pictures', 8.

4 For Peter Kubelka's formulations on the succession/overlaying of film frames, see Jonas Mekas, 'Interview with Peter Kubelka' (1967), in *Film Culture Reader*, ed. P. Adams Sitney (1970; New York: Cooper Square Press, 2000), 285–300.

5 Nekes, 'Whatever happens between the pictures', 10.

6 Ibid., 10.

7 Nicky Hamlyn, 'The Elusive Frame', in *Moving Frame*, exhibition catalogue (London: Royal College of Art, 2006), 23.

8 Nicky Hamlyn, correspondence to the author.

9 Nekes, 'Whatever happens between the pictures', 10.

10 Ibid., 11.

11 Ibid., 13.

12 Peter Tscherkassky, 'Lord of the Frames' (1996), in *Kurt Kren: Structural Films*, 241–8.

13 The Kandinsky essay that Tscherkassky cites is 'On the Problem of Form' (1912), which can be found in *Theories of Modern Art: A Source Book*, ed. Herschel B. Chipp (University of California Press, 1968), 155–8.

14 The numbers preceding the title of Kren's films refer to the order of that film in his filmography and the date. For example, 2/60 is the second film that Kren's filmography and it was made in 1960.

15 Taka Iimura, 'On Film-Installations', *Millennium Film Journal*, no. 2 (Spring/Summer, 1978): 74.

16 Ibid., 76.

17 Stuart Liebman, 'Apparent Motion and Film Structure: Paul Sharits's *Shutter Interface*', *Millennium Film Journal*, no. 2 (Spring/Summer, 1978): 101–9.

18 Ibid., 104.

19 Ibid., 107.

20 See Michael Fried, 'Art and Objecthood', 164 and 171 note 20, for his brief account of the way 'movies' evade the condition of theatricality associated with minimalism, simultaneously sidestepping the characteristics ascribed to modernist art.

21 From notes first published in 2004 to accompany the one-person exhibition '() / *Film Cans and Film Boxes*', Galerie Daniel Buchholz, Cologne, 14 May–1 June 2004. Available online: http://www.galeriebuchholz.de/exhibitions/325-2/

Frames and windows

1 See the Werner Graeff biography and statement in the catalogue *Film as Film: Formal Experiment in Film 1910–1975* (London: Hayward Gallery/Arts Council, 1979), 80.

2 *Hans Richter by Hans Richter*, ed. Cleve Grey (New York: Holt, Rinehart and Winston, 1971), 132.

3 Peter Weibel, 'The Viennese Formal Film', in *Film as Film*, 111.

4 Norbert Pfaffenbichler, 'From Panel Painting to Computer Processing: Notes on the Phenomenon of Abstraction in Contemporary Art', in *Abstraction Now*, ed. Norbert Pfaffenbichler and Sandro Droschl (Vienna: Edition Camera/Kunsterlhaus Vienna, 2004), 60.

5 Stefan Grissemann, 'trans', in *Abstraction Now*, 236.

6 Siegfried Kracauer, 'Man with a Movie Camera' (1929), in *Lines of Resistance*, 358.

7 Lissitzky-Küppers, 'Look at Life through Dziga Vertov's Kino-Eye' (1929), in *Lines of Resistance*, 360.

Constructivism and computers

1 Norbert Pfaffenbichler, 'From Panel Painting to Computer Processing', in *Abstraction Now*, 58–65.

2 Marie Röbl, 'Abstract Heritages and Legacies', in *Abstraction Now*, 76–9.

3 Lev Manovich, 'Abstraction and Complexity', in *Abstraction Now*, 80–5.

4 Miguel Carvalhais, 'Code Acts', in *Abstraction Now*, 86–9.

5 Christian Höller, 'TNK 7362', in *Abstraction Now*, 50–8.

6 See, for example, the section 'Animated Paintings' in the essay 'Cinematography: The Creative Use of Reality' (1960), in *Essential Deren: Collected Writings on Film*, ed. Bruce R. McPherson (Kingston, New York: McPherson, 2005), 110–31.

7 See, for example, Malcolm Le Grice's *Abstract Film and Beyond*, 32: 'If a new form of cinema is to be sought, it should be essentially "cinematic" – not dominated by literature and theatre, nor for that matter by painting or music.'

8 Richard Shiff, 'Photographic Soul', in *Where Is the Photograph?* ed. David Green (Brighton and Maidstone: Photoforum and Photoworks, 2003), 106.

9 Nicky Hamlyn, correspondence with the author.

10 Nicky Hamlyn has written about *Ich Tank* in his essay 'Film, Video, TV', *Coil* no. 9/10 (2000): and his book *Film Art Phenomena* (London: BFI, 2003). This particular quote comes from a correspondence with the author.

Geometry of intervals

1 Eisenstein's 'Stuttgart' paper of 1929 is the focus of François Albera's essay 'Eisenstein and the Theory of the Photogram' which can be found in *Eisenstein Rediscovered*, 194–203. The lecture was the basis of Eisenstein's the essay 'A Dialectical Approach to Film Form'.

2 Sophie Küppers (-Lissitzky), 'Look at Life through Dziga Vertov's Kino-Eye' (1929), in *Lines of Resistance*, 359–60.

3 Facsimiles of the journal *G* have been published in *G: An Avant-Garde Journal of Art, Architecture, Design, and Film (1923-26)*, ed. Detlef Mertins and Michael W. Jennings,

trans. Steven Lindberg and Margareta Ingrid Christian (London: Tate/Getty Research Institute, 2011).

4 El Lissitzky, 'Letter to Sophie Lissitzky' (September 1925), in *El Lissitzky: Life, Letters, Texts*, ed. Sophie Lissitzky-Küppers, trans. Helene Aldwinckle (London: Thames and Hudson, 1968), 67.

5 El Lissitzky, 'Letter to Sophie Lissitzky' (January 1926), in *El Lissitzky: Life, Letters, Texts*, 72.

6 El Lissitzky, 'A. and Pangeometry' (1925) is included in *El Lissitzky: Life, Letters, Texts*, but the version that Rees quotes from in this chapter is a slightly different translation by Eric Dluhosch in El Lissitzky, *Russia: An Architecture for World Revolution* (Cambridge, MA: MIT, 1984), 142–9.

7 Yve-Alain Bois, 'From $-\infty$ to $+\infty$: Axonometry, or Lissitzky's Mathematical Paradigm', in *El Lissitzky. 1890–1941. Architect, Painter, Photographer, Typographer*, ed. Jan Debbaut et al. (Eindhoven: Stedelijk Van Abbemuseum, 1990), 27–33.

8 Panofsky, *Perspective as Symbolic Form*, 154, note 73.

9 Mick Finch, '*Die Marquis Von O*. A painting by Frank Stella?' (Nottingham: Nottingham and Trent University Gallery, 1999). Available online: http://mickfinch.com/texts/stella.html

10 Yve-Alain Bois, 'Lissitzky, Mondrian, Strzemiński: Abstraction and Political Utopia in the Twenties', in *Cadences: Icon and Abstraction in Context*, ed. Joanna Ekman (New York: New Museum of Contemporary Art, 1991), 84.

11 Yve-Alain Bois, 'El Lissitzky: Radical Reversibility', *Art in America* (April 1988): 160–81.

12 Jean Leering, 'Lissitzky's Dilemma, with Reference to His Work after 1927', in *El Lissitzky. 1890-1941. Architect, Painter, Photographer, Typographer*, 59.

13 S. M. Eisenstein, 'Montage and Architecture', in *Selected Works: Vol. II, Towards a Theory of Montage*, 59–81.

14 See the essay 'Other Criteria' collected in Leo Steinberg, *Other Criteria: Confrontations with Twentieth Century Art* (Oxford: Oxford University Press, 1972), especially the section 'The Flatbed Picture Plane', 82–91.

15 Diane Waldman, 'Ellsworth Kelly', in *Ellsworth Kelly: A Retrospective*, ed. Diane Waldman (New York: Solomon R. Guggenheim Foundation, 1996), 20.

16 Clare Bell, 'At Play with Vision: Ellsworth Kelly's "Line, Form and Colour"', in *Ellsworth Kelly: A Retrospective*, 73.

17 The origin of this quote is 'The Precession of Simulacra', in Jean Baudrillard, *Simulations*, trans. Paul Foss et al. (New York: Semiotext(e), 1983), 3.

18 Parker Tyler, 'Reviews and Previews', *Art News* 55, no.4 (1956), 51.

INDEX